MUSE

UNCOVERING THE HIDDEN FIGURES
BEHIND ART HISTORY'S MASTERPIECES

RUTH MILLINGTON
ILLUSTRATED BY DINA RAZIN

PEGASUS BOOKS
NEW YORK LONDON

MUSE

Pegasus Books, Ltd.
148 West 37th Street, 13th Floor
New York, NY 10018

First Pegasus Books cloth edition May 2022

ISBN: 978-1-63936-155-7

10 9 8 7 6 5 4 3 2 1

Printed in the United States of America
Distributed by Simon & Schuster
www.pegasusbooks.com

For Julia and Lily

Muse (noun):
The source of an artist's inspiration

Contents

Introduction 1

The Artist as Muse

Juan de Pareja: A Face of Freedom 13

Dora Maar: The Weeping Woman 21

Emilie Flöge: Dressing Klimt's Kiss 31

Peter Schlesinger: Sink or Swim 41

The Self as Muse

Artemisia Gentileschi: Survivor, Painter, Slayer 53

Frida Kahlo: Heroine of Pain 63

Sunil Gupta: Playing Dead 73

Nilupa Yasmin: Weaving a Way In 83

Family Albums

Helena Dumas: Childhood Uncensored 95

Beyoncé: The Fertility Goddess 103

Fukase Sukezo: Father Figure 111

For the Love of the Muse

Ada Katz: American Beauty 123

George Dyer: Bacon and the Burglar 131

Lawrence Alloway: The Critic Stripped Bare 143

Gala Dalí: Queen of the Castle 155

Performing Muse

Moro: Homemade Sushi 167

Ulay: Breathing in Marina Abramović 173

Grace Jones: Graffiti Goddess 183

Tilda Swinton: Surrealist Shapeshifter 191

Lila Nunes: Guardian Angel 199

Muse of a Movement

Elizabeth Siddall: Ophelia Awakes 209

Sunday Reed: In the Paradise Garden 219

Lady Ottoline Morrell: Bloomsbury Bohemian 231

Marchesa Luisa Casati: Medusa's Stare 241

Muse as Message

Anna Christina Olson: Christina's World 255

Doreen Lawrence: *No Woman, No Cry* 265

Sue Tilley: Supervisor Sleeping 271

Ollie Henderson: Start the Riot 277

Souleo: Icon of Harlem 285

Epilogue: The Muse Manifesto 295

Bibliography 303

Acknowledgements 310

Introduction

Johannes Vermeer's *Girl with a Pearl Earring* (*c.*1665) is one of the most famous paintings in the world, and also one of the most mysterious. Who is this girl, dressed in an unusual blue-and-gold headscarf, with her iconic pearl earring? Why does she stare out of the canvas in such an enigmatic way? What was her relationship with the artist? No one knows for certain, and this secrecy only adds to her allure.

The much-debated identity of Vermeer's model inspired Tracy Chevalier to write the best-selling historical novel, *Girl with a Pearl Earring*, which tells a fictitious story behind the painting. Set in seventeenth-century Holland, it follows the narrative of Griet, a sixteen-year-old Dutch girl who becomes a maid in the house of the successful painter. From his studio, the artist paints solitary women in domestic settings, illuminated by brilliant sunlight. Griet is quiet and calm; she is also beautiful and perceptive, and soon attracts Vermeer's attention. The very first time they meet, he notices the way that she has arranged the vegetables she is chopping:

'I see that you have separated the whites,' he said, indicating the turnips and onions. 'And then the orange, and the purple, they do not sit together. Why is that?'

'The colours fight when they are side by side, sir.'

It is a significant moment, revealing an intimate connection between Vermeer and Griet, who shares his understanding of colour. Alongside her

household duties, the artist teaches his maid to make paint, drawing her into his world. It's not long before Griet becomes his next subject: she sits for the notorious painting, wearing his wealthy wife's pearl earring, with her hair tied up in the striking headscarf. Griet has become the artist's muse, the source of his creative inspiration.

This stereotypical artist–muse relationship portrayed in Chevalier's story is one that is embedded in our consciousness: Griet plays the role of a young, attractive, female muse, existing at the mercy of an influential, older male artist. While she shares Vermeer's artistic sensibility, as his maid, Griet must surrender to his control. Nowhere is this made clearer than in the moment Vermeer pierces her earlobe so that Griet can wear the pearl earring; she endures pain for the sake of the portrait.

Chevalier also submits Griet to the trope of the romantic muse, lacing her narrative with sexual tension and emphasising physical touch between the pair: 'I could not think of anything but his fingers on my neck, his thumb on my lips.' She inspires this man in ways that his wife cannot, and an intimacy develops between the maid and Vermeer that ultimately gives power to his painting. In 2003, Chevalier's book was adapted into a film, starring Scarlett Johansson as Griet against Colin Firth's moody Vermeer. Johansson's sensual portrayal of the servant girl only perpetuates the stereotype of an artist–muse relationship defined by female subordination to male authority. 'Open your mouth. Now lick your lips,' the artist demands, and she silently obeys, perfectly playing the part of compliant muse.

But is this perception of a muse – as powerless, submissive and female – accurate? Or could this characterisation actually be somewhat lazy and untrue? Have muses had more agency than we give them credit for? To find out, we must go back to Ancient Greece to understand the original identity, purpose and status of the muse – but, first, we should also take a look at the Disney 1997 animated feature film, *Hercules*.

'We are the muses, goddesses of the arts and proclaimers of heroes,' declare five sassy, gospel-singing female figures. Calliope, Clio, Melpomene, Terpsichore

and Thalia step out from the ancient vase on which they have been painted to tell the story of Hercules and his heroism. Awakened as goddesses of poetic inspiration, the film portrays them as skilled storytellers, and it's not wrong.

In Greek mythology, there were nine female muses. They were the children of Zeus, King of the Gods, and Mnemosyne, Titaness of memory and artistic inspiration. Born at the foot of Mount Olympus, the muses were gifted goddesses of the arts: music, dance, song, poetry and memory. Ancient Greek vase painting depicts them as animated young women, playing musical instruments, singing and reading from scrolls. Invoked by mortals, the muses inspired musicians, artists and writers, all of whom depended on them for divine creativity, wisdom and insight.

The Greek writer Hesiod claimed in his poem *Theogony* to have spoken with the muses, who turned him from a simple shepherd into a blessed poet: 'The Muses once taught Hesiod to sing / Sweet Songs'. Similarly, narrators of epic poems appealed to a muse, or multiple muses, without whom they could not start their story. 'Sing, goddess' is the opening invocation with which poets made clear that their performance relied on direct communication with a muse, who had taught or told them the tale to be repeated. As Homer begins *The Odyssey*:

> *Tell me about a complicated man.*
> *Muse, tell me how he wandered and was lost*
> *when he had wrecked the holy town of Troy,*
> *and where he went, and who he met, the pain*
> *he suffered in the storms at sea, and how*
> *he worked to save his life and bring his men*
> *back home. He failed to keep them safe; poor fools,*
> *they ate the Sun God's cattle, and the god*
> *kept them from home. Now goddess, child of Zeus,*
> *tell the old story for our modern times.*
> *Find the beginning.*

At their ancient origin, the muses were far from passive subjects for an artist to paint or write about. Instead, they were agents of divine inspiration. The artist–muse relationship was one that was revered, and poets, at their mercy, paid homage to these divinities.

The Ancient Greeks have not been the only ones to question the source of creativity, and attribute it to a higher being. In Hinduism, Saraswati is the goddess of music, learning, art and wisdom, and since *c.*1500 BCE she has featured in paintings and relief sculpture on Hindu temples. In each of her four hands Saraswati holds a symbolic object: a book signifies knowledge, mala beads evoke meditation, a water pot embodies the source of creation, and the ancient string instrument, the veena, represents her gift of music to humanity. Nevertheless, the 'muse' is predominantly a Western concept – one which has evolved dramatically over time, particularly throughout European art history.

During the Italian Renaissance, the likes of Titian, Tintoretto and Mantegna drew on ancient Greek culture to paint allegorical masterpieces in which muses came to symbolise the rebirth of the arts. They appear frequently as joyful young women, dancing and playing music in mythical forests, providing inspiration to those around them. However, there was also a significant shift in the portrayal of muses during the Renaissance: frequently, their drapes and dresses have fallen away to reveal bare bodies, painted in soft, fleshy tones. These nubile nudes appear as seductive mistresses, feeding the fantasy of men, both in and outside of the picture frame. We find that muses have become icons of idealised and sexualised beauty.

As early as the thirteenth century, the arts saw another major change in the relationship between the creator and the muse: visual artists and writers were increasingly influenced by real-life, rather than mythological, subjects. Dante Alighieri famously wrote about Beatrice Portinari as 'the love of his life and inspiration muse'. By the Victorian era, the Pre-Raphaelite Brotherhood were painting models who were friends, fellow artists, wives, sisters and lovers. Artists had become enamoured with, and creatively dependent upon, the muses they knew personally.

Given their interest in myth and legend, many Pre-Raphaelite painters presented their models as doomed damsels. Most notably, John Everett Millais portrayed twenty-three-year-old Elizabeth Siddall as Shakespeare's tragic heroine, drowning in a river, in *Ophelia* (1851–52). Through this definitive painting, not only did Siddall become the face of the Pre-Raphaelite movement, but she has since been held up as a symbol of the mistreated female muse, repeatedly cast as a victim – much like the fictional figure she had posed as – in biographies, plays, novels and period dramas. After her marriage to Dante Gabriel Rossetti, Elizabeth Siddall's surname was shortened to Siddal. Several art historians and academics, including Griselda Pollock, Deborah Cherry and Serena Trowbridge, take issue with this misspelling, arguing that it adds to the mythology around Siddall as a muse who primarily served, and signified, her husband's genius. In order that she be valued as a historic individual who brought her own creativity to the role of muse, I have followed their lead in using 'Siddall'.

Throughout the nineteenth and twentieth centuries, many male artists not only embraced, but also perpetuated, this myth of the romantic, feminine muse, focusing on her as an object of desire. With his bronze sculpture, *The Sculptor and his Muse* (1895), Auguste Rodin presented the muse as a nude, long-haired woman who whispers seductively into the ear of the male creator to provide him with inspiration. Meanwhile, with his modernist oval-headed sculptures such as *The Sleeping Muse* (1910), Constantin Brâncuşi imagined the muse in idealised feminine terms, often with her eyes closed, as a peaceful dreaming beauty.

Meanwhile, Pablo Picasso brought dramatic tension to the surface of his canvases, on which he portrayed the many women who shaped his life and career: Fernande Olivier, Eva Gouel, Olga Khokhlova, Dora Maar, Marie-Thérèse Walter, Jacqueline Roque and Françoise Gilot. 'To my misfortune, and maybe my delight, I place things according to my love affairs,' he declared. While he acknowledged the presence of many muses within his work, Picasso also attempted to deny these women any agency: 'Inspiration exists, but it has

to find you working.' Thus the stereotype of the muse – as a passive, young and attractive female serving man's creative genius – was firmly established. To possess a muse had become a status symbol for the 'great' male artist, and patriarchal art historical accounts have since bought into, and preserved, this idea.

Therefore, with the arrival of feminism came a much-needed critique of the muse. While preceded by a long history of activism, it was during the so-called 'second wave' of the 1960s and 70s, that the feminist art movement drew particular attention to systemic sexism, inequality and discrimination ingrained in the arts, as well as wider society. Critics raised concerns about women being objectified and exploited by philandering playboy artists like Pierre-Auguste Renoir, who once notoriously claimed, 'I paint with my prick.' By the 1980s, art historians such as Rozsika Parker and Griselda Pollock were refuting tropes of the idealised, silent muse perpetuated by masculinist discourses. 'Do Women Have To Be Naked To Get Into the Met. Museum?' demanded the anonymous art activists, Guerrilla Girls, in 1989. More recently, narratives have invited us to see artists' models, especially women, as 'more than a mere muse'. When the portraitist Jonathan Yeo, who had been painting model Cara Delevingne, called her his 'perfect subject and muse' in 2016, he was met with much contempt. 'It's time to lock this silly term away in the attic,' wrote the *Guardian*'s art critic Jonathan Jones.

However, perhaps it is our misconception of the muse – a term which has come to carry patronising, sexist and pejorative connotations – which needs locking away. If we delve *inside* the relationships that real-life muses have held with artists, might we find that they have been far from subordinate and romantic subjects? Instead, have these protagonists been involved and instrumental within their creative partnerships? Is every muse a model, or have they inspired artists in other ways? Are muses also more diverse than traditional narratives have allowed? It's time we took another look at the concept of muse, what the complex role truly entails, and the individuals who have assumed this responsibility.

For a start, must there always be a sexual undercurrent or romantic asso-ciation between artist and muse? Let's return to Vermeer's *Girl with a Pearl Earring*. Many art historians think that the model for Vermeer's masterpiece was in fact his eldest daughter, Maria, who would have been aged twelve at the time; other authors have proposed that Magdalena, his patron's teenage daughter, was the real sitter. Either way, Chevalier's version of events is highly unlikely and demonstrates the unrealistic mythology that exists around the muse.

In truth, many muses have been non-romantic subjects with whom the artist has held a close bond: friends, mentors, art collectors, patrons, mothers, children, siblings, colleagues and companions. Who was the unlikely muse behind Lucian Freud's voluptuous fertility goddess reclining naked on a sofa? What was the relationship between Andrew Wyeth and the young woman in pink, who seems to lie waiting for him on the grass in his celebrated painting, *Christina's World* (1948)? There is often more to an image, and its muse, than first meets the eye.

This book will also uncover the unique value and qualities that each muse brings to the role. Far from silently posing, muses often bring emotional sup-port and intellectual energy to the relationship; they share ideas, inventions and techniques; they provide practical help and funding. When the muse is an artist in their own right, this creates a particularly creatively charged dynamic within the partnership. Since the Renaissance, studio assistants and apprentices have served as muses for the likes of Leonardo da Vinci and Diego Velázquez. Modern art then saw the rise of artist couples acting as mutual muses: Max Ernst and Leonora Carrington, Lee Miller and Man Ray, Emilie Flöge and Gustav Klimt. What impact did the almost-forgotten fashion designer, Flöge, have on Klimt's iconic *The Kiss* (1907–8)? Should we see such masterpieces as co-created by both artist and muse? Beyond individual artworks, which movements have muses sparked?

Of course, many muses have been in romantic relationships with their artists. This book will explore how this dynamic has created tensions and

problems for the likes of Peter Schlesinger and Dora Maar. It will also discuss how many muses, particularly women, have been overlooked and overshadowed by their male contemporaries. Taking into consideration the social and historical context within which muses have operated, this book will question why and how people have adopted the role. Millais's model, Elizabeth Siddall, a poet, artist and muse, had severely limited access to formal art education, and was barred from life drawing classes, as a woman in Victorian Britain. Could she, then, have turned to musedom as a career opportunity? Have muses, particularly women negotiating a male-dominated art world, sought and benefited from the position?

It is also important to consider the ways in which artists, from Artemisia Gentileschi to Frida Kahlo, have framed themselves as their own muse to disrupt dominant narratives, explore their identity and even heal themselves. Why does Sunil Gupta 'play dead' for his own camera? He is one of many artists who have challenged and subverted expectations of the stereotypical muse. Feminist artists, such as Sylvia Sleigh, have consciously depicted male muses nude and reclining, reversing the typical gender dynamic of artist and model. Who were these men who Sleigh painted inside her bohemian New York home during the 1970s? How did they feel about being muses?

In today's post-feminist world, women continue to consciously reclaim the role of an active, authoritative muse. Grace Jones, Beyoncé Knowles, Tilda Swinton; all of these women are formidable agents who choose to enter into an artist–muse relationship on their own terms. Renowned fashion photographer Tim Walker, who frequently shoots models who inspire him, reveals the need for absolute equality within the alliance: 'The portrait is a handshake, the embrace, the agreement where we meet halfway along a collaborative path.' Working with multiple artists – compared with whom they are more prominent – modern muses, such as these, play a defining part in determining the final image.

Although born in Western culture, the construct of the muse has also been adopted by contemporary artists across the world. Why does Chinese artist Pixy Liao photograph her boyfriend as a piece of rolled-up sushi? Who are the naked figures in Fukase Masahisa's family photo albums? How do these artists and their muses interrogate heritage, identity and gendered expectations? Who we see represented in artworks when we visit a gallery is important; what impact does this then have on the muses depicted?

Over time, the concept of a muse has changed considerably. Since its divine origins in Greek mythology, the term has acquired connotations of powerlessness. Today, therefore, it's often met with much criticism and even mockery. But could it be our view of the artist's muse as a passive model that is the real myth? Established by male artists, in order to glorify their gaze and frame their individual genius, sexist ideals of the muse have been perpetuated by patriarchal narratives for centuries. Feminist accounts, too, have framed female muses primarily as exploited victims, doing them a huge disservice.

But if we rewrite muses into history, might we find that they have been just as important as artists? For too long the muse has been constrained by traditional and mythologised accounts, which maintain our perception of a 'great' male artist painting a silent sitter, as we find in Chevalier's *Girl with a Pearl Earring*. This book will contest such oversimplified views and, instead, demonstrate the true power that muses have held. Without doubt, it's time that we reconsidered muses, reclaiming them from reductive stereotypes, to illuminate their real, involved and diverse roles throughout art history.

This book features many familiar faces – individuals who have been immortalised in artworks which are hung on the walls of major museums – and introduces some lesser-known figures. As it reveals these subjects' connection and influence over the artists who pictured them, and the enormous contributions that they made, the muse will be reframed as a momentous, empowered and active agent of art history.

Let's meet the muses.

THE ARTIST AS MUSE

JUAN DE PAREJA
A Face of Freedom

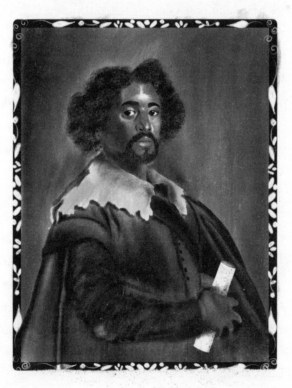

In 1650, the Spanish painter Diego Velázquez exhibited an extraordinary portrait at the annual art exhibition in Rome's Pantheon. Depicted from the waist up, before a shadowy background, a dignified Afro-Latino man proudly holds one arm across his chest. He is elegantly dressed, wearing a charcoal grey cloak, sword belt and large white collar that contrasts with his natural curly black hair, dark beard and eyes. Glowing radiantly in the light that falls upon his face, the sitter stares directly, and powerfully, at the viewer.

When Velázquez's painting *Juan de Pareja* (1650) was unveiled, it caused quite a sensation, particularly among his fellow artists. According to the eighteenth-century biographer Antonio Palomino, it was 'applauded by all the painters from different countries, who said that the other pictures in the show were art but this one alone was "truth".' But was this stately painting really an image of truth when the man Velázquez had portrayed – in such magnificent terms – was, in fact, enslaved by him? Was he not concealing, rather than revealing, reality?

The son of an African-descended woman named Zulema and a Spanish father called Juan, de Pareja was born into slavery in around 1610 in Antequera, near the active slave port of Málaga. It isn't known if he was purchased or inherited by Velázquez, but some time after 1631 de Pareja joined the Spanish painter's studio as his enslaved assistant. There, his duties would have involved helping the artist by grinding pigments, stretching canvases and creating varnishes, among other practical tasks.

Since the Renaissance, artists have enlisted the help of studio assistants not only in the preparation of materials, but in the process of creating artworks. Leonardo da Vinci, Rembrandt van Rijn and Michelangelo are among the 'Old Masters' whose renowned paintings have involved the silent hand of others, including enslaved persons, students and servants. It is therefore also highly

likely that de Pareja would have collaborated with Velázquez on the creation of commissioned portraits.

De Pareja may even have helped to represent royalty, as by the time he entered into Velázquez's studio his master was an official court artist in Spain. Known for his precise realism, Velázquez was employed to paint grand portraits of King Philip IV, his wives and children, and other members of the royal household. In formal posed portraits, Velázquez captured the folds and textures of his sitters' sweeping regal robes and endowed his paying royal superiors with an air of dazzling majesty.

It is in this very same manner that Velázquez chose to represent de Pareja, a muse he was inspired, rather than paid, to paint. There is no indication at all that his sitter is an enslaved person; in fact, far from it – in place of coarse plain clothes, de Pareja is dressed in a close-fitting grey jacket and matching cloak slung fashionably across one shoulder to reveal a sword belt; laid across his shoulders is a bright white lace collar. This painting of striking colour contrasts recalls Velázquez's *Portrait of Philip IV in Armour*, in which the King is dressed in arresting gold and black armour with a crimson sash across his chest.

Like the King, de Pareja has also been illuminated through the use of theatrical lighting, which falls across his face onto his forehead, cheeks and lips. He holds himself confidently, twisting his body slightly to his right, while staring straight at the viewer. There is a defiance about this imposing depiction of de Pareja, particularly given the ways in which slaves were typically characterised in formal and commissioned portraits at this time.

Since owning an enslaved person or servant signalled power and wealth, subservient Black figures were often included in portraits as a means of confirming their white owners' status. For instance, in Jan Verkolje's portrait of Dutch city councillor *Johan de la Faille* (1674) a young Black male, positioned to his finely dressed master's left, bends down in order to hold the leashes of the white man's hunting dogs. Not only does he stoop over deferentially, but exists quite literally in his master's shadow; unnamed and symbolically relegated to the corner of the composition, his individuality has been denied.

Breaking such conventions, Velázquez elevated de Pareja from an anonymous commodity in the background to worthy subject, even naming him in the portrait's title. At the time, it would have been considered an honour to have been painted in these terms by an artist of Velázquez's standing, and particularly if you were an enslaved person. Given that Velázquez could have portrayed de Pareja exactly as he pleased, it's striking that he decided to render him with such gravitas. Why, then, was the painter championing an enslaved person in this manner?

Perhaps Velázquez had recognised the direct parallel which existed between him and de Pareja. Just as his studio assistant worked for him, Velázquez existed in deference to the royal family, providing them with flattering portraits; although not to the same degree, his own dynamic echoed the relationship between enslaved person and enslaver. Just as de Pareja was beholden to Velázquez, the latter served the King, and in the same context – as both men were artists. Had the painter seen something of himself in his subject?

Velázquez does seem to suggest de Pareja's status as an artist in the portrait: a slight tear in his sleeve indicates the arm of a man involved in stretching, priming and painting canvases – perhaps even this one. A master of verisimilitude, was Velázquez sewing truth into the detail of his canvas in order to recognise an enslaved person as an artist?

Velázquez would not have been the first artist–master to have taken a studio assistant as his muse. Leonardo da Vinci was famously inspired to create drawings and paintings of his young servant, assistant and apprentice Gian Giacomo Caprotti da Oreno who joined him at the age of just ten. In his journals, da Vinci describes him as a troublemaker, detailing how this 'thief' and 'liar' frequently stole items and broke things, earning him the nickname Salaì, meaning 'Little Devil'.

Although mischievous, Salaì is easily identifiable in paintings such as *Saint John the Baptist* (*c*.1513–16) through his angelic appearance, beautiful curly hair and enigmatic smile. Some researchers even believe that it was Salaì, and not Lisa del Giocondo, who was the real model for the *Mona Lisa*: the

letters which form 'Mona Lisa' can be rearranged to form 'Mon Salaì'. It's widely thought that da Vinci entered into a sexual relationship with Salaì, who stayed with him for over twenty-five years as a servant, apprentice and muse and, learning from his master, later became a talented artist in his own right. Of course, this relationship highlights the issue of power imbalances which have existed not only between female muses and male artists, but in same-sex pairings, particularly within the era of Renaissance Florence which allowed for pederastic relations.

Despite this, there is no indication that any romance existed between Velázquez and de Pareja, though the artist and muse certainly developed a close personal relationship. It's known that de Pareja acted as an important legal witness for the signing of several documents, including a power of attorney, dating from 1634 to 1653. De Pareja also accompanied his master on the significant trip to Rome where his portrait was first shown to the public.

Standing side by side with his portrait, the striking likeness between real-life muse and painted version would have been immediately visible to viewers, leading painters to remark on the 'truth' of the picture. Palomino also writes in his biography that Velázquez sent de Pareja to present his portrait to some influential Roman friends: 'They stood staring at the painted canvas, and then at the original, with admiration and amazement, not knowing which they should address and which would answer them.'

Perhaps, then, Velázquez had purposely painted his muse in this hyper-realistic manner as a means of showing off his skill and impressing his contemporaries. He once remarked on his desire to stand out: 'I would rather be the first painter of common things than second in higher art.' With this unique and breathtakingly beautiful portrait of a Black enslaved person, elevated to the status of royalty, Velázquez would surely have demonstrated that he was the finest painter of everyday life. Could this, then, be a way of using de Pareja to make a statement?

Acting as an advertisement for his talents, Velázquez could certainly have used this portrait to garner interest for future commissions, particularly as

his portraits of the Royal Family would not have been available for the public to view. In contrast, he owned this portrait of de Pareja, just as he owned the enslaved man himself, and would therefore have been able to do what he wanted with it. If this was the strategy behind the artwork, it surely worked: Velázquez was awarded the commission to paint Pope Innocent X – one of the most influential people in the whole of Europe – later that year.

But Velázquez could easily have chosen to depict a number of potential subjects, such as his pupil, studio assistant and son-in-law, Juan Bautista del Mazo, who succeeded him as court painter to Philip IV of Spain. Moreover, in Velázquez's sympathetic and humanising portrayal of his muse, an affection can be felt for the man whom he came to trust. De Pareja exists beyond a performed status: although he stands proudly, there is a haunting sorrow within his dark eyes, expression and stance. As American contemporary painter Julie Mehretu points out, 'the slipping of his hand under his shawl pulls you to that part of him, just under his heart . . . the piercing look, it's not contempt, I don't read it as rageful or angry and it's not resignation but this very conflicted implicit sadness'.

Velázquez is also, then, telling viewers the story of a man who had no rights of his own at this time. However, that was soon about to change: just months after completing this portrait, Velázquez gave de Pareja back his freedom. Held in the state archive of Rome is the document of his manumission, showing that Velázquez signed a contract on 23 November 1650 that would accord de Pareja his freedom – after another four years of service – in 1654. It's impossible to know if Velázquez took this decision on his own, and some legends describe how it was King Philip IV who demanded the emancipation of de Pareja after seeing his talents as an artist. Either way, by painting him with such majesty, Velázquez seems to anticipate freeing the enslaved man in real life.

Ultimately, from 1654 onwards de Pareja forged a successful career as a portraitist. Making the transition from an enslaved person to a free man and a painter, he created highly accomplished portraits of notable figures including the architect José Ratés Dalmau, the priest and playwright Agustín Moreto,

and even the King of Spain, Philip IV. De Pareja also painted a number of biblical characters and scenes. One of his greatest works, which survives today, is *The Calling of Saint Matthew* (1661), which represents the biblical story of Jesus asking Matthew to become one of his disciples. Matthew, a tax collector, is seated at a table with a bag of gold coins before him; but, raising a hand to his chest, he turns to look at Christ who stands behind him on the right-hand side of the painting, choosing this new life.

Almost mirroring Christ, and at the far left of the composition, stands another significant figure. Wearing an olive-green doublet with matching breeches and stockings, a smart white collar and cuffs is de Pareja, who stares directly at the viewer. Not only has he portrayed himself as a gentleman and witness to this evangelical event, but in his right hand he also holds a piece of paper on which his signature is visible. By signing this document, and by extension the painting, de Pareja asserts his identity as a free and professional painter.

In turning this scene into a self-portrait, de Pareja echoes one of the most famous paintings by his former master, *Las Meninas* (1656). Velázquez's canvas features the family of King Philip IV, including his daughter and several ladies-in-waiting, within the royal palace. Standing on the left, in front of a huge canvas, is Velázquez, who gazes out towards the viewer. Just as Black enslaved persons are sidelined in formal portraits, Velázquez has positioned himself, as a serving artist, on the edge of the group of subjects.

Directly mimicking Velázquez's self-portrait, de Pareja demands that he is seen in the same light as his former master: he, too, is an artist. This painting also recalls Velázquez's portrait of de Pareja himself – here standing in exactly the same pose, gazing out at the viewer, and, although painted a decade later, he looks to be exactly the same age. By taking himself as his own muse de Pareja not only identifies with, but also endorses, Velázquez's earlier representation of him.

However, there is one discernible difference between de Pareja's self-representation and his depiction by Velázquez: the freed painter seems to have lightened his skin. In Spanish society at this time, having a darker complexion

was equated with slavery, and de Pareja would no doubt have faced prejudice despite his status as a free man and professional painter. As Professor of Hispanic Art History Carmen Fracchia points out, 'this statement was the only clear way that Pareja found to convey his status as a man free from the stigma of slavery when the blackness of his skin would always have reminded his audiences of his enslavement'.

It's telling that Velázquez felt no need to lighten the skin of de Pareja; he would not have been affected by the portrayal, whereas de Pareja was, in effect, forced to alter his appearance, given the judgement he would have faced based on his skin colour. De Pareja's self-portrait does, then, also reflect the fact that he was never completely free: in 1660, he became the servant of Velázquez's son-in-law, the court painter Juan Bautista Martínez del Mazo, employed in his workshop. De Pareja remained loyal to Velázquez's family until the very end of his life in 1670.

Today, de Pareja and his story live on in his portrait. It's likely that Velázquez sold the painting to one of the Italians who admired it in Rome, and it was subsequently passed between private collections until 1970 when it came up for sale. The Metropolitan Museum of Art in New York bought it for a then record-breaking £2,310,000, declaring it 'among the most beautiful, most living portraits ever painted' and one of the 'most important acquisitions in the Museum's history'.

The incredible likeness of de Pareja, which first astounded viewers at the Pantheon, continues to move contemporary audiences. Hung in a gallery of Velázquez paintings, de Pareja stands side by side, and on equal terms, with the artist's elite and royal sitters; none, however, have quite the same emotional presence as de Pareja. Although he is not represented in the conventional manner of an enslaved person, there is no illusion here, only integrity: this is a studio assistant, an artist and, above all, a man worth painting. Velázquez has conveyed his muse's dignity and true worth *in spite* of his societal status – which de Pareja confirmed by later portraying himself, as a free man, in this same image.

DORA MAAR
The Weeping Woman

P ablo Picasso, one of the most influential artists of the twentieth century, is associated most of all with pioneering cubism. In his art, he created a new way of looking at the world through abstracted, intersecting and fragmented forms. However, Picasso is just as famous for his tangled, romantic relationships; the women in his life provided inspiration for some of his most admired portraits, most notably *The Weeping Woman* (1937). Who *was* the muse for this cubist masterpiece, and why is she crying? To find out, we need to go back in time, one year earlier, to a café in Paris.

In 1936, Paris was a bohemian centre of art, film and literature. The French capital attracted avant-garde artists, writers and intellectuals from around the world, offering them the opportunity to exhibit in salons and expositions, attend influential art schools, and make a name for themselves. This freedom helped the city to birth many major modern art movements: impressionism, Fauvism, Dada, surrealism and, of course, cubism. During the 1920s and '30s, the creatives of Paris would rendezvous at an art deco-styled café, located in Saint-Germain-des-Prés, called Les Deux Magots. This meeting place for writers, philosophers and artists welcomed the likes of Ernest Hemingway, Simone de Beauvoir and Jean-Paul Sartre, alongside Fernand Léger, Joan Miró and Picasso. Another artist who often came to this legendary café was the talented photographer Dora Maar.

The story of Dora Maar and Pablo Picasso's first encounter has been much mythologised: it is said that Maar, aged twenty-nine at the time, was seated alone at Les Deux Magots, playing a game in which she stabbed a penknife between her fingers into the wood of the table. Years later, the episode was described in detail by another of Picasso's models and lovers, Françoise Gilot, in the Parisian newspaper *Le Figaro*:

Dora Maar wore black gloves with little roses. She took off her gloves and took a long, pointed knife that she stabbed into the table between her spread fingers. From time to time, she missed the mark by a fraction of a millimetre, and her hand was covered in blood. Picasso was fascinated. He asked Dora to give him her gloves, and he saved them under glass.

Maar wanted to win the attention of Picasso, almost thirty years her senior, and this sadistic, sensational knife game worked. Whether the legend of their meeting is entirely true or not, it nevertheless epitomises their emotionally charged, creative and tumultuous nine-year affair, ignited by Maar.

Born in 1907, Dora Maar was raised between Argentina and France by a family who supported her ambitions to become an artist. Settling in Paris aged nineteen, she studied at various art schools, including the progressive École des Beaux-Arts, Académie Julian and École de Photographie, where she developed an imaginative and atmospheric style of black-and-white photography.

Maar soon established herself as a prominent photographer associated with surrealism, a movement through which artists explored dreams, the subconscious and erotic desire. In 1936 she exhibited at the International Surrealist Exhibition in London alongside Salvador Dalí, Man Ray, Eileen Agar and Paul Éluard, where her black-and-white photograph of a mystical, armadillo-like creature, *Père Ubu*, became a celebrated surrealist icon. Maar also worked as a successful photojournalist and commercial photographer. By 1931, aged just twenty-four, she had opened her own studio with the set designer Pierre Kéfer under the name 'Kéfer – Dora Maar', taking on significant commissions for individual portraits, fashion magazines and advertising campaigns.

Maar's talent as a photographer played a hugely significant part in her relationship with Picasso. Early in their affair, they worked alongside one another in her darkroom, where she taught him complex photographic processes, such as cliché-verre, meaning 'glass picture', which involves drawing handmade negatives on glass. Under her direction, Picasso used this technique to create a series of startling, unposed portraits of her.

Picasso, too, inspired Maar. Under the influence of the painter, she created pioneering photomontages by effectively 'painting' with varying levels of light exposure. They had entered into a creative and productive partnership. Tate Modern's director, Frances Morris, who interviewed Maar when the photographer was in her eighties, has spoken of the trust between the couple: 'As much as being a sexual or emotional relationship, it was a collaborative one.'

It was during this early and artistically successful stage of their relationship, just one year after they had first met, that Picasso painted the infamous portrait: *The Weeping Woman* is unmistakably Dora Maar, with her distinctive, shoulder-length black hair, large, wide eyes, dark eyelashes and painted fingernails. But why is she crying?

This cubist canvas has frequently been read as a depiction of the couple's dramatic and impassioned affair, following which Maar suffered a nervous breakdown. 'Dora, for me, was always a weeping woman,' Picasso notoriously said. He drew and painted her, afflicted by tears, over sixty times.

Without doubt, the couple had a stormy relationship. Outspoken and, at times, antagonistic, Maar was not afraid to stand up to Picasso, resulting in explosive arguments between them. Picasso's womanising ways also added to this tension. When Maar met Picasso he was already involved with another woman and muse, Marie-Thérèse Walter, with whom he had a two-year-old daughter, Maya. Marie-Thérèse Walter once confronted Dora Maar in Picasso's studio, insisting that the artist's new muse leave: 'I have a child by this man. It's my place to be here with him. You can leave right now.'

The strong-willed Maar, however, didn't back down: 'I have as much reason as you have to be here. I haven't borne him a child but I don't see what difference that makes.' Picasso continued to paint while they argued, before Marie-Thérèse Walter turned to him, demanding, 'Make up your mind. Which one of us goes?' He later recalled, 'It was a hard decision to make. I liked them both, for different reasons: Marie-Thérèse because she was sweet and gentle and did whatever I wanted her to, and Dora because she was intelligent . . . I told them they'd have to fight it out themselves. So they began to wrestle.'

Picasso seemed to take great pleasure in creating competition between the women in his life, referring to this incident as one of his 'choicest memories'. In many ways, he caused Maar to become a weeping woman. But could it be too simplistic to read Picasso's portrait as a representation of Maar's emotional distress within their relationship? Is there more to this painting than the depiction of an anguished muse at the artist's mercy?

If we are to understand why Picasso painted Maar as a weeping woman, we need to step back from her personal relationship with the artist and look, instead, at her political beliefs. Like many surrealist artists, philosophers and poets during the 1930s, Maar had converted to left-wing politics. In fact, she became one of the Left's most involved activists – a radical move for a woman at a time when women were still largely excluded from politics in France; they only gained the right to vote in 1944.

As the Great Depression of the 1930s hit hard, economic adversity proved beneficial for far-right parties and the fascist threat escalated across Europe. French politics became increasingly polarised, with citizens divided into two fronts: an extreme right-wing league or a left-wing who were united against fascism. Maar was amongst those who signed the Left's *'Appel à la lutte'* ('Call to the struggle') manifesto; advocating for a social revolution, their motto was:

There's not a moment to lose
Unity of action
Call for a general strike!

Then, in 1935, Maar became involved in the Contre-Attaque group, led by the writer and philosopher George Bataille, who called for force and violence, rather than theoretical debate, in the fight against fascism; a passionate member, she not only signed their manifesto but operated their telephone line. She also supported the left-leaning theatre collective Groupe Octobre by recording their aggressively political performances in public spaces.

Maar's deep commitment to left-wing ideology can be found in her social-documentary photography from the 1930s. Travelling to the outskirts of Paris, Barcelona and London, she portrayed labourers, the unemployed and children on desolate city streets and in the poorest neighbourhoods. Her photographs evoke, above all, the humanity of those affected by the devastating Depression, inviting viewers to feel compassion with her subjects.

When the politically engaged Maar met Picasso, her left-wing views made a significant impact on him, as an individual, and as a painter. Increasingly sharing her sympathies, and following in the creative footsteps of Maar, Picasso became absorbed with the theme of human suffering in his work; and so it is through *this* lens that we must look at *The Weeping Woman*. We must also take into account his celebrated painting, completed just weeks before, *Guernica*.

Guernica is considered one of the most powerful and moving anti-war paintings in the world. Through this monumental mural, measuring over seven metres wide, Spanish-born Picasso depicted his outrage at the bombing of Guernica on 26 April 1937, by German and Italian warplanes, during the Spanish Civil War.

The brutal aerial bombing by fascist forces was carried out on market day. Many defenceless people, including children, had gathered in the streets of the small town in Spain's Basque Country. Rather than focusing on fighter planes and armed soldiers, Picasso pictured the pain of these innocent victims, showing the true cost of war in human terms.

It was Dora Maar who found a studio large enough for Picasso to paint *Guernica* in. Through her left-wing network, she gained access to a space located on the Rue des Grands-Augustins, not far from Notre-Dame. The building was the former headquarters of the 'Contre-Attaque' group, of which Maar was a loyal member. Having heard anti-fascist speeches made here, she identified it as the perfect place for Picasso to embark on an epic protest painting.

Maar joined Picasso in the studio, allowing her to witness every stage of *Guernica* being painted over thirty-six days. Whilst Picasso worked, she

photographed him. Taking hundreds of photos, Maar traced the evolution of the tableau, from drawn outlines on the canvas to completed political masterpiece. Published in the art journal *Cahiers d'Art*, her documentary images memorialise the development of *Guernica*, during which Picasso had now become *her* subject.

Maar's images also highlight the immense influence that her black-and-white photography had on the artist. In stark contrast to his earlier colourful approach, Picasso used a monochromatic palette of black, white and grey to paint this mural. His severe, photographic style created a nightmarish vision of fleeing and fallen human figures, animals distorted in agony, and hollow skulls, symbolic of death.

At the top centre of the canvas, you can see a stark light bulb, blazing in the shape of an evil eye. This light illuminates the victims of war, exposing their suffering. It also lights up the vision of Guernica within a compressed, darkened and ambiguous room. With the dangling lamp, it evokes Dora Maar's shadowy darkroom, where Picasso had learnt photography from her.

Maar not only photographed *Guernica*, she also painted some of the hairs on the horse's back, at Picasso's request, and modelled for one of the women. At the extreme left of the painting is a mother, head thrust back, shrieking in grief, and holding the lifeless body of her dead child. This is one of the most devastating and unforgettable images within the painting. It is also the first time that we see Picasso painting a crying woman.

Just one week after completing *Guernica*, and in the very same studio, Picasso began *The Weeping Woman*. Maar recalls that he worked frantically, completing the canvas, for which she sat, in a matter of days, dating the finished work on 26 October 1937. With this work, Picasso was continuing, and deepening, his exploration on the theme of human suffering: the screaming woman, fleeing Guernica, had become a weeping woman, engulfed in grief.

Picasso's *Weeping Woman* cries and cries, with no end in sight. Agony is etched into her face, defined by jagged lines; the handkerchief stuffed into her mouth appears like a shard of glass; and her black dress is the universal symbol

of mourning. If you want confirmation that this painting, like *Guernica*, is an anti-war statement, take a close look at the woman's eyes: you can see the silhouette of a warplane in place of each pupil.

The Weeping Woman is an evocation of overwhelming anguish caused by the atrocities of war. It encapsulates Maar's compassion for human suffering, which she had photographed continually, and sympathetically, in her own work. In this portrait, it's almost as if she is crying in grief at others' pain.

Speaking out about his portrayal of Maar, Picasso revealed, 'For years I gave her a tortured appearance, not out of Sadism, and without any pleasure on my part, but in obedience to a vision that had imposed itself on me.' That vision encompassed the photographer's political sympathies and anti-fascist stance, which he had grown to share.

At the same time, the painting is inflected with Picasso's perception of Maar's personal grief, resulting, in part, from her relationship with him. Picasso was often abusive towards Maar, physically and emotionally, exacerbating the depression and anxiety which she battled throughout her life. 'Women,' the artist once proclaimed, 'are machines for suffering,' fetishising the pain he caused them.

Compulsively unfaithful, Picasso never ended his relationship with Marie-Thérèse Walter while he was with Maar. Furthermore, in 1943, he also took another, younger woman, Françoise Gilot, as his muse and lover. Finding out about Picasso's new love interest, Maar was furious, and confronted him: 'As an artist you may be extraordinary, but morally speaking you're worthless.' Maar's words could be applied to numerous other 'great' figures from history, whose abusive behaviour has been excused, overlooked or hidden by their cloak of 'genius'.

Nine years after Maar instigated the affair with Picasso, she left. Following the painful separation, she suffered a nervous breakdown and was treated by the psychoanalyst Jacques Lacan. Whether through guilt, or still desiring some level of control over Maar, Picasso bought her a house in Provence, from where she painted for the rest of her life.

It's no surprise, then, that *The Weeping Woman* is read as a reflection of their problematic relationship, and Picasso's view of Maar as tormented and anxious, a state which he increasingly induced. However, Maar herself refuted this intimate reading: 'All [Picasso's] portraits of me are lies. Not one is Dora Maar.' She meant more to Picasso than tears, and she knew it.

Resolute in her beliefs, articulate and persuasive, Maar was instrumental in encouraging Picasso's political awareness, which culminated in his greatest painting, *Guernica*. She played an integral role in the creation of this epic mural – emotionally, creatively and even practically. Picasso's depiction of the tragic suffering caused by war became yet more palpable in his next protest piece, *The Weeping Woman*. Far from a forlorn, love-stricken muse at his mercy, Maar changed the trajectory of Picasso's practice.

Muses were of paramount importance to Picasso, and Dora Maar was his most poignant partner. So much more than his plaything, Maar was an active, defining and dominant force, who deserves credit for the cataclysmic role she embraced in his career. At the same time, even a formidable woman like Maar was, in many ways, exploited by Picasso; manipulating his status as a 'great artist' he profited from Maar's crucial input, using her creative talent to further his own career while contributing to her demise. Behind *The Weeping Woman* is Maar's compassion, companionship, intelligence and political activism, all of which profoundly inspired Picasso.

EMILIE FLÖGE
Dressing Klimt's Kiss

Rendered in Gustav Klimt's distinctive decorative style, *The Kiss* (1907–8) portrays an embracing couple, enveloped in golden robes, who kneel on a bed of blossoms. A dark-haired man, adorned with a crown of vine leaves and a geometrically patterned gown, leans in to kiss the ivory-pale face of a woman. Wearing a crown of flowers in her auburn hair and a dress patterned in soft ornamental shapes, she closes her eyes in complete bliss.

Today, Klimt's most popular painting has been reproduced countless times – on Valentine's Day cards, cushion covers, mugs and posters hung on bedroom walls. Evoking tenderness, intimacy and unity, the image is held up in celebration of an idealised romance between a man and woman. But could there be more to this glittering masterpiece than an allegory of love? Who are the couple, and what is the significance of their shimmering, mosaic-like robes?

Klimt painted *The Kiss* from his studio in Vienna at a pivotal moment in the city's history. At the turn of the twentieth century, the Austrian capital was a vibrant epicentre for artists, designers and intellectuals. Among them was the pioneering psychologist Sigmund Freud who, in 1905, and just two years before Klimt painted *The Kiss*, published *Three Essays on the Theory of Sexuality*. With this founding text of psychoanalysis – which framed sexuality as a normal part of development – Freud profoundly challenged attitudes to sex.

While Freud's theories shocked and disgusted many, they influenced a number of contemporary artists, including Oskar Kokoschka, Egon Schiele and Klimt, who began to interrogate sexuality through their visual art. Kokoschka painted darkly expressive couples, reflecting on his troubled relationship with Alma Mahler, the lover and muse who abandoned him; Schiele, meanwhile, used twisting lines to infuse male and female nudes, whom he posed spreadeagled, with an electrifying eroticism.

Klimt, too, depicted nude female figures, undressing biblical and fictional characters including Judith holding the severed head of Holofernes, Eve found in the Garden of Eden, and a sleeping Danaë, the young woman who Zeus seduced in Greek myth. In works such as these, the artist treated his subjects in sensual terms, describing the feminine form with sweeping, unbroken curves. However, breaking away from his fellow contemporaries' focus on stripped-down figures, from around 1900 Klimt also clothed many of his women in ornate outfits, such as that seen in *The Kiss*. What, then, had sparked his focus on fashion?

From the start of his career, Klimt had an interest in the decorative arts. Instead of studying at Vienna's famed Academy of Fine Arts, he trained at the more practical School of Applied Arts between 1876 and 1883, where the influence of the English Arts and Crafts Movement had taken hold. Klimt admired its leader William Morris, who wanted to raise the status of the design – including jewellery and textiles – to that of painting or sculpture. Morris believed that art should be for everyone and infuse domestic life; he famously filled Victorians' homes with his pattern designs featuring leaves, flowers and strawberry-thieving birds.

Like Morris, Klimt took the idea of decoration seriously; he led a group of young rebel artists called the secessionists away from Austria's academic art history and towards a more modern aesthetic: 'To every age its art, to every art its freedom' was their motto. Although Vienna's secession did not promote a particular style, artists including Klimt borrowed an ornamental approach to painting from art nouveau with its emphasis on swirling natural forms and rhythmically repeated patterns. However, the importance of fashion in Klimt's work must likewise be attributed to one particular woman, who also rejected artistic traditions and rebelled against society's norms, but who has been overlooked in many of art history's narratives: Emilie Flöge.

Flöge appears in an early pastel portrait by Klimt, titled simply *Emilie Flöge, Aged 17*, from 1891. Drawn in soft tones, it pictures Flöge from head to waist, wearing a pretty but traditional white gown and delicate tiara in her

pinned-back hair; with her face in profile, she stares away from the artist, who seems to be keeping a respectful, although admiring, distance from his new muse, whom he had recently met. Earlier that year Klimt's younger brother, Ernst, had married a young middle-class woman called Helene Flöge. Following the wedding, the artist became a frequent guest at the Flöges' family home, where he met Helene's three siblings, including her youngest sister, Emilie.

But it wasn't just family ties which drew Klimt to Flöge: aged seventeen, she was already a talented seamstress and aspiring fashion designer who was equally interested in and committed to the ideas of the Vienna Secession. When in 1903 the Wiener Werkstätte – and an alliance of artists and designers – was founded, both Klimt and Flöge became significant members. Inspired by the Arts and Crafts Movement, they wanted contemporary art to infiltrate every area of life, from furniture to fashion, and promoted the concept of the *Gesamtkunstwerk* or total work of art – Klimt through his paintings and Flöge in her progressive dress designs.

Flöge took a leading role in rethinking women's dress for the modern age, designing garments in the style of the new 'reform dress'. With wide sleeves and an empire waist, it was intended to free women's bodies from the traditionally restrictive corset and impractical garments which physically prevented them from fully participating in society. Instead, this easy-to-wear, flowing robe both allowed for, and celebrated, the bodily liberation of women, promoting comfort, practicality and engagement with everyday life. This fashion reform reflected and symbolised wider feminine emancipation across Europe, where the idea of an educated, independent 'New Woman' was taking hold.

Although at the turn of the century in Vienna unmarried middle-class women could forge their own careers, Flöge embarked on what would have been an unusual venture at this time. In 1904, with her two sisters, she opened a fashion house and shop called Schwestern Flöge, located on Vienna's bustling Mariahilfer Strasse. A former apprentice of the three sisters, Herta Wanke, recalled that 'it was Emilie Flöge in particular who kept the salon. It was

only due to her initiative that the firm reached such a height.' The youngest sister was the one who not only sewed and designed garments but, as Wanke accounted, 'directed the whole fashion house', which became particularly well-known for its range of non-conforming reform dresses and one of the city's top fashion salons.

Welcoming the women of Viennese high society into Schwestern Flöge, Flöge dressed them in her haute-couture designs for which she took inspiration from an extensive personal collection of folk art and festival dress which she owned and exhibited in the store. As her apprentice recalled, there were 'glass display cases with beautiful embroideries, Hungarian national costumes, Slovakian needlework, which were something quite exquisite'. The bold colours, symbolic shapes and intricate geometric patterns of these pieces not only informed her own flamboyant creations, but also appear in the paintings of Klimt.

In marked contrast to her first formal portrait by Klimt, in *Emilie Flöge* (1902) the designer, now aged twenty-eight, models one of her own creations – the long blue-mottled robe, embellished with purple spirals, white dots and gold squares, falls to her feet. Exuding confidence, she holds one hand defiantly on her hip, while staring straight at the artist. Although she is naturally tall and slim, Klimt has emphasised her stature to present her as a towering and proud figure.

From this point onwards, it can clearly be observed that Klimt's relationship with fashion begins to dominate his paintings. 'Every aspect of this portrait acclaims the artistic vision of Gustav Klimt and the period,' writes curator Frances Lindsay. However, she may be missing a key point: he is also paying tribute to Flöge as an artist. As well as showing off her own radical and revolutionary reform dress, Klimt brings the focus onto Flöge's strong, slender hands – emerging prominently from her billowing sleeves, they point to the maker behind the dress.

Flöge opened up the world of fashion for Klimt, and they soon began to collaborate on a range of dresses: taking inspiration from her collection of folk

art, as well as stage costumes, kimonos and kaftans, Klimt created designs which Flöge then sewed in the Schwestern Flöge workshop. As curator Jane Alison writes in the catalogue for the Barbican's 2018 exhibition Modern Couples: Art, Intimacy and the Avant-Garde, 'Klimt and Flöge, in a process of co-creation, became standard-bearers of the new liberated man and woman, the alternative king and queen of fashionable Viennese society.'

Numerous photographs show the pair sailing together on a boat on Lake Attersee, where they spent many summers together between 1900 and 1916, along with the wider Flöge family. In these images, they are both dressed in long reform robes embroidered in their designs; mirroring one another, Klimt and Flöge appear as equal and artistic companions. Klimt also photographed Flöge alone in the gardens surrounding and beside the edge of the lake, modelling their co-created long flowing dresses. While she poses seriously for the majority of these shots, in several of them Flöge laughs out loud, as if in on a secret joke with him.

Back in Vienna, Flöge was not the only subject whom Klimt portrayed wearing her dresses. At the Schwestern Flöge store, the designer introduced Klimt to wealthy heiress clients who were all keen to have their portraits painted by him: Sonja Knips, Szeréna Lederer, Friederike Maria Beer and Adele Bloch-Bauer, adorned in Flöge's ornate dresses, were among those who posed for the artist. It is Bloch-Bauer who sat for the iconic painting *The Woman in Gold* (1907), in which she appears empowered, in a wondrous flowing dress embellished with swirling, golden patterns, upon a stylised throne.

While Flöge provided Klimt with a network of female models, Klimt promoted Flöge's salon to his circle of collectors and patrons; his paintings of high-society women, whom he elevated to the status of icons adored in Flöge's innovative designs, were surely the best advertisements she could have wished for. Moreover, Klimt's paintings validated her avant-garde creations as furthering the freedoms of women: by rendering his female sitters confidently garbed in the new reform dress, rather than restrictive traditional garments,

Klimt embraced the iconography of women's liberation, showing his full support and solidarity with Flöge's rebellious feminist fashions.

The same year that Klimt painted Bloch-Bauer as *The Woman in Gold*, he created his most celebrated canvas of all, *The Kiss*, which many believe to represent the artist and his main muse, Flöge, who were inseparable. Given the pose of the embracing couple, the painting invites questions about the exact nature of the pair's relationship – we know that they were close friends, artistic allies and creative collaborators for twenty-six years. But did Klimt and his muse also enter into a romantic partnership?

Between 1897 and 1913 Klimt wrote around four hundred letters and postcards to Flöge, including eight on the very same day, on 10 July 1909. Often hastily scribbled, without proper punctuation, they reveal a closeness between the pair who were in constant correspondence, even while both in Vienna. In short notes, Klimt invites Flöge to attend plays, operas and concerts with him: 'Ballet Russe extended – so we could go to it together,' he writes in typically brief fashion on 24 February 1912. This archive of letters demonstrates the couple's status as close companions who enjoyed the city's rich cultural life together.

Klimt also wrote to his muse while he was travelling in Europe. In his correspondence, he covers a wide range of subjects, including art history, his own painting, his health and often, in what seems to be a favourite subject, the weather! He includes details about trips to museums, galleries and cultural sites, which sparked his imagination, and in 1903 he wrote about the 'unbelievably wonderful' golden mosaics he had seen in Ravenna, which were to partly inspire shimmering paintings such as *The Woman in Gold* and *The Kiss*.

Held up as an allegory of love, some critics perceive *The Kiss* to be a double portrait of the couple and an illustration of their romantic relationship. Wrapped in gleaming golden robes, they evoke the artists, who certainly dressed in such flowing patterned garments. However, in none of his letters does Klimt address Emilie in romantic terms or write with the tone or terminology you might expect of a lover; rather, he uses surprisingly formal

salutations and sign-offs: 'Sincerely Gustav', 'Sincerest greetings' and 'Sincere best wishes'.

Moreover, if you look closely at *The Kiss*, the woman turns away slightly from the man's embrace, offering only her cheek up for his lips. Klimt, who shared a flat with his mother and two sisters, never married, although it is widely believed that he was the father of many illegitimate children with various women. Flöge has been presented by numerous critics and academics as a victim of Klimt, whom art historian Jill Lloyd rightfully refers to as a 'serial philanderer'. But perhaps the painting also shows us that it was Flöge who wanted to keep her independence.

While Klimt travelled for his career, so too did Flöge, who managed her business and decided on its direction. She would visit London and Paris several times each year in order to attend trade shows, source fabrics and accessories, and to keep up to date with new fashion trends. Marriage would undoubtedly have compromised her profession and restricted her business activities, since most married women at this time were expected to prioritise home life and husbands over work.

It is impossible to know the exact nature of the relationship between Klimt and Flöge, and *The Kiss* cannot be used as evidence for their romance. Perhaps there had been a spark and they ignored it, feeling that their connection as professional partners and close friends was more important. What *is* clear, however, is the respect, mutual admiration and commitment which they felt towards one another, which is surely indicated in Klimt's masterpiece. So often we hold romantic love up as the ultimate aim, and overlook the importance of platonic friendships; dressed in Flöge's revolutionary designs, the two appear bound together, oblivious to all else.

Following the Nazi invasion of Austria, in the lead-up to the Second World War, Flöge was forced to close her salon in 1938. Nevertheless, she maintained behind its bolted doors a 'Klimt room', in which she kept the artist's easel, his painter's overalls, drawings and a collection of his own ornamental gowns, protecting the treasured memories of her time together with him. By this time

the older artist had died, suffering a stroke on 11 January 1918; Klimt's last words reportedly were 'Get Flöge.'

Just as Flöge inspired Klimt, today her art-oriented aesthetic continues to make its mark on others. In 2015, Maria Grazia Chiuri and Pierpaolo Piccioli based their Fall/Winter collection for Valentino on her designs: models took to the catwalk in boldly geometric black-and-white gowns and embroidered floor-length robes in the style of the reform dress. In an interview for *Women's Wear Daily*, sometimes referred to as 'the bible of fashion', Chiuri divulged the inspiration behind their designs: 'Women can be multifaceted. They can be muses, they can be artists. And our collections speak about this in a simple way.'

Klimt's sumptuous golden goddess, Flöge, should be seen as far more than a passive princess waiting to be kissed. She was a hugely talented designer, who had a profound influence on the artist and his work; the dresses she designed and co-created with Klimt contributed significantly to his trademark decadent aesthetic. It's no wonder that this avant-garde couple find themselves in each other's arms in *The Kiss*. As if cloaked in their collaboration, the painting acts as a manifestation of the transformational impact they had on one another as equal and mutual muses who, side by side, rejected tradition and embraced the uniting worlds of art and fashion.

PETER SCHLESINGER

Sink or Swim

D avid Hockney – born and raised in the often cold and rainy land of Yorkshire, England – is best known for his dazzling paintings of sun-dappled swimming pools. Having moved to Los Angeles in 1964, the artist was captivated by California's endless sunshine, palm trees and laid-back lifestyle. Openly gay, Hockney turned his gaze on beautiful bronzed men lounging poolside, portraying them naked or semi-clothed, bathed in the golden light of this utopian water world.

One man in particular inspired Hockney: Peter Schlesinger. In paintings from the 1960s and '70s, Schlesinger sunbathes and cools off within the clear blue water of private swimming pools. He is also present in one of Hockney's most recognisable Californian canvases, *Portrait of an Artist (Pool with Two Figures)* from 1972, which made headlines around the world in November 2018 when it sold for $90.3 million at auction – at that time the highest price ever paid for a work by a living artist.

In the painting Schlesinger is dressed in brown shoes, white trousers and a hot pink jacket; standing at the edge of a swimming pool and looking down, he watches as a man, visible beneath the rippling water, swims towards him. In the distance is a boldly coloured landscape, adding to the sultry atmosphere. While it's a warm, inviting scene, there is also a sense of intrigue: why is Schlesinger, typically pictured in various states of undress, clothed so formally? In order to understand this painting and Schlesinger's place in it, we must visit London via LA – so let's dive straight in.

Schlesinger had dreamt since childhood of becoming an artist, and was fortunate enough to be supported by his family. 'My father, who was into photography, gave me my first camera,' he recalls. His parents also signed young Peter up for a summer camp where he could take photography courses, and took him to art classes at the University of California Los Angeles (UCLA).

In 1966, at the age of eighteen, Schlesinger enrolled in a drawing class at UCLA – a decision that would change the course of both his career, and his life.

Schlesinger notes the memorable first day of class: 'The professor walked in – he was a bleached blonde; wearing a tomato-red suit, and green and white polka-dot tie with a matching hat, and round black cartoon glasses; and speaking with a Yorkshire accent.' Schlesinger had just met Hockney, then a relatively unknown artist, whose 'image and personality intrigued' him. The feeling was very much mutual, as Hockney has recalled: 'He was just the kind of person I'd been hoping to meet in my class.'

Outside school, tutor and student were soon spending a huge amount of time together, first as friends, and then as romantic partners. During weekends when his parents were away, Schlesinger would invite the painter back to his home where they, like most other Californian families, had a pool in their backyard. The couple also enjoyed lounging at the houses of shared friends, including the contemporary art dealer and gallery owner, Nick Wilder, who appears in numerous swimming-pool paintings from this period.

It was Wilder's home which served as the setting for Hockney's large canvas, *Peter Getting Out of Nick's Pool* (1966). Painted the same year that the artist and his muse met, it depicts Schlesinger naked and alone in their friend's pool; pictured from behind, he uses his athletic arms to pull himself up and out of the blue water, which ripples in abstracted wavy white lines, iridescent in the midday sun. Scenes of Schlesinger relaxing semi- or completely naked poolside allowed Hockney to modernise what he referred to as the 'three-hundred-year tradition of the bather as a subject in painting'.

However, from a more autobiographical perspective, Hockney's pool paintings also act as a visual diary for the growing intimacy between him and Schlesinger. Although Hockney never painted himself into portraits with his muse, in *Peter Getting Out of Nick's Pool* two empty deckchairs, positioned in front of the wall of Wilder's minimalist house, hint at Hockney's presence beside Schlesinger. Before long, the pair were living together in Hockney's

small home in Santa Monica, which the painter documented in intimate drawings of Schlesinger reading, reclining on their bed and cleaning his teeth in the bathroom doorway.

In the summer of 1967, the couple left California to embark on a tour of Europe. Hockney continued to make simple sketches of his muse, in which Schlesinger looks relaxed in a T-shirt and shorts, resting on deckchairs, and in one watercolour he is seen taking a bath in a French spa. Similarly, Schlesinger took colour photographs of Hockney, many of which have been published in his book, *A Chequered Past*. These images show Hockney posing playfully on the streets of Paris and Venice, while one unstaged shot – which echoes the artist's watercolour of Schlesinger – captures Hockney reclining in a bathtub overflowing with foamy bubbles. These photographs read like any romantic couple's holiday pictures, taken to record happy memories.

Schlesinger's photographs also document the next stage of the couple's relationship: following their travels across Europe, he persuaded Hockney to move to London, where they lived together in Hockney's flat in Notting Hill, then still an affordable area. Hockney invited Schlesinger to decorate it as he wished, and it was soon filled with antiques from the nearby Portobello Road market. By the autumn, Schlesinger had also secured a place at London's esteemed Slade School of Fine Art, where he could continue with his painting studies; encouraged by Hockney, who recognised his 'considerable talent', Schlesinger hung new work in their shared home.

Just as Hockney had been charmed by suburban California, Schlesinger was enthralled by London and everything this artistically rich city could offer him: 'He [Hockney] represented a world outside my own that I was eager to embrace.' When not studying, he was introduced by Hockney to leading figures from the art, design and fashion world, whom he took as his own muses. Schlesinger's closely shot portraits record the couple taking tea with contemporary artists Gilbert and George, meeting Paloma Picasso and watching Manolo Blahnik have his hair cut.

One striking photograph pictures Hockney and Sir Cecil Beaton, sitting side by side on wicker chairs, in the plant-filled conservatory of the society photographer's grand mansion. 'Hockney and I spent many weekends at Cecil Beaton's country house in Wiltshire. It was called Reddish House and was partly real Edwardian and partly a theatrical creation of Cecil's. He had kept scrapbooks for years, which he let me look through, and they were an inspiration for my own albums,' Schlesinger has reminisced, giving voice to the inspiration which other artists can provide for one another.

Far from a one-way relationship, Schlesinger also introduced Hockney to his own newly made creative friends from London's art world; among the most significant was British textile designer Celia Birtwell, who dressed celebrated figures from the Beatles to Jimi Hendrix in her romantic floral prints. Birtwell became another subject for Schlesinger: in one informal photograph she stands casually in the couple's Notting Hill home, resting one arm against their white mantelpiece, a full bookshelf in soft focus behind her. Wearing a flowing white scarf and a baby blue sweater, which matches her eyes, Birtwell smiles in an unforced manner for the camera; it's an intimate portrait of her as both artist and muse, mirroring Schlesinger's own status at the time.

Schlesinger was also instrumental in Birtwell befriending, and then modelling for, Hockney: 'It was only when Peter Schlesinger became his partner that I really got to know him. Peter would often come round to my flat for tea and David would collect him.' Birtwell went on to star in many paintings, including the reputed double portrait, *Mr and Mrs Clark and Percy* (1970–71). Within her light-filled London flat, Birtwell stands, one hand on her hip, in a floor-length black-and-red crêpe dress which had been created for her by her then husband, the fashion designer Ossie Clark. Wearing a green jumper and trousers, Clark lounges on a modern metal-framed chair, with their white cat perched on his knee. With a backdrop of pale decor and furnishings, the painting emphasises the creativity of the couple whose bright outfits symbolise their identity as artists, as well as muses.

In many ways, Schlesinger's London life – among this group of like-minded individuals – sounds like the ideal existence for the emerging artist: 'I would flit in and out of the Slade but I had this whole other life with David, a very unstudenty life.' However, this double existence created tensions for Schlesinger, who increasingly felt the power imbalance inherent in his romantic partnership with the older artist. Today, the student–teacher love affair, even when consensual and between adults, is frowned upon; and although still not banned at most universities, it is increasingly considered an abuse of authority. Hockney's relationship with Schlesinger should also be viewed through this lens: the painter was in his thirties when he met his student, who was then still just a teenager.

In an interview with art historian Marco Livingstone, Hockney, looking back at his time in California, referred to Schlesinger as 'a young, very sexy, attractive boy . . . the sexy boy of your fantasy'. This impression of him is explicit in the artist's swimming-pool paintings. In *Peter Getting Out of Nick's Pool*, the artist invites the viewer to join him in staring at his model's nude body, whose rounded buttocks have been exaggerated with an erotic charge. Schlesinger seems to exist in this dreamy painting for the pleasure of Hockney's male gaze – just as we find in paintings of the female nudes who existed to be looked upon as sexual objects across art history.

Hockney's swimming-pool paintings, in which Schlesinger features as an attractive young muse, have been much celebrated for the artist's open acknowledgement of gay desire at a time when homosexuality was illegal in both Britain and America; it took California until 1975 to repeal its sodomy law. In fact, it was *Peter Getting Out of Nick's Pool* which propelled Hockney's career to the next level. In 1967, the year that homosexuality was decriminalised in Britain, this was the picture which won Hockney the prestigious John Moores Painting Prize; historically, a win has been the turning point for artists, and the same was true for Hockney.

But being framed in Hockney's idealised paintings as a sex object and muse was unhelpful for the younger man, who was intent on forging a creative

career of his own. Although his association with Hockney gained him entry into exclusive art-world circles, Schlesinger explained, in an interview with Christopher Simon Sykes in 2020, that wherever he went he was known as 'David Hockney's boyfriend'. Defined, above all, by his romantic status, Schlesinger's individual artistic identity was being subsumed by Hockney's.

Throughout history, the status of romantic muse has plagued many individuals who were also artists. Among the most significant is Camille Claudel who, in 1883, entered the studio of sculptor Auguste Rodin, where she would become his best student, then later model, muse and mistress. While learning and taking inspiration from Rodin, her own identity as an artist was overlooked, and she ultimately decided to leave him. Like Claudel, Schlesinger found himself in the shadow of an older, more established artist, particularly following the couple's move to London where Hockney's reputation was growing rapidly; he thus began to resent the unequal power dynamic.

This shift in Schlesinger's experience, and subsequent feelings, is apparent in Hockney's portrayals of his muse from this time. In the large acrylic on canvas, *Sur la Terrasse* (1971), Schlesinger stands on the balcony of a hotel room, viewed by Hockney through open French windows. With his back turned to the artist, who is painting his portrait, Schlesinger stares into the distance, surveying the exotic Moroccan landscape. Hockney based the painting on a series of photographs taken in the couple's room at the Hôtel de la Mamounia in Marrakesh, where they had spent two weeks in February earlier that year.

In contrast to the intimate sketches and photographs the couple had taken to document their joyful trip across Europe, this painting reflects the growing gap between Hockney and Schlesinger. Within the composition, diagonal dark shadows on the floor further distance Hockney, and the viewer, from Schlesinger. It's a poignant and sad scene, in which Hockney symbolically anticipates the couple's inevitable separation: on their return from the trip to Morocco, Schlesinger moved out of Hockney's London home, rented his own flat in Notting Hill and soon afterwards entered into a new relationship with Swedish illustrator and fabric designer Eric Bowman.

Meanwhile, Hockney was, in his own words, 'heartbroken'. 'It was very traumatic for me,' he would later recall. 'I'd never been through anything like that. I was miserable, very, very unhappy.' As Hockney's biographer Christopher Simon Sykes has written, Schlesinger was 'the love of his life'. It wasn't just Schlesinger's looks which had attracted Hockney; he also found him 'intelligent' and 'curious', and for years they had shared friends, travels, gallery visits and more. While friends begged him to try to make it work, and suggested he create a separate studio for Schlesinger, Hockney understood his partner's need for artistic independence and knew that he would have to say goodbye.

During this period, Hockney threw himself into painting: 'Whereas with Peter I often went out on an evening, from then on I didn't. For about three months I was painting fourteen, fifteen hours a day. There was nothing else I wanted to do. It was a way of coping with life. It was very lonely; I was incredibly lonely.' Hockney started a new canvas, inspired in part by his discovery of two contrasting photographs lying side by side on the floor of his studio: 'One was of a figure swimming underwater and therefore quite distorted . . . the other was a boy gazing at something on the ground. The idea of painting two figures in different styles appealed so much that I began the painting immediately.' The picture upon which Hockney had embarked was the famed *Portrait of an Artist (Pool with Two Figures)*.

Hockney spent six months working on the canvas before, in the end, destroying it. Speaking in hindsight about his process, he admitted, 'I struggled on and on and fiddled on with it, realising it didn't work, couldn't work.' He could have been speaking about his romantic relationship with Schlesinger, which was by then irreparable. However, in April 1972 Hockney decided to return to the concept in order to 'repaint the picture completely'. Perhaps having recognised what was missing, the painter asked Schlesinger to pose once again for him and, luckily, the young man agreed. Early one Sunday morning, the pair went to London's Kensington Gardens, where Hockney photographed his muse looking down at the ground, wearing a bright pink

jacket, white trousers and brown shoes – just as he appears in the final image, although transported to the edge of a swimming pool in California, where he looks upon another swimming man.

Armed with photographs of Schlesinger, Hockney worked on his painting for eighteen hours a day for two weeks, footage of which was included in the 1973 film, *A Bigger Splash*. Directed by Jack Hazan, it's a semi-fictionalised documentary about Hockney, which focuses on the declining relationship between the artist and his muse; the painter, turning his romantic torture into art, creates the great masterpiece, *Portrait of an Artist (Pool with Two Figures)*, which acts as a reflection of their break-up. This has led many critics to surmise that the second man swimming underwater not only stands for lost love but Schlesinger's new partner, Bowman; Schlesinger, however, refutes this reading.

Hazan's film both sensationalises Hockney's relationship with Schlesinger and perpetuates myths about the muse: while the older painter speaks at length, Schlesinger poses silently for him, appears nude for the most part, and in one scene engages in an explicit gay sex scene, which got the film banned for a time. Blurring the boundaries between autobiography and fabricated fantasy, the narrative unhelpfully depicts Schlesinger as a romanticised, passive object of desire, which was so problematic for the young artist.

Hockney, who had never intended for his partner to be cast in second place, was horrified by the way in which his relationship with Schlesinger had been framed in the film. In an interview, Hazan recalled the painter's distress: 'There was a lot of trouble at first – he was upset and had no idea there was a narrative of him breaking up with his lover.' The artist attempted to ban the film from being shown, and didn't speak to anyone for two weeks, perhaps angry that not only Schlesinger, but also his painting, had been misrepresented.

Although *Portrait of an Artist (Pool with Two Figures)* may be tinged with personal sadness, Hockney had also painted it as a powerful tribute to his muse. In contrast to the earlier canvases in which Schlesinger swims or sunbathes naked, here he has been lifted out of the pool. Clothed in a trendy pink jacket, he has been depicted in the celebratory manner of Hockney's other

artist–muses Birtwell and Clark in their fashion-focused double portrait. Moreover, staring down at the male figure swimming beneath the water, Schlesinger is engaged in the act of looking. This emphatic shift in the representation of him is echoed by the deliberate titling of the work, *Portrait of an Artist (Pool with Two Figures)*, through which Hockney points to his muse's identity *as an artist*.

In this acclaimed canvas, Hockney also transported Schlesinger back to his homeland; he stands beneath the sunshine of the States, illuminated in golden light. The completed painting foreshadowed real life: in 1978, Schlesinger left London and returned to America with his new partner, Bowman. He has since forged his own successful career as an artist, gaining particular recognition for creating large-scale ceramic sculptures which merge classical shapes with abstraction: 'I like exploring the form language of ancient vessels,' he told one interviewer, 'and trying to twist that and push it in different ways.'

It's impossible not to see the influence of Hockney in the rippling lines which cover the surface of Schlesinger's sculptures – proving the difficulty that artists-as-muses, particularly those who sit for more established artists, will always face. However, we must also recognise the enormous debt that Hockney owes Schlesinger, the defining protagonist of his most iconic swimming-pool paintings. Hockney himself identified the momentous impact of Schlesinger on his work, honouring him with the grand, cinematic canvas *Portrait of an Artist (Pool with Two Figures)* in which his muse is positioned centre stage.

Five years later, Hockney painted his muse once again, far away from any pool, in a strikingly simple but powerful painting. In *Peter Schlesinger with Polaroid Camera* (1977) Schlesinger sits alone in an armchair, within a room painted vivid green. Dressed in a purple suit, with a bow tie, he stares assuredly out of the canvas. As if meeting Hockney's eye, Schlesinger seems to have accepted his role as muse but only because he is now being portrayed on equal terms to the painter – beside him is his Polaroid camera positioned on a tripod. From serving Hockney's needs in the early swimming-pool paintings, here Schlesinger has been represented in the way in which he wanted, and deserves, to be perceived – as an artist.

THE SELF AS MUSE

ARTEMISIA GENTILESCHI

Survivor, Painter, Slayer

'Every artist paints himself.' This well-known Renaissance motto somewhat rings true. During the fifteenth century, when individual creativity was valued highly, and mirrors first became widely available, artists often began to take themselves as their own muses. As well as hiding their self-portraits within paintings, they opened the doors of their studios to represent themselves, positioned before an easel, at work. As if caught in the act of art-making, the likes of Diego Velázquez and Rembrandt affirmed themselves as talented artistic geniuses.

But this is an obviously problematic saying of its time, too. Divisively constructing the idea that artists must be men, it ignores women entirely or, at best, relegates them to the prevailing notion of the passive female muse. Women have, therefore, just as zealously, if not more so, taken to self-portraiture to assert their identity as artists. Sofonisba Anguissola and Catharina van Hemessen are among those who have consciously portrayed themselves, paintbrush in hand, on the same terms as their male counterparts. However, none have advocated their creative status quite as defiantly as the celebrated Italian baroque painter Artemisia Gentileschi. She too depicted herself as a painter at work, but more than that, she cunningly turned the tools of male artists against them.

In *Self-Portrait as the Allegory of Painting* (1638–39) Gentileschi, as the title indicates, uses allegory as her weapon of choice. An assured dark-haired woman, wearing a shimmering green dress and a brown apron, stands before a large bare canvas. With a palette in one hand and a paintbrush in the other, she leans in, ready to make the very first mark; in doing so, a gold chain falls away from her neck, its skull-like pendant suspended in mid-air. The pale-skinned brunette woman is without doubt an image of Gentileschi, who painted numerous self-portraits. But this figure, alive with symbolism, is also a personification of 'Painting'.

Gentileschi's representation of 'Painting' comes straight from the pages of *Iconologia*, a popular handbook of symbols written by the sixteenth-century iconographer Cesare Ripa. Arranged in alphabetical order, the arts and sciences, virtues and vices are personified in imaginative descriptions. 'Painting' is characterised by Ripa as 'a beautiful woman, with full black hair, dishevelled, and twisted in various ways, with arched eyebrows that show imaginative thought, the mouth covered with a cloth tied behind her ears, with a chain of gold at her throat from which hangs a mask, and has written in front "imitation"'.

Gentileschi was by no means the only artist to have visualised Ripa's personification of 'Painting', although her image stands in stark contrast to portrayals by her male counterparts. In François Boucher's *Allegory of Painting* (1765) a young woman, reclining on a bed of clouds and surrounded by cherubs, reaches out to paint on a round canvas. In doing so, her pretty pastel-coloured dress falls away to reveal the soft bare skin of her shoulder. Not even looking at her painting – she turns her head sideways so that viewers can see her angelic face – it's obvious that this woman is only posing for the sake of the picture. Following Ripa's example, Boucher's painting emphasises the idea that art, just like an attractive woman, should be observed as an object of beauty.

Gentileschi's figure, on the other hand, is fully involved in the strenuous act of painting. She turns her body at an awkward angle, causing strands of dark hair to come loose, and there is even a glimmer of sweat on her forehead as she focuses her eyes intently on the canvas ahead. Gentileschi is quite clearly contesting the equation of art with the concept of a sensual young woman who exists purely to be looked upon. Instead, she claims agency for the female personification who, rendered in realistic terms, demands respect as an artist hard at work.

By pulling 'Painting' down from an idealistic pedestal, Gentileschi proves that art is both an intellectual and physical endeavour, and one in which she, a woman, is completely absorbed. The artwork's serious atmosphere reflects

the fact that Gentileschi would have encountered far more obstacles than her male contemporaries while pursuing a successful career of her own. In seventeenth-century Europe, female artists were deprived of formal education, denied access to art academies and even their movement was restricted. Gentileschi fought against such adversity, learning to read and write in her twenties, before becoming the first woman to be granted membership of the Accademia delle Arti del Disegno in Florence in 1616.

Nevertheless, Gentileschi recognised that she would always be at a disadvantage, as expressed perfectly in a letter to one of her patrons: 'A woman's name raises doubts until her work is seen.' Experiencing such entrenched inequality in the patriarchal art world, Gentileschi refused to simply emulate the straightforward self-portraits of her male counterparts at work inside their studios. Instead, she needed an approach entirely of her own, with which she could define herself in distinct terms.

At this time, as renowned art historian Mary Garrard has pointed out, 'the art of painting was symbolised by an allegorical female figure, and thus only a woman could identify herself with the personification'. Gentileschi has, therefore, manipulated the device of personification to subvert stereotypes from within: in *Self-Portrait as the Allegory of Painting* she has both identified as an assiduous painter while also elevating herself *beyond* the status of her fellow artists to the prestigious rank of 'Painting'. 'If you can't join them, beat them' is the distinct message of this work, in which Gentileschi exists on a higher plane.

Similarly, Gentileschi embodies another traditional allegorical image in her earlier portrait *Clio, the Muse of History* (1632). A statuesque young woman with brown hair, in the likeness of Gentileschi, wears a green velvet gown with rust-coloured sleeves. Standing within a shadowy space, she places one hand on her hip, while using the other to rest a trumpet on an open book. Gazing into the distance, her head, which she holds up high, has been illuminated by golden light, which catches a crown of laurel leaves and a luminous pearl earring dangling from one ear.

Once again, Gentileschi was referencing Ripa's *Iconologia*, in which he stated that the Muse of History should be illustrated with a crown of laurels, a trumpet and an open book. In both paintings and sculptures from this period, Clio appears frequently in this majestic image. In Johannes Vermeer's *The Art of Painting* (1666–68) a painter, most likely depicting the artist himself, is seated before an easel, paintbrush in hand. Posing for a portrait is a young woman who stands to the left of him, in the light of a window. Wearing a blue dress and a laurel wreath, holding a trumpet and carrying a book, she perfectly matches Ripa's description of Clio.

There is of course, though, an obvious difference between Vermeer and Gentileschi's treatment of the muse. While Vermeer has separated himself, the artist, from the muse who is inspiring him, Gentileschi has assumed the identity of Clio. There is a teasing manner to the way in which Gentileschi appropriates allegory; it's as if she is telling an art-world in-joke to undermine the gendered mythology of artistic achievement as inherently male. While her male contemporaries portrayed themselves in self-portraits as distinct from the feminine allegories of 'Painting' or the muses who provided inspiration, Gentileschi could be both artist and muse.

Gentileschi is also challenging another idea perpetuated by male artists – that the muse is passive. In contrast to Vermeer's model, Gentileschi sets the record straight, instead portraying Clio as an active heroine. Deriving from the Ancient Greek *kleô*, Clio's name means 'to proclaim' or 'to make famous', and she was invoked by those who wished to retell factual accounts. Here she has written on a page of the book 'Artemisia' and the date of the artwork's creation to bestow recognition in turn upon the painter. By associating herself with Clio, the Muse of History, Gentileschi proclaims herself an artist, and one who is rewriting, or rather repainting, history.

Gentileschi employed this manner of self-representation not only to make a bold statement on her identity as a professional female painter, but also as a means of attracting clients. As art historian and curator Letizia Treves has remarked, such paintings should be read as 'a conscious act of self-promotion'.

Gentileschi would have understood the appeal of her beauty to collectors and used her image – of an attractive female artist inspired by herself – to gain the attention of collectors, institutions and paying patrons who made her career viable.

A similar visual strategy has been employed by numerous other female artists, including early twentieth century Hungarian–Indian painter, Amrita Sher-Gil. In her *Self-Portrait at Easel* (*c.*1930), Sher-Gil makes it clear that she is aware of her beauty: with her dark hair and eyes, full lips and arched eyebrows, the artist stands at an easel, wrapped in a red cloak, staring outwards at both the viewer and a mirror, from which she can paint her striking reflection. Sher-Gil had painted this work during a five-year stay in Paris, where she moved to study at the renowned École Nationale des Beaux-Arts. Aware that she was regarded as an erotic and exotic 'other', she revelled in this status, wearing both Western clothing and sarees, and began to experiment with representations of the non-Western body in paintings, including herself.

Both Gentileschi and Sher-Gil are among those women artists, disadvantaged because of their sex, who at the same time used their femininity to their advantage. Rather than denying it, they played on stereotypical notions of the muse as a beautiful woman to be looked at. In canvases such as *Self-Portrait as Tahitian* (1934) Sher-Gil even portrayed herself as the topless muse of Gauguin, whose richly-coloured paintings of Tahitian girls and women she had recently seen. But whilst the male artist exploited his subjects – both in his art and sexually in real life – Sher-Gil has reclaimed herself; here she stands nude, imagined through her own lens, with her hair tied back in an unadorned manner and staring resolutely into the distance. Both Sher-Gil and Gentileschi could cleverly critique the commodification of femininity from within, and particularly in images of themselves as an artist, these two women demonstrated that they too were involved in the act of looking and making artworks, pointing to themselves as both object and subject.

As Gentileschi once wrote to a patron, 'I will show Your Illustrious Lordship what a woman can do,' and her own paintings were the best billboard for this. But there is, of course, far more at play in Gentileschi's portraits than an

advert for her professional talent; she was also drawing upon and expressing personal pain through paint. In 1611, at the age of seventeen, she was raped by the painter Agostino Tassi, who was a friend of her father, artist Orazio Gentileschi and had been entrusted to teach her in private. In the legal trial that followed, Gentileschi was tortured with ties around her fingers to determine if she was telling the truth. 'It is true. It is true. It is true. It is true,' she exclaimed and was eventually believed, winning the case.

In court it emerged that Tassi had previously engaged in an adulterous relationship with his sister-in-law, intended to murder his wife and was planning to steal some of Orazio's paintings. Although he had now been convicted by the court and banished from Rome, the decision was subsequently overturned on the Pope's instructions. Gentileschi, on the other hand, would face lifelong consequences. In much of Europe at this time, rape was considered a source of shame to the family of the victim – in essence, a crime against another man, the owner of the woman, rather than the woman herself. Moreover, if Gentileschi had not been a virgin at the time, under Roman law Tassi's assault would not have been classified as rape. She was therefore quickly married off – to another painter, Pietro Stiattesi – and the couple moved to Florence.

But despite her new start, the impact of such sexual violence, as well as this notion that she was a 'damaged object', had a lasting impact upon Gentileschi, and is manifest in her work. In the year after her rape, she painted *Judith Slaying Holofernes* (*c.*1612–13) in a bold reimagining of the biblical Book of Judith, in which the Jewish heroine seduces the Assyrian general, Holofernes. However, having entered his tent, she has only one intention: to decapitate him before he carries out the destruction of her city, Bethulia.

Judith was a popular subject for Renaissance and baroque artists, who focused on her beauty; in many versions she appears topless or entirely naked, having already carried out the attack. In her characterisation by many male painters, Judith's action loses some of its power – even this bloody attack becomes just a tableau, an after-the-act inspiration to be painted, often reduced to sexual imagery. However, in Gentileschi's psychologically charged version,

Judith fully clothed, in a blue dress and with her sleeves very much rolled up, is directly engaged in the bloody act of the beheading.

It's clear from this canvas that Gentileschi was a follower of Caravaggio: her depiction echoes his 1598 version, in which intense chiaroscuro is used to dramatise the scene in heroic terms. In Caravaggio's canvas, commissioned for a man, the heroine stands back, holding the sword in a gentle manner, apparently distancing herself from the act, with an almost sorrowful expression on her face. In contrast, Gentileschi's Judith leans right in. Just like the figure of 'Painting', she is fully involved in the physical act, this time of killing a man, so much so that she needs the help of a maid to suppress Holofernes.

Around ten years later, Gentileschi painted this poignant scene again, including even more purposeful and powerful iconography. In *Judith and Holofernes* (1620–21), which belongs to the Uffizi gallery, the heroine now wears a spectacular golden yellow dress and a deeply symbolic bracelet – which features depictions of Artemis. In Greek mythology, she was the goddess of wild animals, the hunt and fertility; she was also granted eternal virginity, and gave grave punishment to men who attempted to dishonour her in any form. Through this emblem of ferocious femininity, Gentileschi clearly seems to be identifying with the Holofernes-slaying Judith.

The two versions of *Judith Slaying Holofernes* belong to a large group of paintings by Gentileschi which centre strong, self-motivated heroines from the Bible, history and mythology. Salome serves up the head of St John the Baptist, Jael is about to drive a tent peg through the head of a sleeping Sisera, and Lucretia, having been raped by Sextus Tarquinius, decides to commit suicide to protect her honour. Gentileschi used herself as the model for all these paintings, a fact she made no effort to disguise because she has dressed her cast in clothing of her own time. Given her personal experience of sexual violence, these artworks – in which women fight back and overcome men – can surely be read as a form of cathartic revenge portraiture.

By taking violent and decisive action on the canvas, Gentileschi gives the sense that she is reclaiming ownership of her own body, particularly following

her rape. As she once exclaimed, 'As long as I live, I will have control over my being.' Many survivors of sexual assault feel that they have lost ownership of their bodies – as the main character in Louise O'Neill's 2015 novel *Asking for It* concedes, 'My body is not my own anymore.' By depicting herself as these heroines, Gentileschi affirms her own strength as a survivor; acting as an emboldened agent in each self-representation, she is engaged in empowering acts of painting and writing to killing, all of which involve her body.

Gentileschi is one of the first artists who, having suffered sexual abuse, have turned to art to tell their story and recover their identity. During the 1970s and 1980s, numerous feminist artists began to address violence against women's bodies, including their own. Nan Goldin photographed herself, bruised and battered, to share the damaging effects of her destructive relationship with a man. More recently, in 2014 Emma Sulkowicz, a student at Columbia University, carried a twin mattress around campus for nine months to protest and make visible the rape she had suffered by a fellow student. Titled *Mattress Performance (Carry That Weight)* this piece of performance art made visible the serious but underdiscussed issue of rape culture in universities. Carrying the heavy mattress also symbolised Sulkowicz's strength as a survivor – just as Gentileschi appears in her compelling artworks.

Becoming her own muse was an ultimate act of control for Gentileschi. By twisting the tools of tradition to identify with Clio, 'Painting', biblical protagonists and mythological heroines, she presented herself as both artist and subject, solidifying her concept of self and triumphantly affirming her identity to others. Through such self-possession, she wasn't just asserting ownership of her own body, but speaking out against the male ownership of all female bodies too. Today, through her self-portraits, Gentileschi continues to exist on a higher and untouchable plane of existence, elevated to such status through her own resolve and hard work. As she once wrote, 'The works shall speak for themselves' – which they most certainly do, proclaiming her a survivor and an avenging, pioneering painter.

FRIDA KAHLO
Heroine of Pain

Queen of the self-portrait, Frida Kahlo is instantly recognisable for her flamboyant Mexican-inspired wardrobe of bright blouses and colourful floor-length skirts, heavy jewellery and floral headpieces. However, in *Self-Portrait with the Portrait of Doctor Farill* (1951) she sits in a wheelchair, dressed in a plain, loose white tunic and a floor-length black skirt. Beside her is an easel, upon which is positioned a large painting – it features her smartly dressed orthopaedic surgeon, Juan Farill, who performed seven surgeries on her spine. 'Dr. Farill saved me. He brought me back the joy of life,' wrote Kahlo in her diary.

But Farill is not the only doctor present in this small windowless room. Kahlo herself, having just completed his portrait, holds within one hand a bunch of paintbrushes; in the other she grasps a palette upon which – instead of paint – appears a realistic human heart. With droplets of bright red paint staining her white tunic, Kahlo appears to have been painting with her own flesh and blood, thus inviting viewers to see her as both muse and artist, patient and doctor. While Kahlo is today held up as a feminist fashion icon, in many of her self-portraits she pierces the site of her famous body, investigating herself beyond the surface, in the manner of a medic.

As a child, Kahlo dreamt of becoming a doctor: 'Earlier on I wanted to get into medicine, I was so interested in curing people, relieving them of their pain.' Perhaps this ambition was rooted in her own experiences as a patient: aged six, she contracted polio, leaving her right leg much thinner and weaker than her left, while many researchers also believe that she was born with spina bifida, a condition that affects the development of the spine. By the age of fifteen, she was the first girl to have enrolled on a premedical programme at the Escuela Nacional Preparatoria in Mexico City.

But it was on her way home from this school, on 17 September 1925, that Kahlo was involved in a horrific bus crash. Lucky to survive, the

eighteen-year-old suffered a broken spinal column, collarbone, ribs and pelvis, and fractured her right leg, which was eventually amputated. Kahlo subsequently underwent more than thirty orthopaedic operations, faced a lifetime of chronic pain and, immediately after the accident, was confined to months of bed rest in a constricting body cast. With her dreams of becoming a doctor dashed, Kahlo placed a mirror in the canopy above her head and began to create deeply introspective pictures.

'I never thought of painting until 1926, when I was in bed on account of an automobile accident', she later wrote to her art dealer, Julien Levy. "I was bored as hell in bed . . . so I decided to do something. I stoled [*sic*] from my father some oil paints, and my mother ordered for me a special easel . . . and I started to paint.'

This was the beginning of an inextricable link between medicine, injury, art, intervention and survival for Kahlo. In an early sketch from 1926 she illustrates the accident: in the distance are the colliding bus and tram, surrounded by wounded passengers, while in the foreground Kahlo has focused on her figure, lying motionless on a Red Cross bed and wrapped in bandages. Having formerly intended to fix others, Kahlo now turned her attention onto her own broken body: attempting to regain control, express her suffering and find a way to treat herself, it's as if she was taking on her hoped-for job of doctor – through art.

Some medical researchers, including surgical pathologist Dr Fernando Antelo, have concluded that the traumatic accident, which punctured Kahlo's abdomen and uterus, likely also left her infertile. She later experienced several miscarriages and underwent a number of therapeutic abortions, including in Detroit's Henry Ford Hospital in 1932. Kahlo had been visiting the city with her husband, the Mexican artist Diego Rivera, when she began to miscarry their child. After the pregnancy was terminated, Kahlo spent the next two weeks recovering alone in hospital.

The artist asked doctors to provide her with medical textbooks so that she could see what the foetus of her unborn child would have looked like.

While she was denied such access – on account that such imagery might upset her – Rivera brought her a book, from which she sketched *Frida and the Miscarriage* (1932). Depicting herself in anatomical terms, Kahlo stands naked and cut open to reveal her womb, from which stretches an umbilical cord to a healthy foetus positioned by her side. In her left hand, she holds a heart-shaped palette, as if asserting her role as an investigating doctor and artist, who is painting from the heart.

From this first interrogative drawing, Kahlo then worked up her harrowing self-portrait, *Henry Ford Hospital* (1932): she lies naked and alone on the white sheets of a hospital bed, onto which her blood spills out, while in the distance looms the imposing, industrial skyline of Detroit. Once again, Kahlo has incorporated the imagery of obstetrics – she is encircled by six floating objects, including a pelvic bone, an autoclave machine used to sterilise medical utensils, an orthopaedic cast and a large male foetus; each is attached to a red umbilical cord-like ribbon which she clasps against her swollen stomach in one hand.

While dissecting the therapeutic abortion in the clinical manner of a medical illustration, Kahlo also narrates her subjective experiences as a patient. On the floor beneath the bed is a purple orchid, reflecting a flower which Rivera gifted her during her hospital stay, while above her head soars a snail, which she later revealed was to symbolise the slowness of the miscarriage she had endured. Moreover, she has disregarded each object's correct proportions: the foetus, in particular, is painted on a far bigger scale than Kahlo, signifying her overwhelming sorrow at losing her unborn child.

By painting this scene, Kahlo was attempting to exorcise her grief. 'My painting carries with it the message of pain . . . I painted my own reality,' she notably declared. Kahlo had discovered the benefits of what we would today call 'art therapy'. The term was first coined by British artist Adrian Hill when he discovered the health benefits of drawing and painting while under care for tuberculosis in 1942. Publishing his ideas in his 1945 book *Art Versus Illness*, Hill argued that by 'releasing the creative energy of the frequently inhibited patient' art could enable people to 'build up a strong defence' against their 'misfortunes'.

Since the 1960s, art therapy has been used widely, providing individuals with the means to address painful feelings and difficult experiences through both verbal and non-verbal means. As practising art psychotherapist Kayleigh Ditchburn has explained, 'Art therapy gives people a platform to share their life stories, explore their thoughts and feelings, and look at the self.' Ditchburn invites clients to create artworks, including portraits, before exploring the symbols which surface in a discussion with them. She has subsequently discovered that 'art therapy is particularly effective for people who don't have the words to express their trauma; it gives people a voice where that voice has been taken away elsewhere. Art is a way of expressing the self when we feel isolated and that no one else understands.'

In *Henry Ford Hospital* Kahlo has given voice to a trauma which she would have been expected to keep private. Not only was baby loss a taboo at that time – as it still is in many cultures today – but as art historians David Lomas and Rosemary Howell also importantly point out, 'in the culture to which Kahlo belonged miscarriage was a source of shame'. Kahlo, however, openly shares her experience, detailing both the physical and psychological pain it caused her. Her small body appears isolated within an empty landscape and, as Ditchburn analyses, 'her body doesn't look very secure on the bed, she's right on the edge, it's as if she might fall off'. By depicting her distress, Kahlo was attempting to express, expel and treat her grief.

Kahlo again articulated her infertility in the introspective self-portrait *Roots* (1943). Lying on a bed of cracked dry earth, and wearing a long orange dress, she has cut open her body. From a hole in her chest sprouts a vine with large green leaves. Kahlo is clearly portraying, in invasive terms, her identity as a barren woman who belongs to a parched landscape. The artist disclosed the pain of being childless in letters to her thoracic surgeon, Dr Eloesser:

'Doctorcito querido: I have wanted to write to you for a long [sic] time than you can imagine. I had so looked forward to having a little Dieguito that I cried a lot, but it's over, there is nothing else that can be done except to bear it.'

Developing a bond that went far beyond the normal patient–doctor relationship, Kahlo sought Eloesser's medical opinion, confided in him, dedicated a self-portrait to him and also painted his portrait. Having once wanted to enter the medical profession, Kahlo identified with several of her doctors, perhaps even recognising herself as their equal as she continually treated herself through art. In *Roots* the artist has even illustrated the therapeutic power which painting gave her: the winding pattern of stems presents a route for her emotional pain to course out of her body, in the form of brushstrokes. While she could not procreate, Kahlo could transform her agony into art: 'Painting completed my life. I lost three children . . . Painting replaced all of that,' she once declared.

Kahlo also turned to painting to express the hurt caused by her husband, who was twenty years her senior: 'I have suffered two serious accidents in my life, one in which a streetcar ran over me . . . The other accident is Diego,' she famously told a friend. While the couple – who became mutual muses – offered each other much creative support, their relationship was also marred by tensions. Both partners had numerous extramarital affairs, but when Rivera began a relationship with Kahlo's sister Cristina, he crossed a line; Kahlo was devastated.

In 1939 the couple divorced and, before they remarried the next year, Kahlo painted *The Two Fridas* (1939) in which two symbolic versions of Kahlo sit side by side on a bench. On the left she appears in a white European-style lace gown, while on the right she wears traditional Mexican costume, holding a small portrait of Rivera who encouraged her to dress in this manner.

While this double portrait evokes Kahlo's sense of divided cultural identity – she had a German father and a Mexican mother – she has also torn both selves open to articulate her heartache. Beneath the skin are the exposed and anatomically accurate hearts of each Kahlo, connected by an artery, which has been cut off by surgical pincers that the European Kahlo holds in her lap. With blood dripping onto the white fabric of her dress, it's as if she has decisively ruptured the connection between the traditional Kahlo and

Rivera. Instead, the two self-reliant women proudly hold hands, comforting one another through, and sharing, the psychological pain.

This sense of self-support pervades another of Kahlo's most iconic images, *The Broken Column* (1944). Painted shortly after she underwent spinal surgery to correct ongoing problems caused by the crash, Kahlo has again portrayed herself in incisive terms: a fractured ionic column is positioned in place of her spine and her exposed chest is pierced by nails. With the lower half of her body covered by a bloodstained white sheet, it's as if Kahlo has just come out of surgery; she is crying in pain, and white tears fall from her eyes. But she is held in place by a sturdy metal corset, lined with white fabric, which acts as a self-contained cage around her chest.

Situating herself in a remote, cracked landscape, Kahlo also symbolises her acute sense of isolation: 'I paint myself because I am so often alone and because I am the subject I know best,' she once stated. While she was undoubtedly referring to her material seclusion, during times of bed rest and hospital stays, Kahlo also experienced a deep sense of psychological separation from the world brought on by a range of complex mental health disorders.

The same year that she painted *The Broken Column*, Kahlo started to write, draw and paint in a personal journal. Never meant by the artist to be published, it reads as an outpouring of emotion. Covering its pages are hundreds of ink doodles, sketches of skeletons, severed legs, and haunting self-portraits of Kahlo crying. One distinctive page is covered in a mass of expressively drawn black roots, while others are scrawled with strokes of flaming red, evoking fires which can't be extinguished.

'The diary looks very raw. Kahlo didn't hold back, there's a lot of emotions – anger, frustration and lots of pain – it's as if she's trying to figure things out,' Ditchburn has commented. It is also filled with stream-of-consciousness text within which repeated phrases reveal Kahlo's troubled state of mind: 'Madness sickness fear', 'my madness', 'anguish', 'despair and unhappiness' and 'A despair which no words can describe' are among the declarations of Kahlo who was analysing herself as 'the subject I want to know better'.

Kahlo suffered major depressive episodes and attempted suicide on several occasions. It was after one failed attempt in 1949 that her close friend Olga Campos, who was studying psychology at the Universidad Autónoma de México, interviewed her and performed a series of psychological tests on her. Campos had intended to write a book elucidating the creative process of artists, but she never completed it.

However, Campos's findings were later published by Kahlo scholar and child psychiatrist Dr Salomon Grimberg in *Frida Kahlo: Song of Herself* (2008), in which he also invited psychologist Dr James Bridger Harris to interpret the results. Harris's summarising report diagnoses the artist as suffering from depression, dysthymia (a chronic disquiet), substance abuse, a narcissistic personality and deficits in self-concepts. 'She also had what we now know as chronic pain syndrome,' he explains. 'When people have chronic physical pain, they often suffer from social isolation, withdrawal, periods of depression, substance abuse . . . She had all of that.'

While Kahlo was treated continually for her many physical health problems, she received no such care for her psychological illnesses, many of which today would be treated through psychotherapy. 'I think that little by little I'll be able to solve my problems and survive,' she mused, attempting to cure herself through art. Kahlo's fifty-five known self-portraits undoubtedly illustrate her narcissistic personality disorder – a mental condition in which people have a deep need for excessive attention and admiration, and an inflated sense of their own importance. At the same time, behind this mask of confidence, narcissists suffer from fragile self-esteem, and this mask-like quality is apparent throughout Kahlo's stoic self-portraits, in which she never smiles.

'You have the polished paintings in which there's a sense of keeping up appearances, and these contrast with the diary, in which we find the true sense of self, what she didn't want people to see, what she felt too vulnerable to show the world,' Ditchburn has contended. In this light, Kahlo's colourful wardrobe can also be seen, in part, as a self-prescribed treatment through which the artist distracted people from her disabilities: 'I must have full skirts and long, now

that my sick leg is so ugly,' she exclaimed at the opening of her first exhibition of paintings at New York's Julien Levy gallery in 1938.

Kahlo's weak sense of self would also have been compounded by her life-changing accident. As art psychotherapist Susan M. D. Carr has ascertained, chronic illness and social isolation can disrupt a person's 'sense of self-identity'. Carr co-creates portraits with, of and for her clients as a means of recalibrating a 'stronger, more coherent' sense of self in them. Likewise, Kahlo can be seen searching for and projecting her new identity, following the crash, in her paintings. Having formerly intended to become a doctor, she instead consolidates her identity through self-portraits in which she presents herself as her own surgeon.

Kahlo was also disrupting the dominant clichéd narrative of women's madness which had so far been represented across the visual arts by men. During the eighteenth and nineteenth centuries, male painters began to portray mentally ill women as either angry, dangerous and hypersexualised, or as sad and sobbing, tormented by romantic rejection. In stark contrast, Kahlo appears strong and in a state of composed control throughout her self-portraits. Despite her tears, in *The Broken Column* Kahlo has a steadfast gaze and dignified pose: 'I can withstand this pain,' she seems to be telling herself and her viewers. Kahlo's firm metal corset further symbolises her resolve, in the face of both her physical and emotional suffering; for this reason, Mexican people refer to Kahlo as '*la heroína del dolor*', meaning 'the heroine of pain'.

Rivera, too, paid tribute to Kahlo's anatomical-based depictions of her personal anguish, some of which he undoubtedly caused or exacerbated, describing her as 'the only artist in the history of art who tore open her chest and heart to reveal the biological truth of her feelings'. It's as if Kahlo was using medical imagery not only to diagnose her psychological pain, but also to validate it as a real and tangible condition which needed treating in the same manner as her physical afflictions.

Kahlo's introspective self-portraits have carved the path for numerous other women artists living with mental health disorders, who have used art as a

cathartic vehicle for healing. Kahlo's direct influence can be felt particularly in the confessional work of renowned member of the Young British Artists, Tracy Emin. Echoing Kahlo's *Henry Ford Hospital*, Emin's installation *My Bed* (1998) consists of a dishevelled, stained bed covered in condoms, underwear and menstrual blood. It was inspired by a period of four days during which Emin, while suffering from suicidal depression, didn't leave her bed. In her 2005 autobiography, *Strangeland*, she explains, 'I only survived thanks to art. It gave me faith in my own existence.'

Sadly, Kahlo's diary charts a descent into despair supporting the theory that her death on 13 July 1954 was suicide by overdose. But her legacy undeniably lives on – she can be seen not only as an influential artist, but also as a pioneering doctor who has indirectly treated a multitude of patients, including other artists who use art as therapy. Kahlo seems to be asking for such recognition in her last signed, *Self-Portrait with the Portrait of Doctor Farill*, in which she has positioned herself side by side with the painting she made of her surgeon. Just like Farill, who wears a dark suit, jacket and tie, Kahlo is smartly dressed, in black and white; the pair even have matching monobrows. Kahlo is demonstrating to the viewer their equal status – she has been just as important as this surgeon in attempting to heal herself. Throughout her self-portraits not only does Kahlo hold up a mirror to herself as someone who is in pain, but she also presents herself as someone who is in the act of trying to get rid of it, opening her body for investigation and operating on, in order to release her hurt through creative expression.

SUNIL GUPTA
Playing Dead

For over five decades, Indian-born photographer Sunil Gupta has taken pictures of male muses to mark important moments in the history of international gay rights. Since the 1970s, he's photographed American men cruising Manhattan's Christopher Street, shot intimate portraits of queer couples at home in Canada, and documented political demonstrations in London, where he currently lives.

However, in 1999 Gupta turned the camera directly, and exclusively, on himself. In his colour photograph *Shroud*, the artist lies completely still on a bed, wrapped in a heavy white cloth which covers most of his body, with the exception of his feet and head; his eyes are closed. Contrasting with Gupta's celebratory and impassioned images of gay liberation, it's a sombre scene. Why, when he had eventually taken himself as his own muse, was he playing dead?

Born in Delhi in 1953, Gupta grew up in a country in which homosexuality was illegal – it was only recently decriminalised in 2018. The artist knew early on that he was gay, 'although I didn't have a word for it'. Stigmatised and criminalised, men like Gupta were expected to surrender to social pressure and marry a woman so as not to dishonour their family – a practice which still exists today.

However, aged fifteen, Gupta moved with his family to Montréal in Canada which he describes as 'fortunate' since 'gay liberation arrived at the same time as me'. As an eighteen-year-old student at college in Montréal, Gupta used photography to explore and capture his new surroundings, including an increasingly sexually liberated community of gay men in the city's bars, saunas and art-house cinemas.

Gupta's early black-and-white series, titled 'Friends and Lovers' (1970–75), documents Canada's emerging gay liberation movement and Gupta's assimilation into it: friends embrace at the beach in Toronto, fellow artists clutch their

cameras, couples meet at gay bars and fellow students join marches, holding high homemade cardboard banners with '*Solidarité*' scrawled upon them. The artist's photographs from this time read as a personal album of meaningful places and people, whom he refers to as his 'extended gay family'.

From the very start of his career, Gupta has carefully selected his subjects: 'I don't like to shoot people I don't know at all.' Instead, he describes the 'cooperative effort always involved in making the picture'. This exchange, built upon trust, is particularly evident in his intimate, close-up shots of gay couples in their homes. In one image two men, seated on the crumpled duvet of their bed, kiss; there is a frankness to Gupta's shot, which frames and affirms the ordinariness of this Canadian couple's love.

Throughout the 1970s in Canada, the growing LGBTQ movement encouraged people to 'come out' – the term was coined following the first Gay Liberation March in New York City in June 1970. One of the organisers had declared, 'We'll never have the freedom and civil rights we deserve as human beings unless we stop hiding in closets and in the shelter of anonymity.' Coming out of hiding became an important rite of passage for queer people, and Gupta joined many in sharing the truth of his own sexuality with his family.

However, given the artist's Indian heritage, 'coming out' was never going to be as straightforward for Gupta as it was for his white, Canadian-born friends. He recalls telling his father, who 'thought it was a cry for help, a problem or a phase'. He also took a pragmatic approach, advising Gupta that, regardless of who he had sex with, he would 'need to get married and have a son'. As the artist has accounted, 'In India, honour is a really big thing – marriage is brokered and even if you're gay, the idea is that you serve the family.' Gupta never broached the subject of sex with his father again, coming to an unspoken agreement – that he 'just wouldn't put sex in front of' his family.

Nevertheless, Gupta did defiantly 'come out', embracing and broadcasting his sexuality through photography. Studying at Canada's Concordia University, he took photos of gay rights demonstrations for the student newspaper.

Then, in 1976, he relocated to New York City to study at The New School under the direction of the legendary street photographer Lisette Model. It was an important move, on both an artistic and personal level, as Gupta found the city alive with the gay revolution – 'being gay became seriously cool', he recalls, joining the ranks.

Gupta spent his weekends photographing the non-stop parade of men cruising the 'Main Street' of gay New York, Christopher Street in the West Village. The artist would approach subjects to ask if he could take their picture; and they usually welcomed it, having invited the attention in the first place: 'They were dressed up and showing off, they wanted to be looked at and seen in this way,' the artist remembers.

In his black-and-white series 'Christopher Street' (1976), Gupta can be seen acknowledging, and broadcasting, his homoerotic desire by turning his gaze on men strutting their openly 'out' selves in short, cut-off denim shorts, shades and tight leather jackets. As he has reflected, 'I photographed men instead of sleeping with them,' using the camera as a substitute for sex since there were 'too many people, not enough time'. Gupta also sub-scribed to a more political approach to promiscuity, joining a growing 'rebellion against the capitalist ideal of the nuclear family' – this was particularly significant for the photographer, given his upbringing in a marriage-centred culture.

In New York, Gupta established his identity and place within a wilfully reckless liberation movement. However, his experience back in Delhi was diametrically opposed; returning to his home town in the early 1980s, when homosexuality was still illegal, he found the complete 'absence of gay culture'. Feeling compelled to tell the stories of members of the LGBTQ community, who were still very much in hiding, Gupta embarked on his series 'Exiles' (1986–87). Across twelve large-scale colour images, Gupta portrayed gay male couples in front of Delhi's famous tourist sites and ancient monuments. As he has said: 'It had always seemed to me that art history seemed to stop at Greece and never properly dealt with gay issues from another place. Therefore,

it became imperative to create some images of gay Indian men; they didn't seem to exist.'

Through 'Exiles', the artist was proving the existence of gay people in India to both himself and the world. Nevertheless, Gupta had to be careful. In contrast to shooting 'Christopher Street', a series focused on passing male muses who were 'out and proud', Gupta had to recruit a number of volunteers who were willing to pose for 'Exiles'. Although the artist secured a selection of models, many wanted their identity kept secret, and so Gupta either cropped his subjects' faces from the image or pictured these men from behind.

One of the 'Exile' photographs shows the torso of a young man – his head has been cropped from view – standing alone in a white T-shirt and shorts in front of a building, which is in the process of being decorated with lights and banners for a wedding. The word 'Welcome' glitters in gold, incongruous with the lack of acceptance of gay marriage, and a quote from Gupta's model printed onto the photograph's bottom white border further highlights the subject's plight: 'Everyone is married. Mother wants me to get married. I probably will, there is the family name and respect to consider.'

More than twenty years later, Gupta staged another series of photographs, 'The New Pre-Raphaelites' (2008), in order to explore once again the lives of queer Indian men in his home town of Delhi. Although homosexuality was still illegal in India, this time Gupta was excited to discover 'a new generation of young queer men and women'; educated and in their twenties, these individuals were 'confident and articulate and not in the mood to wait, they wanted change now'. They would hold discussions in the evenings and watch films, 'using culture as a tool with which to discuss sexuality'.

This engaged LGBTQ community reminded Gupta of the Pre-Raphaelite Brotherhood, whose vividly coloured narrative paintings he had seen in galleries such as Tate Britain in London, where he lived in between periods of residence in India. Gupta perceived parallels between the nineteenth-century British artists – who welcomed debate and challenged the stifling double standards of sexual morality for men and women in Victorian society – with India's

community of queer men who were critiquing their own culture's double standards: 'The quality of colours and the vibrancy of it all and the mood of the Pre-Raphaelite Brotherhood – it really reminded me of the mood in India.'

Moreover, Gupta has pointed out that the problematic Section 377 of the Indian Penal Code – the law criminalising homosexuality– was actually instituted by the British during their rule of India in the nineteenth century. To protest what became widely known as 'the Anti-Sodomy Law' Gupta turned pointedly to the Pre-Raphaelites for inspiration; he shot ten photographs, each re-imagining a painting by one of the British artists, but with South Asian gay, lesbian and transgender individuals posing in the place of the original models.

A particularly striking image from 'The New Pre-Raphaelites' series depicts a young Indian man wearing white silk pantaloons and sprawled topless on a bed; one arm rests upon his chest, the other falls to the floor – he is obviously dead. Gupta had revised Henry Wallis's iconic painting *The Death of Chatterton* (1856), which portrays the English Romantic poet lying lifeless on his bed, his red hair falling in ringlets away from his pale face in an almost Christ-like pose, with torn sheets of poetry on the floor.

For many, Thomas Chatterton's legendary suicide by poison, at the age of just seventeen, turned him into a symbolic martyr for art. During the nineteenth century he was commemorated by painters, photographers and poets; Keats dedicated his celebrated work *Endymion* to Chatterton's memory, and Wordsworth, in one of his most famous poems, 'Resolution and Independence', paid homage to the 'thought of Chatterton, the marvellous Boy / The sleepless Soul that perished in his pride.'

Re-staging *The Death of Chatterton*, Gupta posed a slim and beautiful young Indian man, with thick dark hair and full lips, also called Sunil, on a bed. The artist had met his muse through the online chat room, 'Gay Delhi', which he was moderating at the time; Sunil, soon taking an interest in the artist's photography, willingly modelled for this photograph. With his eyes closed, and reclining pose echoing that of Chatterton in the original work, he is illuminated by rays of sunlight which fall through the window blinds

behind him; his exquisite corpse glimmers, almost seductively, drawing out the homoerotic undertones which some perceive in Wallis's painting.

'The New Pre-Raphaelites' series marks a shift in Gupta's practice; constructing narratives such as Chatterton's suicide, the artist had begun to deploy metaphor and theatre with which to hold up queer individuals as icons of art: his gay Indian model Sunil, dressed in a brilliant costume, has been elevated to the status of tragic muse, gothic hero and 'marvellous Boy', with the power to inspire artists, as the young poet had done for writers of his day.

At the same time, Sunil, like each of Gupta's muses in the series, is clearly a real person rather than a fictional character. The bedroom, within which he has been discovered dead, is modern and mundane; the window's blinds look worn, tinged with yellow. Throughout 'The New Pre-Raphaelites' series Gupta makes it clear that his models exist as brave protagonists in the struggle to remove Section 377. Moreover, Sunil-as-Chatterton echoes Gupta's own solemn self-portraits, including *Shroud*, which he had shot back in London in 1999.

While in Delhi Gupta had discovered an active band of queer men allied in their cause, in Britain he witnessed one big hurdle to the creation of a united community: racism. As soon as he graduated from London's Royal College of Art in 1983, he realised that in the city, 'race was a big issue'. By the 1980s, when he was residing in South London, the artist found little had changed. He was living 'in a very gay but mainly white world' in which Asian men felt isolated and fearful: 'These men were afraid to go alone into a gay bar in the West End.'

Wanting to create a safe space, Gupta co-founded a South Asian group for the gay community in London, meeting on Sunday afternoons, often in secret from their families. Gupta wanted to shoot pictures of this community but he recalls that the men were too scared: 'They couldn't take a chance to be photographed.' With no willing models, Gupta decided to turn the camera on himself. He felt it was crucial that he forefront the experience of an openly gay Indian man: 'In the media, gay Asian men are not seen as an object of sexual

desire; they are invisible, there is just no representation.' Gupta has pointed out the difference in their depiction to the hyper-sexualised racial stereotypes of Black men, whose bodies are frequently fetishised.

By this time Gupta also had another reality, and taboo, to confront: in 1995, he was diagnosed with HIV. Faced with the virus, Gupta was afraid, for both his physical well-being and his place in the gay community. Suddenly, the artist – whose identity was wrapped up in his sexuality – felt alienated: 'I was living in South London at the time, surrounded by gay bars, which have increasingly transformed into sex clubs. When you arrive, you're asked to take off your clothes – these spaces are set up for sexual activity.' But now, as an HIV positive man, Gupta questioned whether these places were 'shutting me in or out?'.

In response to this question, and personal anxiety, Gupta shot 'From Here to Eternity' (1999), a series of six diptychs featuring pairs of sharply contrasting images. In each set Gupta has framed himself in various poses alone at home, in a doctor's surgery, and receiving medical treatment for the virus. These images of the self are adjoined to shots of public gay spaces, such as sex clubs, but during the daytime when they are closed, and from which the artist now faced exclusion.

Belonging to this poignant series are the paired photographs, *Shroud* and *Pleasuredrome*: in the left-hand image, the artist lies motionless on his bed, covered in a white shroud – it marks a period during which Gupta was suffering from a particularly bad bout of illness brought on by the virus. This personal view is juxtaposed with that of a gay sex club: 'PLEASUREDROME' hangs above the closed door, portraying the 'barricade' represented by these places.

Despite the personal subject matter, this series offered Gupta a public platform: 'I feel very fortunate, photography's a tool with which to express myself and speak about some of the issues stigmatised – being gay and HIV positive.' Since its first outbreak in the 1980s, the HIV/AIDS epidemic has only fuelled homophobia, with many perceiving the virus as 'punishment' for

homosexuality. As Gupta has explained, 'Gay liberation was based on pro-
miscuity, so there was zero sympathy for AIDS.' He is far from the first gay
male artist to have used self-portraiture to confront the silencing of discussions
around homosexuality and AIDS, joining the likes of Robert Mapplethorpe,
Derek Harman, Peter Hujar and his mutual muse David Wojnarowicz.

However, Gupta also represents the intersection of race with gender and
sexuality in his work. If we return to *Shroud* and *Pleasuredrome*, he has covered
his body with a white shroud, pointing to his heritage: 'I'm playing dead . . .
and that's an Indian custom – to clean the dead body and wrap it in a white
cloth.' Gupta presents the viewer with layers of his complex identity, the
shroud echoing the experiences of all gay Asian men who have had to cloak
their sexuality and AIDS diagnosis in secrecy: 'Being gay in India has become
easier, but being HIV positive has not – I speak publicly about both.'

Turning the camera on himself was not painless for Gupta: 'I found it
daunting to put up a picture of myself.' It's easy to appreciate artists who frame
themselves as muses in powerful terms – just think of Artemisia Gentileschi's
self-portrait in which she appears as an emboldened allegory of 'Painting'.
However, in Gupta's series 'From Here to Eternity', he has deliberately posi-
tioned himself as a *tragic* muse, recalling Wallis's Pre-Raphaelite painting of
Thomas Chatterton to highlight his own painful experience – both physical
and mental – at the hands of the virus.

Nevertheless, Gupta has acknowledged that in many ways he has found
photography to be an important form of therapy: 'I find using the camera
incredibly therapeutic and empowering.' Alongside his own practice, Gupta
has run workshops for HIV-positive people in which participants are given
the opportunity to tell their own stories through various art forms. As he has
explained, 'It's empowering to tell your truth, your story,' which is exactly what
he does in his own work – for himself and others.

Throughout his career, Gupta has elevated gay men from America, Canada
and India to the status of muse, telling their stories, and ensuring their valued
visibility in art. He has always asked permission and respected the needs and

privacy of his models, explaining that 'the friendship and relationship with the muse is built on trust'. Recently, one couple who had been photographed for 'Friends and Lovers' demanded that the image be destroyed as they no longer wanted to be exhibited; Gupta agreed, despite it having been acquired by the prestigious Tate gallery.

Gupta has also, usually in the absence of willing models, turned inwards. These photographs, in which the artist takes himself as his own muse, are the most moving. Here, the photographer proves to us that it's courageous, and affirming, to show yourself as vulnerable; he also reveals that there is far more to being gay than being 'out and proud', carefree and liberated, in cultures as far apart as Britain and India. Negotiating an intersection of race, migration and homosexuality, and embracing the therapeutic potential of the camera, Gupta fully explores and honestly expresses his multifaceted identity.

Although Gupta's father died relatively young, his mother came to accept his sexuality, attending exhibitions of his work and even becoming friendly with several of his boyfriends, 'usually after we broke up!' the artist has since joked, adding that 'older women and gay men get on'. Today Gupta continues to use photography to investigate and reflect on his founding question, which he's still not answered entirely, since it keeps shifting: 'What does it mean to be a gay Indian man?'

NILUPA YASMIN

Weaving a Way In

Please do not touch. Who hasn't seen these words neatly typed onto a museum or gallery label?

Alongside this warning, Perspex glass, protective cases and rope cordons guard many a fragile sculpture or priceless painting, creating a physical barrier between object and interested audiences. However, in the case of artist Nilupa Yasmin, visitors are welcomed to touch, and even walk all over, her handcrafted work; although she asks that you take your shoes off, please.

Since 2015, Yasmin has made large-scale, brightly coloured woven mats, which are either exhibited as wall hangings, or more typically, and as she prefers, laid flat on the gallery floor. Enchanted by the beauty of Yasmin's artworks, which appear as intricately patterned magic carpets, audiences accept the artist's invitation to step onto them, barefoot. However, once engaged, visitors discern that these crafted items, beyond existing as decorative objects, are layered with personal meaning.

Yasmin belongs to a Bangladeshi family who settled in Birmingham, England, over the course of several decades: her grandfather immigrated during the 1960s, followed by her father in the 1970s and mother in 1995. Born and raised in Sparkbrook, a predominantly South Asian area of Birmingham, as a child Yasmin was surrounded by a very diverse community. The first in her family to enter into higher education, she started her undergraduate degree in Photography at Coventry University in 2014. Here, however, she discovered that she was 'the only brown and visibly Muslim person' on the course. Experiencing an 'identity crisis', and encouraged by her tutors, the artist began to explore notions of the cross-cultural self in her work.

Early on in her studies, Yasmin was drawn to photograph Foleshill Road, one of the most multicultural areas of Coventry, which is home to a majority of immigrant South Asian Muslim, Sikh and Hindu communities. Much

like Sparkbrook, colourful clothing and fabric stores, selling sarees, long salwar kameez suits and food from around the world, populate it. As Yasmin has recounted, she came across 'a long stretch of shops and small businesses held together with years of hopes, dreams and hard work. These shops have become a source of livelihood, telling a story of the history and culture whilst becoming a home to its residents.'

Yasmin also learnt that Coventry has a rich history of ribbon-weaving. From the early 1700s to the 1860s, the silk industry employed half the working population of the city, and Coventry was the main centre of ribbon production in England. Having photographed Foleshill and its inhabitants, Yasmin wanted to exhibit these images in a way that paid homage to Coventry's past and present, including its ribbon-weaving heritage. Seeking an appropriate way to display her photographs in dialogue with one another she came across the perfect solution – not in her studio, but back at home.

In Bengali culture, multigenerational households are common, and Yasmin's maternal grandparents lived at home with her. On numerous occasions, she had seen her grandmother praying and, particularly during the summer, sleeping on a large handmade mat, called a shital pati. Originating from Bangladesh, this ancient craft item is woven together with strips of cane and, loosely translating as 'cool mat', is cold to the touch; it's widely used by Bengali people as a mat for prayer or lying down on, particularly during the hotter months of the year.

Inspired by her grandmother's shital pati, Yasmin cut her colour photographs of Foleshill into thin strips before weaving them together by hand into a huge mat. Yasmin had transformed individual images into an intricate and vivid installation, which she titled *Baiyn* বায়ন, the Bengali word for weaving. Although abstract on first glance, the mat's complex patterns represent Coventry's multicultural migrated communities both then and now, as well as the city's historic ribbon-weaving industry.

Through the crafting of *Baiyn*, Yasmin was also reflecting on her own Bengali heritage, although she was yet to unearth, and could never have

imagined, just how significant weaving would be to her. Yasmin recalls sitting at the kitchen table, plaiting together photographs, when her mum walked past and commented casually, 'Oh, my grandma used to weave.' Yasmin was taken aback and, questioning her mother further, found out that her great-grandmother had made a living from weaving bamboo strips into utilitarian objects which she sold back in Bangladesh; the young artist had a 'professional weaver' in her family history.

In many cultures, including those of South Asia, crafts such as weaving are typically passed from mother to daughter. Although her mother had missed out when she moved to Britain, Yasmin recognised that she had now 'inherited the craft of weaving'. Still today, the artist is amazed that she is following in the footsteps of her ancestor: 'I've always found it incredible that both me and my great-grandmother have made a living out of weaving in very different ways, so many years apart.'

Identifying her affinity with the textile culture of Bangladesh was a turning point for Yasmin. She realised just how 'alienated' she had become from her own heritage, as she has explained: 'You're trying to assimilate into British culture and bring your home culture with you. I'm too British for the Bangladeshi community, and too Bangladeshi to be British.' She found herself questioning, 'Where do I belong? What's home? What's my identity?' Through weaving, Yasmin began to explore, reconnect with, and preserve her South Asian heritage: 'I retraced the ideas of arts and crafts back to Bangladesh. It was a form of learning. This exploration also brought me and my mum, who had been assimilated into British culture, closer together.'

Yasmin also became interested in 'the gender associations of craft' throughout art history, which has shaped her practice and affinity with weaving. Alongside knitting, quilting, sewing, embroidery and needlework, weaving has historically been associated with the domestic sphere and subsequently considered 'women's work'. Within the hierarchy of aesthetics, feminine crafts have been marginalised and undervalued, in contrast to the 'high art' forms of painting and sculpture.

Women have, however, harnessed the power latent in craft forms to tell their own subversive stories. Today there is a word for this, and one which Yasmin identifies with: 'craftivism'. Coined in 2003 by writer Betsy Greer, the term joins the separate spheres of craft and activism. 'Voicing opinions through creativity makes your voice stronger,' Greer has argued. Through her work, Yasmin deliberately flaunts the associations between weaving and feminine crafts: 'What I make is art but because I identify as a woman, it is just seen as a domestic act.' By weaving, Yasmin validates the traditional activities of women, including her great-grandmother; she connects with her own heritage; and she undoubtedly enables her own authentic voice to be heard louder, not just by others but by herself.

Early on in her career Yasmin also realised that – if she was to fully understand her place in the world – she would have to take a more personal approach in her art. In order to look deep inside, Yasmin would have to take herself as her own muse. In 2017, she did just this when she crafted *Grow me a Waterlily*, a richly coloured artwork, again woven together with photographs, which stretches to seven feet high. Its poignant title is incredibly personal: 'My name Nilupa comes from Niloufa which means Waterlily. Hence the name, "Grow me a Waterlily", was essentially a poetic way of saying growing myself.'

Exhibited in 2018 at Argentea gallery in Birmingham, *Grow me a Waterlily* was pinned loosely to the stark white wall and, draping down, it covered one corner of the smooth grey gallery floor. On this occasion, Yasmin also included a number of small woven stools and fabrics, grouped together and positioned upon the textured mat, as part of a wider tableau. In an accompanying caption, she invited visitors to enter into, and engage with, the installation, which had been fashioned in the image of her family's contemporary British Bangladeshi home:

When you enter a Bengali house, you are welcomed into a living room. Shoes are lined up outside the room to keep the space clean. You will see a table in the room, a table filled with plates of food for every guest. This represents a sense of unity, a tradition and a similarity of home in every house you enter. A reminder

of Bangladesh is always present in the room, whether it's in the photographs, scriptures or woven stools. Muras are woven stools made from bamboo sticks, dotted around the room for when the sofas are too cramped. Bangladesh is always a part of the living room, even in England. Folded near the sofa you see a little row of kanthas. These colourful and embroidered blankets are made from old worn-down sarees and fabrics. Stitched together, each tells a story of time, memory and hope.

I ask you politely to take off your shoes when you step into my living room; I pray in here and I like to keep it clean. Sit on my Maa's Mura and look around, maybe you'll find a part of you too.

Evoking notions of home and the idea of belonging, Yasmin was warmly welcoming visitors to enter into this captivating reconstruction of her living room. However, having stepped upon the mat, guests who looked more closely at the woven-in-photographs found the artist looking back at them. Threaded into *Grow me a Waterlily* are forty-two colour photographs of Yasmin, which she shot under the bright lights of her studio, and pasted over digitally woven archival imagery of her family from personal photo albums.

In each of these woven photographs, Yasmin poses in a different outfit, from a floral printed teal saree passed down from her grandmother to her simple neutral prayer outfit. In the overlapping, interlocking images, the artist shows us that we are the sum of our parts – family, history and heritage are interlaced fragments which make up a fabricated whole: 'Each image tells a story of some sort,' Yasmin has reflected.

Yasmin also exhibits her self-portrait photographs, whole and unwoven, as untitled works in their own right. In one striking image she is dressed in her mother's long-sleeved red-and-gold wedding Banarasi saree, with a matching veil and gold bridal jewellery, including bracelets. She points out that when she took this photograph she was 'exactly the same age as when my mother had been married' and the jewellery was bought for her when she was just two years old by her grandparents. 'This specific image was a big play on society's expectations of marriage for a woman'.

These posed portraits highlight that it is not just photography and weaving, but fashion, which acts as a form of self-expression for the artist. 'I've always found fabric as something that has been immensely politicised, so me expressing my identity through those notions of fabric became important.' If there's one item of clothing that has been politicised more than any other, it's the headscarf, which Yasmin highlights in a number of closely cropped self-portraits.

Often smiling at the camera and tilting her head to one side, Yasmin shows off her collection of distinct headscarves; from monotone black, green and red veils to a polka dot-patterned scarf, these fabric coverings always match her outfits, which range from traditional sarees to contemporary blouses. Wrapped in a turban, worn down or tied more decoratively, the headscarf – which Yasmin touches with her hands in several works – signifies her identity as a Muslim woman.

Many Muslim women turn to traditions of head covering as a means of observing hijab. As Yasmin explains, 'The term means modesty, and in Islam both men and women are taught to uphold modesty in all aspects of their life, from the way in which they spend money to how they speak about success at work. Many women, therefore, choose to wear the headscarf as an embodiment of hijab. It allows you to conceal parts of yourself that you don't want men – who are not part of your family – to see.'

Yasmin points out that in Western countries, such as Britain, wearing a headscarf is a choice for Muslim women like her. She perceives the act of veiling as 'liberating', since she can control 'who sees what', including her hair. However, she also recognises that the veil is 'indicative of oppression' in other cultures and countries, including Iran where women have been required by law to cover up using the chador, a full-body cloak, since the country's Islamic Revolution of 1979.

During the 1990s Iranian artist Shirin Neshat, whom Yasmin cites as a 'huge influence', staged a series of black-and-white self-portraits, titled 'Women of Allah' (1993–97), in which she looks directly at the viewer from beneath a long black cloak. Emerging from this covering, her face, feet and hands

are covered in calligraphic Farsi text by contemporary Iranian women poets, and she holds a gun. In a statement about the series, Neshat revealed, 'These photographs became iconic portraits of wilfully armed Muslim women. Yet every image, every woman's submissive gaze, suggests a far more complex and paradoxical reality behind the surface.'

Summarily, Yasmin confronts Westerners' assumptions about Muslim women as icons of oppression, particularly in a world in which the veil is often perceived as a symbol of segregation and subjugation. Modelling her collection of varied headscarves, through which her appearance shifts significantly, Yasmin asserts the self-expression that this item of clothing can allow women like her. As she has described, 'my headscarf is part of my identity', which she presents as something shifting and composite. 'It's not necessarily religious but rather a part of my journey into understanding who I am. It means something different to different women.'

Neshat and Yasmin are among a growing number of Muslim artists, joining the likes of Lalla Essaydi, Farwa Moledina and Feriel Bendjama, who demand new ways of looking at women who wear the veil. They are not just subverting imagery from contemporary Western media, either. During the nineteenth century, European artists such as Jean-Auguste-Dominique Ingres and Jean-Léon Gérôme, painted fantasies of Muslim women lazing in harems, wearing sumptuous robes and lying in suggestive poses. Most famously, *La Grande Odalisque* (1814) by Ingres presents a reclining nude woman as an odalisque, or concubine; the artist has painted her wearing a colourful headscarf, appropriating this item of clothing to indicate that she is an exotic and erotic 'other' to be consumed.

In his seminal 1978 book, *Orientalism*, the art historian Edward Said critiques orientalist paintings such as this. Orientalism, he argues, is a tool to exoticise Islamic and Arabic people and construct them as the 'other' in order to justify colonial ambitions:

The Orient that appears in Orientalism, then, is a system of representations framed by a whole set of forces that brought the Orient into Western learning, Western consciousness, and later, Western empire. [. . .] The Orient is the stage

on which the whole East is confined. On this stage will appear the figures, whose role it is to represent the larger whole from which they emanate. The Orient then seems to be, not an unlimited extension beyond the familiar European world, but rather a closed field, a theatrical stage affixed to Europe.

As well as this traditional framing of the Muslim woman as an erotic 'other', within much Western contemporary art – and particularly photography – veiled females are frequently depicted as downtrodden. In 2019, Dutch artist Jouk Oosterhof was selected as a finalist in the Taylor Wessing Photographic Portrait Prize for her series 'Invisible, In Focus: Child Brides in Bangladesh' (2018). In colour portraits, scarves hide the faces of young girls, aged as young as thirteen, to protect their identities and render them invisible. While importantly pointing to the high percentage of child brides in Bangladesh, these photographs do also perpetuate a dominant victim narrative, within which Muslim women are always objects of oppression, curiosity and concern.

In contrast to this outsider's gaze, Yasmin presents herself as a real Muslim woman, taking ownership of her own story from an inside perspective. While pointing to the symbolic significance of the veil in the unwoven artworks, Yasmin also interlaces imagery of the headscarf with that of other fabrics, fashions and her family in the woven mats. These layered patchwork pieces indicate that the veil is not alone in defining the artist's identity, but belongs to a multifaceted whole.

Yasmin also points out that she, like many Muslims, is on a 'journey with modesty which is ever changing'. This shift is reflected in the artist's self-portraits – in many, she wears deliberately loose-fitting clothing, while in others she dons shorter dresses. She is also mindful of other muses' altering attitudes towards, and expressions of, modesty. Yasmin's mother, who features in photographs in her woven mats wearing a headscarf, has recently chosen to dress in a niqab, a veil which covers the face, leaving only the eyes exposed. 'She would now have the right to ask me to remove images of her face from my past works, although she's happy with their inclusion for the time being,' Yasmin clarifies.

If, and when, her mother requires removal of her representation from artworks, Yasmin will acquiesce. Yasmin will also always ask for permission from her subjects

to photograph them, include past images of them in museum exhibitions, or print photographs of them in books; and as her reputation rises, more muses ask that their images are held back from such wide public view. Diverging from artists, past and present, who have depicted Muslim women without consent and with disregard for their modesty, Yasmin respects her sitters' personal wishes.

Given this notion of modesty among Muslim people, it is self-portraiture that allows Yasmin the greatest level of artistic autonomy; its liberating impact also has a deeply personal effect upon her. 'I never intended to become my own muse,' the artist has reflected, 'but it gives you the freedom to play around with who you are.' At the heart of Yasmin's work is the desire to find, illuminate and depict her identity, on her own terms and for her own sake. Although her work is predominantly personal, Yasmin does generate public discourses around identity across religion and cultures: 'I'm making a statement about myself; the subject I know best; although it was never my intention, my work is also relatable to other people. The work almost has a life in itself outside of who I am, because it does relate to others. It becomes more than just my story; it becomes the story of others too.'

Many female visitors have identified with Yasmin's introspective work; moved by and connecting to representations of a veiled woman in a gallery, they have written to her, including one art student who emailed, 'Looking at images of you on a wall, at someone who looks like me is hardly ever seen. I feel proud of your images. That people who look like us can actually be shown in art isn't something we were ever taught in school.'

The personal stories we tell ourselves are the most powerful of all, which Yasmin has discovered. Through the acts of weaving and photographing herself, she is able to unite the threads of her narrative, past and present, and make sense of the ways in which hybrid cultures, place, faith and family intersect to structure the complex self. By expressing the rich tapestry of her life, as a British Bangladeshi Muslim woman, she offers alternative views of the veil, Islam and its intersections with contemporary femininity; she only asks that audiences leave their assumptions, like their shoes, at the door.

FAMILY ALBUMS

HELENA DUMAS
Childhood Uncensored

From devil-possessed Regan in *The Exorcist* to *The Shining*'s ghostly Grady Twins, there's something exquisitely terrifying about little girls in horror films. This creepy, sinister mood pervades *The Painter* (1994) by contemporary South African artist Marlene Dumas. Stretching to two metres high, the towering canvas features a naked, blonde-haired girl who stands against a pale indeterminable background, staring at the viewer with a sullen expression. The giant toddler's stomach is a discoloured mottled blue, and her hands are both stained – one red, one blue. Is this paint on her hands, the viewer is left to wonder, or something worse?

Throughout the 1980s and 1990s, Dumas relentlessly explored the theme of childhood in her work, producing paintings of pregnancy scans, newborn babies, toddlers and pre-pubescent teenagers. Rendered in her signature style – using thin washes of paint – these shadowy artworks subvert and challenge the familiar notions of the innocent child, not least in her own daughter, Helena, who was born in 1989. It is Helena, then aged three or four, who is the subject of *The Painter*; Dumas worked from a photograph of her messily finger-painting while completely naked in the garden.

Right from the start of her career, Dumas has shunned live models, preferring to use photographs, which she refers to as 'source material'. Her chaotically ordered studio in Amsterdam – she moved to the Netherlands in the 1970s – is filled with images. Artist drawers are crammed full of collected printouts, photographs, film stills and magazine articles, and reproductions of famous paintings cover the studio's walls. *Girl with a Pearl Earring* is there, so is *Mona Lisa*, pasted alongside newspaper cuttings. Around the edges of the room, shelves are stacked with heavy art books as well as dark folders and boxes, which Dumas has neatly labelled.

Dumas's first-ever folder, labelled simply 'Heads', contains pages and pages of clippings, all featuring the faces of women. 'First, it had heads of men and

women. It just said "Heads". Then it became just "Heads of Women". I must have taken the men out,' she has explained. Within this worn folder are photographs of women she admires, such as Simone de Beauvoir, as well as more light-hearted images; one glossy magazine article stars Monica Lewinsky holding a pink poodle in her arms. Throughout them all, it is evident that photographs of the female figure in particular have come to dominate Dumas's practice.

Dumas very consciously works in a post-photographic world – a world in which stories are shared through visual reproductions: 'I don't paint people, I paint images. But this is the age of images, not paintings. People prefer looking at images than paintings. Or the images in these paintings'. Her emphasis on photography as a source of inspiration is also explained, in part, by her upbringing – and growing up in South Africa during a period of apartheid and censorship in which television was banned until the mid-1970s. Only books, magazines and newspapers offered her a window into the wider world, including the history of art.

Many of Dumas's paintings are layered with deliberate allusions to art and its histories. In *The Painter*, her unclothed daughter, whose hands are covered in paint, complicates traditional notions of the muse that exist within the artistic patriarchy. 'Historically . . . it was always the male artist who was the painter and his model the female,' Dumas has commented. 'Here we have a female child (the source, my daughter) taking the main role. She painted herself. The model becomes the artist.' Embodying the duality – of both passive nude female muse and active painter – Helena makes a mockery of stereotypes, equating creativity with this intentionally menacing image of childhood.

In titling it *The Painter*, Dumas also seems to be reflecting on her own creative hand. 'Titles,' she says, 'give direction to the way a picture is looked at.' The viewer is invited to consider who *The Painter* refers to: Dumas or her daughter, or is she perhaps conflating them both? The artist and her chosen muse are, after all, inextricably bound – they are each other's flesh and blood.

The artist's own emotions, including fear, certainly infuse this portrait of her daughter; Dumas's concerns as both an artist and mother are somewhat

mirrored in the painting. A particular sense of dread drips from Helena's paint-dipped hands, hinting at a murderous act; a feeling emphasised by her hostile expression. Pervaded by such dark and violent undertones, *The Painter* shows Dumas confronting her own anxieties as a mother: 'I think if you bring this new person into the world and you don't have that fear that they may do bad things, then there must be something wrong with you.'

This chilling painting simultaneously carries another of Dumas's worries: 'Since Helena was born, the fear that something can happen to this child has been like nothing I'd ever known before. That fear is definitely very much present in the painting.' Helena's bluish skin and tainted hands are strikingly reminiscent of livor mortis – the pooling of the blood in the lowest points of the body that sets in just minutes after death.

This death-like quality also infuses Dumas's closely cropped painting *Helena's Dream* (2008), in which the artist focuses on the face of her daughter. With the full, rounded cheeks of a small child and her closed eyes, Helena looks almost heavenly, cherub-like. But there is something ghostly about the artwork, too. The child's skin is rendered in translucent pinks with accents of grey to highlight her hair, lips and eyebrows and, framed further by a dark, flat void, this layered image evokes the stark contrasts of an X-ray. Dumas's investigative painting leaves the viewer questioning whether the child is sleeping, or if she has in fact slipped into death.

By using watery washes applied in thin pools of paint and gestural brushstrokes, Dumas always seems to be searching for, and trying to show, the essence of her subjects as something that exists somewhere beneath their skin. While working from photographs, instead of life, Dumas is deeply committed to portraying her muses with truth and authenticity: 'I deal with second-hand images and first-hand experiences,' she has remarked. From 1979 to 1980, she studied psychology at the University of Amsterdam, which explains her approach to portraiture; above all, she is interested in what she refers to as 'the psychology of people'.

Dumas is not merely motivated by uncovering the psychology of her muses; she also seems concerned with the thought processes of her viewers – their

reactions become a vital element of each artwork. To involve her audiences fully, Dumas creates deliberate ambiguity in her paintings, particularly those featuring children. In *The Cover-Up* (1994) a young child, who stands in a dark unknown space, lifts her pale blue dress over her head to reveal matching knickers. There is something disquieting about the girl's act of undressing, which simultaneously exposes her body while concealing her face. This intentional uncertainty raises questions: what photograph was Dumas working from this time? Where is the action taking place? Is the child alone or is someone just out of sight? Speaking about this painting, Dumas declared, 'It's suggestive, it suggests all sorts of narratives, but it doesn't really tell you what's going on at all.'

Created on an enormous scale, just like *The Painter*, this canvas confronts viewers with the vast expanse of the child's naked body. This is an image that bears implications, almost accusations, of criminality. The provocative title of this work further admonishes us: this is a picture you shouldn't be looking at. In *The Cover-Up*, Dumas seems to suggest that it is the viewer's own perspective that places unsettling narratives and erotic assumptions onto the naked body of the child, although she does somewhat direct this point of view.

Provocative paintings such as this recall the controversial photographs which American photographer Sally Mann took of her children. In her photobook *Immediate Family* (1992), an intimate series of sixty-five black-and-white photographs focuses on her three young children, Emmett, Jessie and Virginia, who were all under the age of ten at the time. Against the backdrop of the family's woodland summer home in Virginia, they sleep, play and pose unreservedly for their mother's camera.

In thirteen of the images the children are naked and, when the book was published, accusations of exploitation and child pornography were levelled against Mann. The artist defended herself, arguing that her work was 'natural through the eyes of a mother' and that context was essential: 'There was no internet in those days. I'd never seen child pornography. It wasn't in people's consciousness. Showing my children's bodies didn't seem unusual to me. Exploitation was the farthest thing from my mind.'

Nevertheless, when the *Wall Street Journal* ran an op-ed critiquing Mann's work, they censored the printed photograph *Virginia at 4* (1989) by placing black bars over the four-year-old's eyes, nipples and pubic area. 'It felt like a mutilation, not only of the image but also of Virginia herself and of her innocence,' wrote Mann. This editorial choice suggested indecency in the mother's images of her children. Similarly, when the Museum of Modern Art promoted Dumas's 2008 solo show they decided against using a full image of the artist's most iconic work, *The Painter*, on their posters, instead opting for a cropped detail of Helena's face.

In many ways, Dumas already censors her images of children. In contrast to Mann's factual family photographs, Dumas deliberately blurs portrayals of her subjects through her expressive and abstracted manner of painting, removing the viewer from mimetic representations and demonstrating that the viewer is looking at a constructed artwork, not a photograph of a child: 'All this information is simply the beginning of a piece. But, of course, the source is not where it ends. That's a very important point.'

It's unclear if the child represented in *The Cover-Up* is Helena or not; having obscured her face, Dumas leaves us guessing. At a gallery talk, when one viewer asked the artist, 'What is the age of the child?' in reference to another painting of a small naked girl, Dumas retorted, 'It's not a child. It's a painting.' By creating a distance between her subject and audiences, Dumas erects a protective barrier around Helena, denying viewers direct access to her. But this detachment between viewer and depicted muse does also allow the artist to be deliberately provocative with her contrived paintings.

Where Mann says her work has been misinterpreted, and that context is everything, Dumas deliberately removes context. She makes viewers decipher her images without all of the necessary information and, directed by the artist's unnerving titles, audiences inevitably see sinister stories. Dumas places a level of responsibility on her audience, while guaranteeing that they will think such inappropriate things – in the case of *The Cover-Up*, Dumas invokes feelings of guilt and shame associated with the act of looking upon the naked body of a

child. In contrast to Mann, Dumas's paintings purposely reveal the problem of releasing images of children into the world, particularly in the post-internet age. She once commented, 'My daughter shows me her body without posing to please. She shows me the cruelty and magic of innocence.' Her paintings of children demonstrate this duality of innocence, which is both gentle and painful to see, while placing accountability on the onlooker.

In a later work, *Helena 2001 no. 2* (2001), Dumas's daughter is seen moving away from the openness of childhood. Now a teenager, she clutches a white towel to her body, pulling it in closely. Although facing the viewer, she glances away; it becomes clear that she is also aware of onlookers and her role as a muse. She looks uncomfortable – a feeling which resonates with viewers. This painting was exhibited in Dumas's 2015 solo show at London's Tate Modern, which was tellingly titled 'The Image as Burden'.

As an adult, Helena has continued to pose for photographs taken by her mother, which are then worked up into paintings. In the 2018 painting *Birth*, Dumas portrayed Helena as a pregnant woman, now expecting her own child. Echoing *The Painter*, the full-frontal, naked Helena is again represented on a monumental scale: she stands at nearly ten feet tall. She is holding her arms above her head, and the focus is on her swollen stomach. But this is far from a sentimental account of approaching motherhood – behind Helena's pale body is a sheen of blood-red paint. According to Dumas, 'There is no beauty, if it doesn't show some of the terribleness of life.' Her daughter seems to agree; Helena thinks *The Painter* is 'one of the best paintings I've done', the artist has disclosed.

Dumas's canvases, like great horror films, toy with viewers' suppressed fears, dark thoughts and preconceptions. Emerging as a ghostly apparition in her mother's paintings, Helena destabilises all sentimental notions of childhood. Instead, she invites viewers to complete the unsettling and ambiguous narratives around her, showing that images always require interpretation and ultimately involve artist, muse and viewer; who is who amongst these roles is also deliberately hazy and unresolved.

BEYONCÉ
The Fertility Goddess

In February 2017, Beyoncé Giselle Knowles-Carter announced that she was pregnant, and with twins no less. Taking to Instagram to share the news, she uploaded a symbolic photo: wearing blue satin underwear, a sheer mulberry-coloured bra and a long, light green veil, Beyoncé kneels before a hedge of flowers and a bright blue sky. Cradling her pregnant stomach with both hands, the proud mother-to-be looks directly at the viewer with a brooding gaze.

This mesmerising maternity photograph was taken by Awol Erizku, an Ethiopian–American artist who is best known for staging photographs which disrupt the canon of art history. He has described his motivation: 'I grew up studying western art, especially European art. That's what you learn in school. And I always felt like I'd never seen enough, say, eastern art to balance it out, to know what people of my heritage did. To a large extent this history has been expropriated and, in a sense, "whitewashed" in text books.' In order to intervene, Erizku typically inserts contemporary Black muses – who bring with them their own cultural references – into traditional masterpieces.

Reimagined through Erizku's diasporic lens, Leonardo da Vinci's *The Lady with an Ermine* (*c*.1489–91) becomes *Lady with a Pitbull* (2009); where the original white maiden has been replaced by a casually dressed young Black woman who holds – instead of the white ermine – a pit-bull terrier. Similarly, *Girl with a Bamboo Earring* (2009) is a clever update on Vermeer's famous portrait, in which the young Dutch girl has been substituted by a striking African-American woman; theatrically lit, Erizku draws attention to her iconic blue-and-gold headscarf, which has been paired with a large gold bamboo earring.

Given the artist's penchant for revisionist portraits, Erizku's photograph of Beyoncé raises a question: which historical masterpiece was he mimicking this

time? Kneeling down at what looks like a grassy altar, holding her stomach, and pairing light blue underwear with a long gauzy veil, Beyoncé is clearly channelling devotional depictions of the Virgin Mary. During the Italian Renaissance, artists portrayed the Madonna – both with and without her child – wearing blue, with her head covered, and positioned before an idealised landscape. *The Conestabile Madonna* (c.1502–4), for example, is a small circular painting by Raphael, in which Mary, who has a halo above her head, wears her signature blue hooded cloak and cradles her baby within a green meadow.

Employing the iconography of Christian art, Erizku represents Beyoncé's status as an expectant mother in sacred terms, which is exactly how his sitter felt about her pregnancy. In the 2013 HBO autobiographical film *Life is But a Dream*, Beyoncé, who had previously suffered several miscarriages, speaks about the 'amazing' honour of carrying her first child Blue Ivy: 'Being pregnant was very much like falling in love. You are so open. You are so overjoyed. There's no words that can express having a baby growing inside of you, so of course you want to scream it out and tell everyone . . . I felt like God was giving me a chance to assist in a miracle.'

A miracle is one of the ways in which Beyoncé's second pregnancy, with twins Rumi and Sir, is framed in Erizku's photographic portrait: if you look closely at the colourful flowers behind her head, even these have been carefully arranged in a halo-like shape, adding to the divine atmosphere of the artwork.

However, there is one stark difference between Erizku's photograph and sacrosanct portraits of the Madonna: physical signs of the Virgin Mary's pregnancy are typically hidden beneath long flowing robes. In fact, throughout Western art history, portraits of women expecting babies – typically wives painted by their husbands – deliberately conceal their abounding condition beneath loose clothing and distracting folds of fabric, as a means of preventing viewers from conflating pregnancy with sexuality.

In contrast, Beyoncé bares her naked stomach to boast a large baby bump. Taking agency over her body, and the growing life within it, Beyoncé joins a pantheon of contemporary female artists who have portrayed themselves

during various stages of pregnancy. When expecting her daughter, American painter Chantal Joffe took herself as her own muse: 'Being pregnant, it was like, "Wow, how brilliant to paint yourself changing so much."' In the expressively painted canvas, *Self-Portrait Pregnant II* (2004) Joffe, wearing only underwear, stands side on in order to capture the size of her swollen stomach.

As art historian and curator Karen Hearn has pointed out, 'When female artists become pregnant themselves, very often their work changes radically – it can be a real watershed.' The experience of pregnancy was no different for Beyoncé, who told *British Vogue* in December 2020 just how huge the impact had been on her: 'Something cracked open inside of me right after giving birth to my first daughter. From that point on, I truly understood my power, and motherhood has been my biggest inspiration.'

In several interviews Beyoncé has reflected on the new perspective on life she has gained since becoming pregnant: 'If someone told me fifteen years ago that my body would go through so many changes and fluctuations, and that I would feel more womanly and secure with my curves, I would not have believed them.' Posed for Erizku's maternity portrait, Beyoncé draws attention to her growing body and, flaunting her full figure, makes the link between pregnancy and sexuality explicit.

The heightened sensuality of Beyoncé, who wears very little, in Erizku's portrait, is suggestive of another prominent figure from art history: Venus. Most famously, in Sandro Botticelli's masterpiece *The Birth of Venus* (1485–86), the Roman goddess of love and sex stands naked inside a giant scallop shell, surrounded by nymphs and pink roses caught in a breath of wind. Similarly, Beyoncé is framed by flowers, while the placement of her hands on her pregnant stomach echoes Venus's hands – which both hide, and invite viewers to imagine, her pudenda.

But, in Erizku's frame, the slim white body of Botticelli's beauty has been defiantly replaced with Beyoncé's fuller figure – her kneeling pose accentuates the curve of her thighs. As such, the artist's muse is closer in appearance to prehistoric fertility figurines, often referred to as 'Venus figures', which have

been uncovered from countries around the world. Sculpted from a variety of natural materials, these statuettes depict nude women with wide hips, exaggerated busts and rotund stomachs.

Most notably, the *Venus of Willendorf* (*c.*28,000–25,000 BCE), carved from oolitic limestone and tinted red with an ochre pigment, emphasises the figure's voluminous breasts, uncovered pudenda, wide hips and full thighs. Sized at just over eleven centimetres tall, the *Venus of Willendorf* is typical of fertility figurines which were likely intended to be handheld and, given the emphasis on areas of the body associated with reproduction, are widely believed to have been used as good-luck totems associated with fertility.

Similarly, in Akan culture, a matriarchal society originating in West Africa, fertility figures have historically been used by women wanting to get pregnant. Akuaba figures – instantly recognisable for their flat disc-like heads, bare protruding breasts and necks ringed with creases – represent young women of prime childbearing age. Miniature in size, they are designed so that women can carry them on their backs, treating them as a surrogate child until they conceive.

Once an Akan woman becomes pregnant, she will place the akuaba on a shrine, offering it up to the spirits who responded to her prayers for a child. Kneeling on earthy fertile ground, suggestive of an altar, Beyoncé's approaching motherhood appears as a source of feminine power to be sought after; she alludes to the ways in which fertility has historically been celebrated by various cultures, and particularly in matrilineal African societies. Embracing womanhood in its most abundant terms, Beyoncé manifests as a modern-day fertility figure.

In a wider series of photographs, shot by Erizku, Beyoncé further evokes the appearance of African goddesses associated with fertility. In several images, she swims gracefully underwater, floats upside down and dives acrobatically. Wearing a yellow dress, which has been tied around her breasts, its layers spread out like tentacles to reveal her bare bump beneath, she channels the water deity Yemoja who, in Nigeria's Yoruba religion, is the patron saint for expectant mothers and often depicted as a mermaid.

Throughout the underwater images, Beyoncé also channels Oshun, the Yoruba goddess associated with fertility, motherhood, love and beauty, who typically adorns herself in gold ornaments and wears a flowing yellow dress. Performing at the 2017 Grammys – her first appearance since the announcement of her pregnancy with the twins – Beyoncé wore a sparkling, sequined floor-length gold gown and a golden halo, alluding to the ancient spirit through her spectacular symbolic costume.

In contemporary Western culture, motherhood is often marginalised and undervalued; women are told that it shouldn't determine their worth or identity. However, Beyoncé presents motherhood, denoted through the imagery of deities, as a powerful, life-giving force. In her visual album *Black is King* the performer refers to herself as Osun, the African goddess of love and water. She equates being a mother with creative power, including the inspiration behind her music.

Beyoncé also challenges notions that maternity – epitomised by the chaste and pure Virgin Mary – is separate from sexuality, visualised in art across the ages by the beautiful goddess Venus. On stage, as in her pregnancy photo shoot, Beyoncé conflates these two embodiments of femininity. By further assimilating imagery from African cultures and religions, which prize fertility highly, she makes an empowering statement: women can be both sexual beings and mothers. She makes a compelling case for the power to be harnessed from the intersection of motherhood, fertility and femininity.

An African-American woman, Beyoncé also hails Black motherhood, pointing to her powerful ancient ancestors, which make up her rich family history. It's worth noting that Beyoncé, like all daughters in matrilineal societies, has taken her name from her mother Tina Knowles, with whom she has always enjoyed a very close relationship: 'A lot of people don't know that Beyoncé is my last name. It's my maiden name,' Knowles proudly told Oprah Winfrey in 2013.

Pre-Beyoncé, Erizku had replaced the white sitters of famous paintings with contemporary Black models, revising one artwork at a time. However,

with Beyoncé, he has interwoven cultural references, allowing her to bring her multiple sources of inspiration into his portraits in which she embodies motherhood, which acts as her muse. In an interview for *Rolling Stone* in 2017 Erizku opened up about their creative relationship: 'She's a very smart person and she knows what she's doing. She knows what she wants and she has such a big heart – she's so open to artist collaborations. Whether it's Beyoncé or someone I met on the street, my approach to making portraits and making art is that it has to be organic.'

The pregnancy photo shoot was a clever collaboration for both artist and muse, who were allied in their diasporic strategy to create a mixtape of iconography, which exalts motherhood in its fullness. Beyoncé, the most Grammy-winning female artist in history, has claimed that becoming a mother has been one of her 'greatest achievements', which Erizku has framed for her. Not only does he capture her humanity, and the physicality of pregnancy, but the artist ensures she looks divine; like an ancient fertility figure she demands devotion for mothers, our creators of life. Adoration certainly came in the form of over eleven million likes when Beyoncé posted the photo of her veiled as a Black Venus on Instagram.

FUKASE SUKEZO
Father Figure

S ince its invention in the early nineteenth century, photography has played a hugely valuable role in family life; nowhere is this clearer than within the pages of the family photo album. A vanishing object in the digital age, its collection of printed photographs freezes significant moments in time: birthdays, graduations, weddings and anniversaries. It also preserves people, often depicted in group portraits, which foster a strong sense of belonging and shared identity between relatives.

However, the family album is definitely *not* a place where you would expect to come across nude photographs, and particularly not of your parents. But, in 1991, Japanese photographer Fukase Masahisa published a photobook of group family portraits, titled *Kazoku*, which translates as *Family*, in which several young women, his mother and father, and even the artist himself, pose nude and semi-clothed for the camera.

Family is, in many ways, a typical family photo album, in which thirty-one black-and-white group portraits have been curated in chronological order. Over the course of twenty years, from 1971 to 1989, Fukase photographed his family – parents, siblings and their partners, nephews and nieces – who posed in assorted groupings inside a studio. Crowded together, and arranged strategically in rows, the family make sure that everyone's face can be seen; sharing the same slim build and neatly combed black hair, they appear unified.

The first portrait in Fukase's series features ten members of the family, including small children, who are held by their parents. Kneeling on the floor, sitting on chairs and standing together, these relatives appear as a tight-knit group. The image reflects the importance of the family unit, particularly within Japan's collectivist culture – exemplified by the fact that historically, the Japanese have laid such emphasis on family that a first name follows a surname.

Moreover, although ideas of the family have changed considerably in recent decades, the concept of '*ie*', which translates as 'continuing family', does still remain. The Japanese have a saying that family members, including parents and grandparents, should live close enough that they can carry over a bowl of hot soup – an idea expressed in Fukase's portraits which present three generations of his family.

In Fukase's first photograph, the family surrounds Sukezo; a slender middle-aged man, wearing a casual polo neck and glasses, he smiles comfortably for the camera. Throughout *Family*, Fukase has placed a defined emphasis on his father, who remains in the same central position in each group portrait. Framed as the head of this family unit, Fukase points to another tradition in Japanese culture – the father has historically been regarded as the breadwinner and receives the utmost respect from his family.

At the same time, the viewer's attention is also drawn to a semi-naked young woman who stands on the far-left edge of the group. Wearing only a white cotton waist-wrap – an item traditionally worn beneath a kimono – her slightly waved long black hair covers her breasts suggestively though she gazes demurely at the camera. The rest of the group, mostly smiling politely, appear unaware of or unperturbed by her provocative behaviour.

Although Fukase has adopted the format of the family group photograph, images such as this take a subversive turn and raise crucial questions for the viewer: who are these theatrical figures and what is their significance? What was the real relationship between father and son? Was Fukase mocking his father or celebrating him in this satirical family album?

Photography meant more to Fukase's family than most, as is highlighted by the staged backdrop and pared-down setting for the series; each of the portraits was shot in the family-run Fukase Photographic Studio, located in the small town of Bifuka on the Japanese island Hokkaido. Founded by the artist's grandfather in 1908, at a time when very few people had access to cameras, the studio soon became popular with families seeking commemorative portraits. Business boomed, and the successful studio was passed on to Sukezo.

Fukase was born in 1934, and from the age of six his parents taught him the family trade, including how to wash and process photographic prints. While he was attending high school, his father also gave him a new portable model of camera, encouraging him to follow in his footsteps. Sukezo hoped, and expected, that Fukase would one day take over the studio; traditionally in the patriarchal culture of Japan, assets and responsibilities are handed down from father to eldest son, and Fukase was therefore the studio's rightful heir.

However, he noted that he started to bear a 'grudge' towards commercial photography and the studio, feeling that his life had, in effect, already been mapped out for him. Aged eighteen, instead of taking over the family business, Fukase moved to Tokyo where he enrolled in the College of Art at Nihon University. Although he joined the Photography Department, he wanted to study a very different style of photography to that practised by his father within the walls of the family-run studio.

Since photography's arrival in Japan during the 1850s, when it was first adopted by commercial photographers and scholars, the term 'shashin' was invented; translated as 'truth copy', it stresses the idea that the camera faithfully records people and places. By documenting families on important occasions and capturing celebrations for posterity, Fukase's father was a photographer in this traditional sense.

Then, towards the turn of the twentieth century Japan saw the arrival of 'geijutsu shashin', meaning 'art photography', which saw photographers adopt a more expressive, personal and experimental approach to picture-taking. The landscape and nature became popular subjects among photographers who strove to capture visual beauty through their lens. In an essay from 1991, Fukase wrote, 'I had to choose whether I wanted to be a shashin-shi, a "studio" photographer, or a shashin-ka, an art photographer in the modern sense.' Turning his back on his family's profession, Fukase defiantly chose to pursue shashin-ka.

Starting his career as a freelance photographer, Fukase felt compelled to capture those who were closest to him. His first experimental photobook, *Yugi*

[Homo Ludence] (1971), features both his first wife, Yukiyo Kawakami, whom he married and divorced young, as well as his second wife, Yōko Wanibe. For more than a decade, Wanibe, a charismatic stage actress, became Fukase's primary muse. In the black-and-white series 'From the Window' (1974) she is portrayed leaving their house every day and, from the pavement below, looks up at Fukase who was positioned with his camera in an upstairs window. Smiling, shouting and peering out from beneath her transparent umbrella, it's obvious that Yōko was an active participant, who collaborated with her husband to challenge conventional Japanese portraiture.

Fukase's beloved cat, Sasuke the Second, was another significant muse for the artist. In countless photographs, he is portrayed as a close companion: Sasuke travels with Fukase on the front seat of a car, his ears pricked up as it speeds along; he peeps out of a partially unzipped holdall bag, watching an elephant in its enclosure at the zoo; he plays in the wet sand at the beach. In many other photographs Sasuke simply stares straight down the lens of the camera, yawning widely: 'I didn't want to take photos of cats that looked beautiful or cute, but rather the affection you can see when I appear in their eyes.'

Taking family, including his pet, as his subject matter, it's obvious that Fukase never quite abandoned his roots in portrait photography, which he used to document his life – albeit in a performative manner. While making a name for himself in Tokyo, Fukase also maintained a strong connection with his home town, regularly making the long thirty-six-hour train journey back to Hokkaido. It was during the 1970s, when his younger brother Toshiteru had taken over the Fukase Photographic Studio family business, that Fukase embarked on *Family*, which would take him twenty years to complete. Using an old camera which belonged to the business, and gathering his relatives together, Fukase photographed them inside the very studio which he had once rejected.

Early images in *Family* include Yōko who, as in her individual portraits, poses playfully for the camera; she is the woman whose hair covers her breasts in the first portrait. In 1976, Yōko left Fukase and the couple divorced,

prompting the heartbroken photographer to return home to Hokkaido. Continuing to take family portraits, Fukase replaced his wife with young female actors and dancers from Tokyo, who strike deliberately droll, theatrical and sometimes ridiculous poses, often pulling faces for the camera.

In one image a completely naked woman, whose hair has been tied back to expose her breasts, although her hands cover her genitalia, looks entirely comfortable as she stands smiling alongside nine members of the Fukase family. The ironic nature of this photograph has been enhanced by the inclusion of the family cat, who looks keen to escape the hold of one female relative.

Fukase's approach, including the comic insertion of performers, might at first glance appear to poke fun at both his family and their photographic business. However, he always positions the guest stars to the far left of his relatives, as if not wanting to fully disrupt their ranks. Moreover, the extended Fukase family are seemingly in on his joke too; in several images they play along with this sardonic reimagining of the family portrait. In one dramatic photograph the whole group turns their back on the camera, with the exception of Fukase's father. Seated, once again, at the heart of the group and looking straight ahead, Sukezo has been singled out. In another photograph, Fukase and his father are pictured alone in the studio; standing shoulder to shoulder, with their hands by their sides, the two men pose properly for the camera while wearing only white underwear.

Although parodying the formal family photograph, Fukase's images do stress the significance of his father, who partakes in his son's play on portraiture. The importance of Fukase's father to him is also evident in another series of over one hundred black-and-white photographs, titled *Memories of Father* (1971–90), which the artist worked on in parallel with *Family*. Likewise published in the format of an album, this complementary body of work reveals Fukase once again deconstructing the tradition of family portraiture. However, on this occasion, the artist took Sukezo as his sole subject.

A poignant photobook, *Memories of Father* acts as a visual autobiography of Sukezo's life, which incorporates archival images alongside Fukase's own

photographs of his father. It begins with pictures of Sukezo as a baby, being held by his parents, before showing him as a small boy in rural Hokkaido: he stands proudly in a smart blazer and hat, ready for school; he rides a bike; he sits up straight within rows of fellow students for a class photograph. The album then charts Sukezo's life as he starts his own family and, becoming a father, takes his children on trips, including to a bowling alley. Several photographs capture Sukezo at his most carefree: in one he holds up a long slim fishing rod, smiling gleefully for the camera, as he reveals his catch.

Seen side by side, *Memories of Father* and *Family* tell two sides to the same story. Within the staged studio portraits, Sukezo is framed as head of the Fukase family, appearing as a governing presence within the business which he successfully ran for many years. In *Memories of Father*, Fukase chronicles Sukezo's personal narrative, revealing his identity and personality, which exists beyond the parameters of the studio; Fukase points out that there is much more to his father than the leading roles – across work and family life – which many men must assume, particularly in patriarchal societies such as that of Japan.

In both photobooks, Fukase also focuses on the vulnerability of his father as he ages. *Memories of Father* includes photographs of Sukezo as he moves from middle into old age. Several images show Sukezo, who is sick in hospital, lying covered in bed sheets. Similarly, the *Family* photographs highlight Sukezo's transformation as he ages. One of the later images in this album features Fukase and his father, alone in the studio, posing for the camera wearing dark trousers but topless. Sukezo, who is seated on a chair, looks frail; his bare chest is emaciated to the point that his ribs are visible. Fukase stands behind him, placing his hands protectively on the skinny shoulders; it's a moving image of a child caring for his elderly father.

Fukase doesn't stop there: we also see Sukezo in death. After suffering from pneumonia in his later life, he passed away in 1987. In *Memories of Father*, a photograph shows his coffined body about to be cremated, while another records his funeral at which his family wear smart black mourning clothes.

Nine members of the family, including Fukase, have also posed in the same outfits for a formal group portrait in *Family*; in the place usually occupied by Sukezo is a framed life-sized portrait of him smiling – it's one which Fukase had taken of him in the studio in 1974.

Far from mocking his father, it becomes clear that Fukase selected Sukezo as his muse to pay tribute to him and his life, which was defined in large part by photography. By placing the photograph of his late father within the funeral photograph, Fukase reveals the performative ritual of smiling for a photographer behind the lens, which Sukezo observes even in death; his legacy now lives on in his sons.

Throughout *Family*, Fukase is also illuminating the clever ways in which photographers, including Sukezo, control and distort narratives with their camera. The insertion of incongruous naked female models – a recurrent motif throughout art history – highlights the carefully constructed element to group portraits within a photographer's studio. There is a fictional element to the family portrait, Fukase shows the viewer. Not only does he elevate the family album into a fine art object, but he also points to the artistry involved in taking a group portrait. Although Sukezo observed the tradition of 'truth photography', a great level of creative staging was involved in this.

It also becomes obvious that Fukase's style of 'art photography' is not as far separated from his father's practice as might first appear. In his nostalgically tinted *Memories of Father*, Fukase focuses on his father's life outside the studio, illuminating the real and complex man behind the camera; he is recording truth. Although, on the surface, they had pursued opposing types of photography – '*shashin*' and '*geijutsu shashin*' – father and son were both involved in capturing the theatre of life through the portraits of families, including their own.

After Sukezo passed away, the family business struggled; with the advent of affordable cameras, people no longer required professional portrait photographers. Fukase's series can therefore also be understood as a homage to the tangible family album, filled with memories, which had defined the lives

of three generations of the Fukase family. The first and last image featured in the *Family* photobook are of the Fukase Photographic Studio, immortalising the place which the artist had once left behind, to which he then returned, and with which he was indelibly connected.

In *Family* and *Memories of Father*, Fukase's ageing father also acts as a memento mori, reminding us that death is inevitable for us all. Marked by a deep sense of loss, these intense series offer an unflinching commentary on the transience of life. As Fukase understood and wrote, 'Every member of the family whose inverted image I capture on the film inside my camera will die. The camera catches them, and in that instant it is a recording instrument of death.' He went on to conclude, 'For me, everything is a commemorative photograph, to be eventually stuck in a battered old photo-album.'

In 1992, just one year after he published *Family* and *Memories of Father*, Fukase suffered a traumatic brain injury when he fell down the steep steps of a bar in Tokyo. He entered a coma from which he never woke up and died in 2012. Like his father, Fukase is preserved within the pages of his family albums, within which he frequently appears side by side with Sukezo. Inheriting a compulsion to commemorate people, Fukase had taken as his final muse the man who had created, taught and inspired him – his father.

FOR THE LOVE OF THE MUSE

FOR THE LOVE OF THE MUSE

ADA KATZ
American Beauty

If you'd walked down New York's Park Avenue during the summer of 2019 you would have seen, positioned roadside on the grassy landscaped parkways, seven identical cut-outs of a stylish woman. In each of the eight-foot-high flat sculptures, made from smooth porcelain enamel and steel, the female figure wore a yellow sun hat, cropped tan-coloured trousers and a sleeveless black blouse.

The duplicate cut-out sculptures, which were collectively called *Park Avenue Departure*, depicted the woman from behind with one hand placed casually in her pocket and grey-streaked black hair falling onto her shoulders. She looked, in many ways, like any other pedestrian crossing the city's street. But she also presented passers-by with a puzzle: who was she and why was her face hidden?

Let's start by meeting the ninety-two-year-old man behind these public sculptures: Alex Katz. Today, the American artist is renowned for painting pristine portraits using flat surfaces, heightened colours and minimal details. His works have been shown at hundreds of galleries around the world, from the Whitney Museum of American Art to Tate St Ives, but his iconic imagery and stripped-down style took some time to develop.

Born the son of Russian immigrants to New York City in 1927, Katz grew up in the diverse suburb of Queens, where he remembers spending his early days drawing. After returning from a period in the navy in 1946, he enrolled at the city's Cooper Union School of Art before receiving a scholarship to attend the Skowhegan School of Painting and Sculpture in Maine. It was here that Katz remembers getting 'really involved in painting, and in particular painting from life'.

Emerging from art school in the early 1950s, Katz moved to Manhattan, where he found a radical new type of painting reigning supreme: abstract expressionism. The likes of Jackson Pollock, Lee Krasner and Willem de

Kooning were making colossal, mural-sized works characterised by layers of paint, which they dripped, swept and splattered across the surface of the canvas to give an impression of spontaneity.

In response to this new energetic abstraction, Katz started to work in a more painterly manner. At the same time, he refused to embrace abstract art entirely; still interested in representing the human figure, he turned to modern masters like Matisse for inspiration. However, existing in a space between past and present, Katz didn't quite fit in: 'I completely alienated myself from traditional modern art and from traditional realistic painting, and also from the avant-garde.'

During this period, the artist's confidence was at an all-time low as he fought to find a unique approach to portraiture: 'I kept making paintings, and they were good, but they were boring.' Experimenting endlessly, Katz binned 'maybe a thousand paintings' in the process. Despite this, the testing paid off; by the mid-1950s he had evolved a crisp and skilfully cool style, which both drew on but also countered the work of his contemporaries. As he has remembered: 'There were no large figurative paintings that were interesting, as far as I could see, so it was an open area. Those Klines and de Koonings had so much big energy; I wanted to make something that knocked them off the wall. Just like that – more muscle, more energy. They set the standard. It wasn't the style I wanted to follow, but I wanted to paint up to their standards. So I took a figurative work and I said, "Well, I want a figurative painting on the scale of the Abstract Expressionists," you know, on a big scale.'

Katz set about making enormous paintings of figures against flat fields of unmodulated colour. Like the abstract expressionists, he was interested in exploring the act of painting itself, with a focus on pure medium, shape and brushstroke. At the same time, Katz took inspiration from visual imagery in the city – packaging, posters and advertising billboards – wanting to capture 'quick things passing'. Without realising it, he was paving the way for pop art.

By 1957 Katz decided to take real and recognisable people as his subject matter, working from them in live sittings, as he had been taught at art school

in Maine. Uninterested in creating narratives, he preferred instead to hold up individuals as icons of the everyday, cropping them in close-up compositions. That very same and pivotal year, the painter's primary subject, model and muse walked into his life – the woman from the Park Avenue cut-out sculptures, Ada Del Moro.

It was at the opening of his two-artist show at the small, artist-run Tanager gallery that Katz first met Ada. As the evening drew to a close, Ada joined the artist and a group of friends for coffee. Katz remembers, 'A whole bunch of us went out to have coffee afterward. Ada had a tan, and a *great* smile, and she was with this guy who looked like Robert Taylor – fantastic-looking guy. But he didn't put her coat on – I did.'

Recalling this first encounter, Ada remembered how she suddenly found herself the subject of the artist's gaze: 'I was sitting with my hands in my lap,' she said, 'and this guy that I was interested in was looking at my eyes, my ears, my shoulders. The whole thing was just very sensual. And I didn't think I could handle it. But then it became just this thing that he did. I was sitting and he was painting, and that was it.'

Straight away, Katz began to paint portraits of Ada; the artist had found his muse and subject. 'My wife, Ada, is my muse. It just sort of turned out that way. She's like Dora Maar [Picasso's muse and lover]. She's a perfect model – a European–American beauty. If she was two inches taller she could nail Miss America!'

With these words, Katz shows us the potent influence of Picasso, who proudly held up the female muse as an essential instrument in the great male artist's toolbox. Of course, Picasso's misogynistic conduct, with Maar and other women in his life, set a bad example, encouraging the exploitation of female partners. However, through his considerate relationship with Ada, Katz demonstrates the way in which the muse deserves to be treated, and it's reflected in his portraits of her.

Hanging in the Met in New York, you can find one of Katz's earliest paintings of his muse, titled simply *Ada* (1957). Dressed in a smart-casual black

jumper and a cerulean coloured skirt, Ada is seated on a chair. Positioned against a simple beige background, the focus is on Ada's distinctive mid-length dark hair and eyes, contrasting with her red lips which are kept closed in an indeterminate expression. As she stares directly out of the canvas, hands folded in her lap, Ada appears thoughtful, assured and relaxed in the artist's presence.

Katz was captivated by both the beauty and intelligence of this smart, educated woman. At a time when few women followed a career in science, Ada had trained at Brooklyn College and New York University as a research biologist. She then went to Milan on a Fulbright scholarship to specialise in tumour genetics and, by the time she met Katz, was working at the Sloan Kettering Institute as one of the only women employed in the laboratory.

Ada and Katz shared the same ambition, explained in part by their similar backgrounds. Both had been born in New York to immigrant parents, as Katz has openly discussed: 'We're Jewish off the boat, and they're Italian off the boat. On Sunday afternoons, both families listened to opera on the radio. No one ever voted for a Republican.' Supported by their parents, both Ada and Katz turned to education as a track for upward mobility in American society.

Within a year of meeting, the well-matched couple got married, and in 1960, they welcomed their son Vincent to the world. This was a pivotal moment for Ada, who decided to leave her job at Sloan Kettering to focus on motherhood. This choice also allowed her to become a full-time muse for her artist husband. From the moment that they had met, Ada became Katz's favourite subject. Now, with more time to give, she also became his main model.

While most couples create family photo albums, Ada and Katz filled the rooms of their home with paintings – mostly of Ada on her own, although some feature the couple together. In Ada's words: 'We didn't take pictures of each other . . . he painted.'

In *The Black Dress* (1960) Ada appears repeatedly, six times across the canvas – once again foreshadowing the identical Park Avenue cut-outs. She wears a simple, chic black cocktail dress, and is seen standing, seated and positioned beside Katz's portrait of their friend, the poet James Schuyler. The

scene evokes New York's gallery openings which, having brought Ada and Katz together, they continued to attend as a couple. Painting her as the only attendee at this imagined opening Katz signals that, for him, she is the only woman in the room; he can't keep his eyes off her.

Even before she met Katz, Ada had developed a deep interest in contemporary art and literature, alongside her professional career as a scientist. 'Ada is smart and inquisitive about radical art. She got to Samuel Beckett before the poets I knew did,' Katz once remarked. Through her marriage to an artist, Ada has moved in artistic circles, and in 1979 she co-founded the Eye and Ear Theater Company, where she invited collaboration between writers and contemporary artists, producing plays in which painters designed sets and costumes.

The Black Dress also highlights Katz's defining focus on fashion – in portraits of all his models, but particularly those of Ada. We often think of the muse stripped down, laid bare and painted as a site of erotic desire shown off by the artist to admiring onlookers. However, Katz belongs to a significant selection of artists who have refused to portray their romantic partners nude, deliberately, and respectfully, distancing the viewer from the muse's most intimate self.

Most notably, over the last three years of his life, Amedeo Modigliani – known for his portraits of elongated figures with oval faces – painted his muse and fellow artist Jeanne Hébuterne more than twenty times, but not once does she appear naked. He refused to share his muse completely with the artworks' audience. 'Some things are private,' he seems to say. Similarly, Ada is always clothed, and what she wears, including the black cocktail dress in this painting, is noteworthy.

Katz used fashion in his portraits as a symbolic signifier: 'I'm painting the society in which I live. So it has that social identification, but it's also pretty optical. I'm just trying to paint what I'm looking at. Fashion is a part of that.' As such, his paintings can be read as a visual diary of the context and American society in which he and Ada were living.

Throughout the 1960s, Ada appears in sleek black sunglasses, pillbox hats and stylish sweaters with her Jacqueline Kennedy-cut black helmet hair. A perfect picture of elegance and poise, she is the sophisticated first lady of Katz's paintings. These portraits celebrate Ada, who like Katz was born to an immigrant family, as having been accepted into American high society. In paintings like *The Black Dress* she owns her iconic outfit; she is a symbol of success, epitomising the American Dream.

And it's not just through era-specific fashion that Katz captures Ada's American beauty over time; he also presents her as an ageing woman. By the *Park Avenue Departure* cut-outs, grey streaks are visible in the muse's shoulder-length hair. Similarly, in later painted portraits, fine lines and creases appear on her face. Despite his simplified style, Katz doesn't shy away from reflecting Ada's age, refusing to airbrush out the realities of her growing old, gracefully.

In many ways, Katz's portraits oppose the stereotype of the older woman – often imagined as a sweet, rosy-cheeked old lady, or witch – which we find in both art and the media. Instead, even when she is well into her eighties Ada still appears stylishly well-dressed in contemporary fashions. As he said, 'I could use her in many different ways and now as an older glamorous woman. She's perfect. She'll still stop traffic. It's perfect casting.'

Stopping traffic is exactly what Ada did through the *Park Avenue Departure* larger-than-life public sculptures, leaving people to wonder who this sophisti-cated woman was. But why, if Katz was continuing to celebrate his wife, had the artist turned his muse away from onlookers, hiding her face?

Despite being the subject of over a thousand paintings, Ada has remained an intensely private person, giving very few interviews. At the same time, and since identifying his stylised approach, Katz has treated his sitters, including Ada, with a blend of realism and abstraction, simplifying their features through planes of flat colour and clean, easy outlines. This suited Ada, who is consistently kept at a slight distance from viewers through the artist's approach. In addition, she is always dressed up, covered, and inscrutable in her expressions.

With the cut-outs, placed so prominently in Park Avenue, Katz also chose to add another device, and one which had been used before by artists including Salvador Dalí in his paintings of Gala. Depicting Ada with her back to the viewer in these public cut-outs, Katz was creating a boundary between artwork and public, separating the muse from the masses. Moreover, by being turned away, as if she could walk off at any moment, she appears to be calling the shots.

We often think of the muse as a younger woman, entering into a short-lived, temporary role. But Ada, who consciously gave up a successful career as a scientist and then committed to the position for over forty-eight years, defies these expectations. Starring in pared-down portraits, scaled up to billboard size, or traffic-stopping cut-out sculptures, she has been held up as a serene, stylish and contemporary icon. Commanding each portrait through the decades, she has required the lifelong attention and devotion of her artist partner. Today Katz's paintings of Ada are his most coveted.

GEORGE DYER
Bacon and the Burglar

'You're not much of a burglar, are you? Take your clothes off. Come to bed, and you can have whatever you want.'

These are the first words uttered by British painter Francis Bacon to the young man who has just fallen through the skylight of his studio – while attempting a burglary – in John Maybury's 1998 film, *Love is the Devil*. From this legendary midnight meeting in 1963, the biopic follows the unlikely relationship between the artist and an East London criminal, George Dyer, who became Bacon's lover and greatest muse. His distorted face features in more than forty paintings by Bacon, including many of the artist's most famous and haunting works.

Maybury's cinematic version of events was based on Bacon's own claim – that he had caught Dyer breaking into his apartment and studio at 7 Reece Mews in South Kensington. However, the artist later admitted that this was a lie. What, then, is the true story between Bacon and the burglar, who appears as a tragic figure surrounded by shadows in the artist's nightmarish canvases? If the painter had lied so easily about their first encounter, is this melancholy image of Dyer also fantasy? But let's start at the beginning: how did the pair really meet?

It was in the autumn of 1963 when Dyer quite simply introduced himself to Bacon, in a pub in Soho. At a time when homosexuality was still illegal in Britain, the area's culturally liberated atmosphere did attract many gay men, as well as an eclectic mix of the city's artists, musicians and even criminals. Bacon could frequently be found in the area with his inner circle of drinking buddies, and recalled the day when Dyer, who was 'down the far end of the bar', walked over and said in his cockney accent, 'You all seem to be having a good time, can I buy you a drink?'

Bacon, then in his fifties, was already a well-established figurative painter in Britain who had recently held a solo show at the Tate. Twenty-nine-year-old

Dyer, on the other hand, was a petty thief who had drifted from juvenile detention centre to jail; to use Bacon's words, he had 'spent more time in prison than out'. Having been brought up in London's East End by a family of law-breakers – even his mother attempted to steal from him while he slept – Dyer had followed the path most expected of him. 'He only went in for stealing because he had been born into it . . . Everybody he knew went in for it,' Bacon justified.

The art critic John Russell remembered Dyer as 'a compact and chunky force of nature' who 'embodied a pent-up energy . . . a spirit of mischief, touched at times by melancholia', describing 'his wild humour, his sense of life as a gamble and the alarm system that had been bred into him from boyhood'. He maximised his athletic masculinity by wearing smart suits with braces and a narrow, tightly knotted tie, deliberately evoking the infamous British criminals the Kray Twins, whom he reportedly both feared and revered.

Bacon was immediately captivated by the dark-haired, handsome stranger who had made the first move. Not long after meeting Dyer, Bacon painted a small-scale triptych, *Three Studies for a Portrait of George Dyer* (1963), which marks the beginning of the couple's relationship – as friends, companions, lovers and, of course, as artist and muse. Dyer's head is repeated across each of the three panels – turned to the left, turned to the right, and in a face-on view – against a shadowy black background. In each iteration he has been painted into life by Bacon's sweeping brushstrokes of red, peach and white which twist his features, blurring the boundaries between abstraction and figuration.

This canvas undeniably shows the influence of Picasso's cubism on Bacon's fragmented approach to portraiture. In fact, the British artist attributed his entire career as a painter to Picasso; he had started out by working as an interior designer, leaving his native Ireland to travel across Europe during the early 1920s. However, in 1927 Bacon was so inspired by a Picasso exhibition at the Paul Rosenberg gallery in Paris that he decisively changed course: 'Picasso is the reason why I paint. He is the father figure, who gave me the wish to paint.'

While the impact of Picasso's style on Bacon has been well documented, the effect of the Spanish artist can also be found in the painter's deeply personal subject matter and models. Picasso's romantic partners – Marie-Thérèse Walter, Jacqueline Roque, Olga Khokhlova, Françoise Gilot and Dora Maar – are the women whose faces appear repeatedly in his most renowned portraits. If Bacon was to truly follow in the footsteps of Picasso, then he too would need a muse.

Before Dyer, he had taken numerous other male lovers as his models. These included the pilot and mechanic Peter Lacy, who was in a ten-year relationship with the artist from around 1952 and appears in several canvases, including the erotically charged *Two Figures* (1953). Within a dark bedroom, two blurred nude figures with short dark hair are found in a primal embrace, one dominating the other on a bed of roughly painted, white crumpled sheets; it hints at the sadomasochistic sex Bacon is known to have engaged in with Lacy.

Bacon was attracted to domineering types. 'A man beyond good and evil who would stop at nothing was also the kind of man whom Bacon, in his active sexual fantasies, most hoped to meet', reflected art historian Michael Peppiatt, also a close friend. Similarly, actor Paul Danquah, who shared a flat with Bacon for over five years, remembered how 'three of Francis's most important boyfriends came out of the East End. He seemed to like people who were bad news. Excessive manhood . . . Masculine in suits, that's what he liked.'

It's no surprise, then, that Bacon was drawn to Dyer, who deliberately played up to the image of the 'gangster'. In many of his portraits, such as *Portrait of George Dyer in a Mirror* (1968), Dyer appears in his characteristically close-fitting suit, white shirt and tie, a vision of constructed hyper-masculinity imagined through Bacon's male gaze. Just as Picasso had drawn attention to the interconnection between sex, love and art through the portraits of his many muses, Bacon had found in Dyer a man who could serve as both sexual partner and the subject of his art: 'Men's bodies sexually arouse me so I paint men's bodies very often, it makes up almost all of my works.'

However, there is much more to Bacon's depictions of Dyer than an emphasis on his sexuality. In *Portrait of George Dyer in a Mirror* the muse stares

into a mirror, positioned on a stand, within which his appearance has been split in two. It's as if Bacon is breaking him open to reveal the man behind the facade of masculinity. As the artist later reflected, Dyer 'could be terribly engaging and gentle. He used to love being with children and animals. I think he was a nicer person than me. He was more compassionate.' Perhaps, then, Dyer did not quite fulfil Bacon's masochistic fantasy; as if Dyer fell short of his expectations, the artist once lamented that his muse was 'too nice to be a crook'.

This fragility is more pronounced in the slightly later *Portrait of George Dyer Talking* (1966), in which the sitter has been stripped bare, with the exception of white underpants. In a full-length portrait, he sits on a swivel stool beneath a bare light bulb in a room painted lilac; with his legs crossed and hands clasped anxiously together. Using broken brushstrokes, Bacon seems to be pulling Dyer apart with paint to apprehend his inner psychology. There is an overall frenetic energy to this canvas, within which Dyer seems to spin restlessly. But beneath his feet is a shadow, rendered in a deep shade of maroon, lying perfectly still; it's as if Bacon is shining a light on the true nature of his unsettled muse and the self which he tried to conceal.

This portrait was based on a photograph, *George Dyer in the Reece Mews Studio* (*c.*1964), taken by *Vogue* photographer John Deakin, a friend of Bacon. Dyer posed for the camera – although looking nervously away from its lens – inside Bacon's notoriously chaotic studio. He was one of very few people whom the artist allowed to enter into this sacred space, and was able to sit still for hours. Nevertheless, Bacon much preferred to work from photographs and, following his death, over a hundred images of Dyer were discovered at the artist's home.

Bacon spoke about his favoured method of working from photographs, particularly when it came to painting the portraits of people he was close to: 'If I like them, I don't want to do, to practise the injury that I do to them in my work before them. If I like them, I would rather practise the injury in private, by which I think I can record the fact of them more clearly,' he told David

Sylvester for *Fragments of a Portrait*, a 1966 BBC documentary. It seems that Bacon, taking into some consideration his sitters' feelings, did not feel able to distort them into such ghoulish visions before their own eyes.

But Dyer would have seen the unflattering portraits, and is reported to have declared his dislike for them: 'I think they are really horrible and I don't really understand them.' It's no surprise when Bacon – just as Picasso had portrayed Maar as *The Weeping Woman* – exposed Dyer in this way, constantly accompanied by uncanny shadows which assume a life of their own.

Bacon was, of course, painting during the post-Second World War era, when British artists began to emphasise themes of alienation and anxiety, and evoke the monstrous capabilities of mankind. However, the mood of unease – forever present in Bacon's portraits of Dyer – also has its basis in a more personal reality. Dyer suffered from anxiety and depression, and turned to alcohol as a means of numbing this pain. Bacon, too, drank heavily and the pair fought frequently. The artist recalled how Dyer became, like many people, 'totally impossible with drink', although recognising that he, too, was to blame: 'I also think that I have a difficult character. I'm a pain. I say the truth even if it hurts. I have the excuse of liking wine, and when I'm drunk, I talk a lot of nonsense.'

Bacon's portraits betray not only Dyer's nature but the pair's increasingly destructive dynamic. In *Portrait of George Dyer Staring into a Mirror* (1967), a suited Dyer, seated on the same unsteady revolving stool again, stares at his own fractured reflection in a sinister black mirror on the wall; seemingly questioning his existence, the relationship with Bacon, his role as muse and even his place in this painting. In each portrayal of Dyer, Bacon plays with shadows, which typically fall at his muse's feet – here, however, the darkness is cast within the mirror, surrounding him on all sides in the ominous reflection.

The recurring motif of the mirror also reflects back the artist's own feelings towards his sitter, a fact that he recognised: 'It's true to say that of course, that when you paint anything you are also painting not only the subject but yourself as well as the object that you are trying to record, because painting is a

dual performance.' His image of Dyer is, then, filtered through his own obsession with this muse and growing anxieties about their unstable connection. This, of course, seems to have been exactly the sort of relationship that Bacon wanted, for the sake of both his sexual and creative needs, as he admitted: 'I feel ever so strongly that an artist must be nourished by his passions and his despairs. These things alter an artist whether for the good or the better or the worse. It must alter him. The feelings of desperation and unhappiness are more useful to an artist than the feeling of contentment, because desperation and unhappiness stretch your whole sensibility.'

Bacon was less interested in depicting a likeness of Dyer than in capturing the toxic energy which they both created. His statement that real friendship consists of 'two people pulling each other to bits' can certainly be found in this vision of their bad romance. It's as if Bacon required such overwhelming emotions, which he could then channel into the melancholic portraits of Dyer.

Just as Bacon seems to have needed a troubled muse, Dyer also enjoyed the protection of his older partner and, at least to begin with, benefited from this relationship. The painter paid him a salary of £60 a month, for posing and doing handyman work, and gave him additional money to add to his wardrobe of tailored suits. Bacon tried to encourage Dyer to find work, too: 'If he'd had any discipline, he could have got a job easily, because he was very good with his hands. I got him something with my framer – he was going to learn gilding, which pays very good money. But he didn't make anything of it. I can understand that it's much more exciting to steal than to go out to a job every day, but in the end he did nothing but go and get completely drunk.'

It seems that Dyer didn't help himself, but he must also have suffered from a lack of confidence; it couldn't have been easy to exist beneath the shadow of the older, successful artist, and in the company of Bacon's art-world friends, many of whom were known to dislike him.

By 1968, the relationship between these two men, who came from such different worlds and generations, inevitably started to fall apart. When Dyer discovered that Bacon was having an affair with another man, he took revenge

by calling the police to tell them that the artist had drugs stashed in an African statue in his studio, resulting in a court case in 1968 – Bacon was eventually found not guilty, but the damage had been done.

Enraged by his muse, Bacon painted *Two Studies of George Dyer with Dog* (1968) in which Dyer is seated in just his white underwear within the same lilac room as in earlier portraits. Once again, Bacon has played with Dyer's shadow – this time it doubles as both Dyer and the police dog in a muddied shade of green and a bitter expression of the artist's anger at his muse. As Bacon recalled, 'At the time of my arrest, and for a long time after, I stayed furious. To release some of the tension, I straight away went to my easel . . . did a large painting. He [Dyer] is sitting on a chair with the nasty flattened police dog at his feet sniffing towards the statue . . . which became George's head.'

Although the romantic relationship between the two men was now over, in 1971 Dyer travelled to Paris with Bacon for the painter's major retrospective at the Grand Palais. Bacon, having admired Picasso for so long, was about to achieve the same level of recognition as the French painter, joining him as only one of two living artists to have been awarded a major retrospective by the museum during their lifetime.

However, two days before the show opened, Dyer was discovered dead from a deliberate alcohol and drug overdose in the bathroom of the Hôtel des Saint-Pères. Given his history of several other suicide attempts, it seems that his depression had become too much to cope with. But was this also a way of getting back at the artist who had moved on? Bacon thought so: 'Think of the timing. Of course it was deliberate,' he whipped in one interview.

Not wanting Dyer's death to overshadow his imminent success, Bacon managed to keep the suicide a secret. Supported by friends, who worked with the French authorities to stop the news getting out, he attended opening night alongside the art world's elite and the president of France, Georges Pompidou. While suppressing the personal news, Bacon would have been confronted all evening long with the image of his late lover, given that Dyer was the star subject of many paintings on show.

While on the surface Bacon seemed unperturbed by Dyer's death, in the years that followed he was agonised about it: 'I feel profoundly guilty about his death. If I hadn't gone out, if I'd simply stayed in and made sure he was all right, he might have been alive now.' This wasn't the first time it had happened to the artist either – just hours before the opening of his solo show at the Tate in 1962, he had received a telegram announcing that Peter Lacy had killed himself. Bacon had played a part in these unhealthy relationships and, in the case of Dyer, funded his alcohol addiction.

Although Bacon had soon moved on from Lacy to Dyer, he now seemed unable to let Dyer go: he continued to paint his late muse, drawing from photos, memories and his imagination, and even returned to stay in the hotel room in which Dyer had committed suicide, as if torturing himself. Possessed by guilt, he painted the triptych *In Memory of George Dyer* (1971) and then a further three, referred to as *The Black Triptychs*, between 1972 and 1974, in which Dyer appears in the moments before, during and after his death.

In *Triptych May–June 1973* (1973), Bacon has confronted Dyer's suicide: the muse appears three times – in the left-hand panel he is crouched naked on the toilet; on the right, he vomits into the sink; and in the central panel he is subsumed by a huge black shadow, which symbolises death. In 1985 Bacon told *The Times*, 'This picture – it is of somebody – a great friend of mine. When I had a show in Paris in '72 he committed suicide. He was found in the lavatory like that and he was sick into the basin. And I suppose in so far as my pictures are ever any kind of illustration this comes as close as any to a kind of narrative.'

In order to represent the horrifying reality of Dyer's death, Bacon once again used symbolic shadows. Here, they loom large, suggesting the iconography of Greek tragedy. In each panel, Dyer is accompanied by a black spectre, evoking the form of the Furies, the three terrible ancient Greek goddesses of vengeance who lived in the Underworld; it's as if he has succumbed to his final and tragic fate.

At the same time, this triple portrait also distils the feelings that Dyer evoked in the artist: guilt, loss, grief. While a candidly autobiographical artwork,

there is a sense that Bacon is playing with the concept of both the tragic muse and the trope of the tortured artist, who has just lost their love. He wasn't the first artist to have done so: Dante Gabriel Rossetti completed *Beata Beatrix* (c. 1864–70), a portrait of Elizabeth Siddall, his wife and fellow artist, following her death. In this ghostly painting Siddall, whose eyes are closed, has been imagined in the character of Dante Alighieri's beloved, Beatrice; Rossetti is drawing a parallel between the Italian poet's despair at the death of his great love and his own grief. Similarly, Bacon, although he had initially hidden Dyer's death, memorialised this tragic event in several of his greatest masterpieces.

The suicide of Dyer has subsequently become a legend, just as did the first meeting between the men about which Bacon had initially lied. The muse's brother, Lee Dyer, thought rather generously that Bacon had concocted the burglar story for the sake of his new boyfriend who wasn't as openly gay as the artist: 'I think personally he may have made that story up because he didn't want to say to my mother how he'd met him.' But surely this man, who wanted to be seen in the same light as Picasso, was also constructing a myth that would secure his reputation as a great artist with remarkable muses of his own. Similarly, in commemorating Dyer's death through art, Bacon was constructing another narrative about the fate of his doomed romantic muse.

But above all, Bacon was motivated by capturing truth rather than fiction on the canvas. As he once declared, 'You can't be more horrific than life itself.' Without doubt, Bacon relied on his romantic muses, and particularly Dyer, for this truth. Fixated on the figure of Dyer during what was the greatest decade of his career, he attempted to distil the aura of this complex man and their fractious relationship through distorted visions in paint. Drawn to the darkness of humanity, Bacon felt compelled to express despair, fear and pain: 'If you can talk about it, why paint it?' he mused; his frightening but beautiful canvases certainly embody the most terrifying aspects of love, the true cost of which is inevitably loss.

'We are all prisoners, we are all prisoners of love, one's family, one's child-hood, profession,' Bacon admitted, accounting for the fact that he could not

fight his own fate, and was pulled towards Dyer whom he painted obsessively
in life and death, until the day that he met his next muse, John Edwards,
in 1974. In each of his living portraits, Dyer appears as a split character,
accompanied by darkness and one half of a volatile relationship with Bacon.
Within the final portraits, Bacon struggles to exorcise his sense of loss, as well
as guilt, at the suicide of the great romantic muse whose shadow he could
never quite escape.

LAWRENCE ALLOWAY
The Critic Stripped Bare

I had noted from my childhood,' said feminist artist Sylvia Sleigh, 'that there were always pictures of beautiful women but very few pictures of handsome men so I thought that it would be truly fair to paint handsome men for women.'

During the 1960s, Sleigh shocked the art world with her hyper-realist portraits of naked male bodies. Turning the tables on art history, she substituted nude men for the reclining, undressed women traditionally seen in masterpieces, painted by the likes of Peter Paul Rubens or Gustave Courbet. Today, she is celebrated for challenging such gendered stereotypes with her subversive images. But who were these male muses? Were they complicit in her feminist intervention? What did they think of these provocative paintings?

Between 1934 and 1937, Sleigh studied at Brighton Art School in Sussex, where she specialised in painting. Early on, she was outraged to discover that the art education system was steeped in sexism; distinct double standards meant that only female nudes, not male ones, were allowed to pose as life models, and she later recalled how female art students were 'treated in a second-rate fashion'.

In 1941, Sleigh married a local painter and art history lecturer, Michael Greenwood. Suffering a crisis in confidence as an artist – there are rumours that Greenwood undermined her practice – she stopped painting. Moving to London, she worked instead in a women's clothing store on Bond Street, dressing prestigious and celebrity clients, including Hollywood icon Vivien Leigh. Back in Brighton, Sleigh opened her own shop, and enjoyed some success until it was forced to close at the outbreak of the Second World War.

Although the married couple remained together for thirteen years, they often lived apart. Leaving Greenwood behind in London, Sleigh spent much of her time in the small village of Pett in Sussex. Here, she began to start

painting again, and attended life-drawing sessions. In 1943, she also decided to attend an evening art history class, at the University of London, which changed the course of her life for ever.

It was at this art history class that Sleigh first met Lawrence Alloway. Aged twenty-seven, she was ten years older than the seventeen-year-old who was just beginning to make a name for himself, as a critic and curator of contemporary art. From the very start, the pair were emotionally and intellectually drawn to one another, and, as her marriage deteriorated over time, Sleigh's connection with Alloway developed from close friendship to romantic relationship.

Following her eventual divorce from Greenwood in 1954, she married Alloway, within just months. In 1961, the couple emigrated to New York, where Alloway took up the role of senior curator at the very recently built Guggenheim Museum, looking after its great collection of modern art by Marc Chagall, Joan Miró and Piet Mondrian, amongst others.

Relocating to America was also the best thing that Sleigh could have done for her artistic career. Arriving in New York, she encountered second-wave feminism, which was surging across the city. In 1963, Betty Friedan's bestseller *The Feminine Mystique* appeared on bookshelves. Friedan had interviewed fellow college classmates, now stay-at-home mothers, and discovered how unhappy many of them were: 'Each suburban wife struggles with it alone. As she made the beds, shopped for groceries, matched slipcover material, ate peanut butter sandwiches with her children, chauffeured Cub Scouts and Brownies, lay beside her husband at night – she was afraid to ask even of herself the silent question – "Is this all?".'

The problem, Friedan argued, was the notion of 'the feminine mystique'. Women were expected to dream of becoming mothers and wives, but what if they wanted a professional career? The writer set out her manifesto: 'The only way for a woman, as for a man, to find herself, to know herself as a person, is by creative work of her own.'

Writers, including freelance journalist Gloria Steinem, took up the fight against sexism. Steinem famously went undercover as a Playboy Bunny,

spending eleven days in Hugh Hefner's New York Playboy Club. Her article, 'A Bunny's Tale', published in *Show* magazine, exposed the rampant sexism and dehumanising objectification that Bunnies suffered.

In the visual arts, Faith Ringgold led a group called the 'Ad Hoc Women Artists' Committee' who, in 1970, left hens' eggs and sanitary products in the Whitney Museum, with the words '50 per-cent' written on them, demanding that 50 per cent of artists in the upcoming biennial that year be women. Painting her eggs black, Ringgold also drew attention to her identity as a Black female artist, creating a much-needed dialogue, and asking for intersection, between feminism and the civil rights movement.

Having long felt the injustices of a patriarchal art world back home in Britain, Sleigh assumed a leading role in New York's growing and active feminist art scene, where she found acceptance and purpose: 'Feminism gave us this intense freedom of expression thus allowing a change. Anything that helps to express the artist's ideas, whether it is to surprise, glorify, shock or simply express a philosophy will lead to a change or will simply allow an opportunity for change.' Sleigh was a founding member of the all-women artist's cooperative SOHO20 Gallery. She also co-founded A.I.R. Gallery, America's first gallery run by women for women, providing an exhibition space for professional female artists: 'At a certain point I realised what my mission was. And that was to help women, to stress the importance of equality.'

During the mid-1960s, Sleigh's feminist convictions began to infiltrate her paintings – of nude male figures. She depicted her models in domestic interiors, reclining on beautifully patterned sofas and chairs, or looking at themselves in the mirror. Sleigh was deliberately, and defiantly, taking on centuries of art history, in which women had been painted naked for men to gaze upon.

In museums around the world, you will find celebrated masterpieces in which men are clothed but women's bodies are exposed. Black and Indigenous women are often objectified, fetishised as an exotic 'other' to fulfil unspoken fantasies of the male viewer; on the other hand, white women are frequently

depicted as sexualised and desired; their pale skin instead depicted as inviting the touch of an artist.

Hanging in the Musée d'Orsay in Paris, for example, is Édouard Manet's impressionist painting, *Le Déjeuner sur l'herbe* (1862–63). Set within idyllic woodland, a group gather around a picnic; both of the male guests are smartly dressed, in jackets and ties, whilst their white female companion is completely naked. In the background, a second pale-skinned woman bathes in a stream, her sheer white dress leaving very little to the imagination.

Another famous painting from art history featuring the white female nude is Diego Velázquez's *Rokeby Venus* (1647–51). Venus, the Roman goddess of love, is reclining, nude, on a bed. Her son Cupid holds up a mirror in which she admires her sensual reflection. Across the frame of this mirror are draped pink ribbons, alluding to the fetters which Cupid would use to bind lovers together, and serving to enhance the erotic atmosphere of the painting.

Many art historians have now critiqued the ways in which male artists painted women to be looked upon as objects of desire. As the art critic John Berger wrote in his seminal book *Ways of Seeing* in 1972, 'You painted a naked woman because you enjoyed looking at her, put a mirror in her hand and you called the painting "Vanity," thus morally condemning the woman whose nakedness you had depicted for your own pleasure.'

Then in 1975 Laura Mulvey, a feminist film theorist, coined the term 'the male gaze'. In a groundbreaking essay titled 'Visual Pleasure and Narrative Cinema' she argued that traditional Hollywood films represent women as sexual objects, positioned for the pleasure of the heterosexual male viewer. As Mulvey wrote, women are characterised by their 'to-be-looked-at-ness' and 'spectacle', while man is 'the bearer of the look'.

Even before the arrival of these theories and texts, however, Sleigh made a significant first step in calling out the sexist objectification of women in art. Turning her female gaze on the male nude, she confronted portraiture's gender imbalance. She deliberately reworked recognisable, famous paintings by replacing naked women with male models: 'It was very necessary to do

this because women had often been painted as objects of desire in humiliating poses. I don't mind the "desire" part, it's the "object" that's not very nice.'

In 1971 Sleigh painted her own provocative version of Velázquez's *Rokeby Venus*. In *Philip Golub Reclining*, the graceful, twenty-something son of artists Nancy Spero and Leon Golub is seen sprawled naked on a sofa. He gazes upon his beautiful body in a large wall mirror. In its reflection, Sleigh has also included herself, seated at an easel, scrutinising her subject in a clever and overt reversal of the traditional male–female roles associated with art history.

However, Sleigh was adamant that she had no intention of humiliating or objectifying men: 'In the '60s I made a point of finding male models and I painted them as portraits, not as sex objects, but sympathetically as intelligent and admired people, not as women had so often been depicted as unindividuated houris.'

Many of Sleigh's models were close friends – artists, writers and musicians – who both she and her husband welcomed into their bohemian New York home. Rather than idealising them, Sleigh captured the beauty of these men by including distinguishing features, from body hair to birth marks; at other times, she incorporated still-life objects, such as books or musical instruments, that pointed to her sitters' unique personalities and talents. 'I paint people whom I like or love . . . The human situation adds a certain poignancy to portraits.'

One of Sleigh's most frequently painted and clearly recognisable muses during the 1970s was Paul Rosano, whom she had first met while he was working as a life model at the School of Visual Arts. He's immediately identifiable for his tall, slim build, his casual style – he often wore cut-off denim shorts and flip-flops – and his full Afro hairstyle. The Black disco scene had popularised the Afro, particularly among musicians like Rosana, who Sleigh frequently pictured with his guitar.

In 1974, she painted *Paul Rosano: Double Portrait* in which her model surveys himself in the mirror, and can be seen, by the viewer, from several angles. Sleigh painted this three-quarter-length portrait in exquisite and explicit detail,

including the shadows of Rosano's ribcage, marked tan lines, and the trailing patterns of his dark pubic hair.

One year later, Rosano's provocative portrait was included in a Bronx Museum exhibition hung in the Bronx County Courthouse, 'The Year of the Woman', where it created significant controversy. One of the county's leading judges, Owen McGivern, took great offence at the image, and demanded that the entire exhibition be cancelled because of the 'explicit Male nudity'.

Sleigh responded to this attempt at censorship with a frank and pointed public statement: 'I wonder if the judge would object to a female nude (hung in the show) . . . I don't see why male genitals are more sacred than female.' Judge McGivern's complaint was dismissed, and Sleigh's painting remained on show. The incident only served to further illuminate the sexism and double standards of art history, drawing attention to, and confirming the need for, Sleigh's feminist cause.

Another of her most notable paintings, in which Rosano also appears, is *The Turkish Bath* (1973). With this artwork, she reworked the erotic, nineteenth-century painting of the same title by Jean-Auguste-Dominique Ingres, in which he depicted a room filled with dozens of nude women who recline around a pool, their tangled limbs offering up an erotic fantasy for the male viewer.

Sleigh replaced Ingres's anonymous crowd of female bathers with her more personal take on the subject. She pictured five of her close male friends: Rosano, seen playing the guitar, the artist Scott Burton, and art critics John Perreault and Carter Ratcliff. This painting also includes Sleigh's most important model and muse: reclining in the foreground, and looking directly at the viewer, is her husband, Lawrence Alloway.

It was not long after Sleigh first met Alloway, at the art history class back in England, that she started to use him as a model for her paintings. An early work, *At the Café* (1950), shows the couple seated together at a train station café. There is a formality to the scene, in which Alloway wears a jacket and bow tie, and Sleigh a black dress, with white pearls and a hat. However, there

is a knowing intimacy between them: their arms, leaning across the tabletop, touch and, as their hands disappear from view, it seems likely that they are secretly linked.

Sleigh painted this picture while she was still living in Sussex, and married but estranged from her first husband, Michael Greenwood. She later explained that the double portrait 'commemorates the many times that I had to leave Lawrence and return to Pett . . . Many times when he took me to the station we went to a café while waiting for my train.'

During this time, Sleigh and Alloway began to write tender, heartfelt letters to one another. Some are typed, in neat lines of formal font, with news clippings attached. Others are handwritten, filled with poems, pen-ink drawings and pencil sketches. The couple continued to correspond in this manner throughout their marriage, particularly while travelling independently of one another. These letters reveal the couple's connection as romantic, emotional and intellectual partners: 'I love you, madly, intellectually, impulsively, constantly,' wrote Alloway to Sleigh in 1949. They also highlight his role in Sleigh's creative life; among the repeated terms of endearment, she constantly addresses him as her muse: 'Dearest Lawrence, thank you for your love, it is so important to me, you are my muse indeed; and I love you so well, dear love, adored poet. A golden vision of you always accompanies me; my Apollo. I love you, Sylvia.'

Given Sleigh's gender-swapped paintings of the nude, it makes sense that she perceived of, and directly referred to, Alloway as her muse, reversing the stereotype of the female muse and male artist. Apollo was the Greek god of music and arts, and became a common term of endearment she continually used to reference the inspiration he provided for her.

Sleigh painted over fifty portraits of Alloway, who is characterised by his blonde hair, bright blue eyes and contemplative expression. In the painting *Portrait of Lawrence Alloway* (1965) Sleigh has caught her husband deep in thought, staring into the distance, while sitting on an iconic red Arne Jacobsen Egg chair. His grey shirt is casually unbuttoned to reveal his chest and a book lies beside him on the floor.

Sleigh also painted him naked on many occasions, lying in bed, or reclining on the sofa. However, far from reducing him to an object of desire, she was capturing intimate moments, in which he appears relaxed in their home. She frequently framed him with the background of their Chelsea town house, including modernist furniture and floral William Morris wallpaper, exhibiting the couple's mutual interest in modern art and design.

Many of Alloway's letters to Sleigh demonstrate their shared love of art. Alloway would send Sleigh postcards of celebrated paintings from museums he visited, such as the Louvre in Paris, or post invitation cards for gallery shows. In lengthier correspondence, he would include detailed discussions on art history, drawing parallels to, and praising, his wife's paintings: 'I adore your painting. The synthesis of the different rhythms of growth is wonderful. The summer-snow of the blossom, the exquisite tone of the upper trunks on the blue sky, is so delicate and yet impetuous too,' he wrote in a letter dated 22 December 1948.

In another letter, he tells Sleigh: 'I have been looking at your paintings again – with what pleasure I need not tell you. I was passing your Venus when I simply had to stop and examine the delicious, sensuous, felicitous brush-work.'

Alloway's admiration for Sleigh as a painter is also apparent in the love poems he wrote, and included in letters, to her:

> *Today when the clouds are exact*
> *Like Rene Magritte weather*
> *I think of you my loving*
> *Double and double-dealer*
> *At the game of likeness*
> *On the shore where formerly*
> *I was your foreground figure*
> *The cliffs and complicated greyness*
> *The slanted shore, the shells*
> *(I have their doubles here)*

Are doppelgangers on
The canvas where your brush
Records its double function
To please and possess.

Poems like this also demonstrate how Alloway revelled in his role as muse, as the 'foreground figure', for his wife's paintings.

In more playful letters, Alloway included sketches of an alter ego, Dandylion, which he'd created. The half-human, half-lion cartoon is seen engaged in everyday tasks, from reading and writing to sleeping and sunbathing. In a letter from 1950, Alloway notes how Dandylion's 'tail curled up with pleasure' while reading a note from Sleigh. In another, dated 6 October 1948, he shows him working at a typewriter: 'Dandylion wants you to see him at work.'

Behind the comic cartoons, Alloway was a deeply intelligent man. As a curator and critic, he favoured contemporary art that pushed boundaries. Back in London, he had started his career at the forward-looking Institute of Contemporary Arts, serving as assistant director from 1955 to 1960. In New York, he became an advocate for abstract art and 'pop art', a famous term which he coined.

Sleigh's feminist activism also positively influenced Alloway, who became an ally to the feminist art movement and promoted women's art across America. In 1977, he called out the '3-to-1 advantage' of men over women in the Whitney Annual, becoming the first male critic to publicly endorse the claims made by female artists; then, in 1979, he wrote the notable article 'Women's Art and the Failure of Art Criticism' in 1979.

Although Alloway supported female artists, he never wrote publicly about, or directly promoted, his wife's work. One reason for this, certainly, is that he would have been considered biased – we only have to look at his letters to see his overwhelming praise of Sleigh's painting style. However, perhaps Alloway also recognised the importance of staying silent. A highly intelligent man, steeped in a knowledge of art history, Alloway understood the significance of Sleigh's gender-swapped paintings.

Surely, then, Alloway realised that he could allow her the most power by posing, compliantly, as her naked male subject. By taking on the role of muse, not critic, he was actively supporting her subversive paintings and feminist statement. His silence also ensured that Sleigh, not he, was given the spotlight. It was not his place to say what she had so eloquently stated in her paintings.

If we return to Alloway's inclusion in the Turkish bath, we can see him posed prominently in the foreground. He looks outwards, seemingly at us the viewer. But, if you think about it, he would actually have been looking at his wife. As an art historian and critic, Alloway fully understood the importance of these paintings; held within this glance is his support, endorsement and validation for what she was doing – taking on centuries of sexist paintings.

After Alloway died in 1990, Sleigh continued to paint for a further two decades. In 1999 she finished a gargantuan, mural-size painting, which took her twenty years to complete: *Invitation to a Voyage: The Hudson River at Fishkill (Riverside)* (1979–99). The celebratory work consists of fourteen panels, each eight feet tall by five feet wide, in which she portrayed herself and Alloway spending time with their friends – artists and critics – painting, talking and picnicking in woodland, by the banks of the Hudson River.

This painting is Sleigh's feminist spin on Manet's *Le Déjeuner sur l'herbe*. She exchanged Manet's nude women for clothed female friends who are engaged in conversation with their male counterparts. Sleigh always maintained that her utmost goal was to create equality in her paintings, and the art world: 'I wanted, above all, to express the equality of men and women.'

With *Invitation to a Voyage: The Hudson River at Fishkill (Riverside)*, Sleigh undoubtedly achieves her aim, while also paying enormous tribute to her husband, Lawrence Alloway, who was a loyal ally to her cause. Fully committing to the role of muse, Alloway used it to reimagine gender stereotypes – particularly within the outdated structures of the art world – legitimise his wife's work, and transfer all power to her in a true act of love.

GALA DALÍ
Queen of the Castle

Hanging in the Thyssen art museum in Madrid is Salvador Dalí's surrealist masterpiece *Dream Caused by the Flight of a Bee around a Pomegranate a Second before Waking* (1944). Suspended in a watery landscape a naked, sleeping woman lies with both arms behind her head. She floats above a grey rock and is surrounded by hovering elements from her dream: two drops of water, an elephant on long stilt-like legs, two pouncing tigers, a pomegranate and a buzzing bee.

As one of the most iconic images of surrealism, Dalí's painting epitomises the cultural movement's emphasis on the subconscious, dreams and desire. It also demonstrates the surrealists' obsession with, and reliance on, the female muse. While the movement's male artists have been much critiqued for fragmenting and fetishising women's bodies, which they treated as sites of erotic desire, they also celebrated the irrationality of great romantic love, seeking out and taking inspiration from real-life partners, many of whom were also artists.

Among the most significant romantic muses of surrealism, and asleep in Dalí's painting, is Gala Dalí. Today, she has been overlooked, misrepresented and even defamed within many art historical narratives, in which she has been referred to as a 'demonic dominatrix', and cast as a money-grabbing monster. But, if we awaken Gala, will we find that such accusations and insults are well-deserved? Why did she gain such an awful reputation? What was the real role she played as a romantic muse in the life of those artists she inspired?

Born Elena Ivanovna Diakonova to a family of Russian intellectuals in 1895, Gala was given her nickname by the poet Paul Éluard, whom she met in a Swiss sanatorium where they were both recovering from tuberculosis as teenagers. Aged seventeen, Gala was a strong-minded and independent young woman and, following her engagement to Éluard, she moved away

from her family to Paris to embark on a new life with him and their daughter, who was born shortly afterwards.

Early on, Gala inspired her husband to write numerous love poems, including 'Woman in Love' and 'The Curve of Your Eyes', with which he built his reputation as a writer. Far from simply existing as the subject matter of her husband's work, she also acted as a critic and champion, and even wrote the preface to one of his earliest books, *Dialogue des inutiles* (1914): 'Do not be shocked that a woman – or rather, a stranger – is presenting this little volume to the reader,' she declared, albeit under a pseudonym. 'She decided to play an invisible role even if that role was important,' explains the art historian and curator Estrella de Diego.

As a founding member of surrealism, Éluard introduced his magnetic wife to artists in the group, encouraging partnerships – both artistic and romantic – between her and other surrealists. Fully immersing herself in the movement, Gala soon became a significant subject in the work of Man Ray as well as Max Ernst, with whom the couple lived in a *ménage à trois* for three years. In his closely cropped oil painting *Gala Éluard* (1924) Ernst, who worked collaboratively from a photograph by Man Ray, has depicted Gala's wide brown eyes framed with dark lashes, above which strange objects seem to unfurl from her mind.

Across photographs and paintings, Gala became the face of surrealism, her intense dark eyes acting as a symbolic window into the unconscious mind. The surrealists were inspired by the writings of Sigmund Freud and, as their leader André Breton set out in the founding manifesto of 1924, were committed to the 'resolution of these two states, dream and reality, which are seemingly so contradictory, into a kind of absolute reality, a surreality'. Wide-eyed and named in the title of this work, Gala is imagined not as a passive sitter, but as an active and recognised participant in the surrealists' explorations into inner realities, for which they were dependent on female muses for inspiration.

Similarly, in his enigmatic portrait *Au Rendez Vous des Amis* (1922), Ernst portrays Gala as an involved member of the group. The viewer encounters

fifteen surrealists, alongside the historical figures who inspired them: Ernst sits on Dostoyevsky's knee, surrounded by Éluard, Breton and Giorgio de Chirico, among others. Standing among these men, and staring out at the viewer, is the only woman: Gala. Wearing a pleated long mauve dress with her dark hair pinned back, she is a decisively feminine presence within the group, pictured both on equal terms with, and acting as the accomplice to, her male counterparts.

While Gala had already become an impressive force and critical presence within the movement by the early 1920s, she was yet to meet the artist with whom she would strike up the most significant creative collaboration. Once again, it was her husband who made the introduction. During the summer of 1929, Gala joined Éluard on a trip to the Catalonian town of Cadaqués to meet a young, emerging Spanish painter, then working on the periphery of surrealism: Salvador Dalí.

Following her visit to Spain, Gala started an affair with Dalí, which Éluard must have thought would be a temporary liaison, much like the earlier fling with Ernst. This relationship, however, was far from fleeting. As Dalí later wrote, 'She was destined to be my Gradiva, the one who moves forward, my victory, my wife.' Gala soon abandoned her now successful, wealthy husband for the penniless artist, swapping her chic Parisian flat for a fishing village in Spain. Many must have been surprised by her actions at the time, not least Éluard, but Gala was on a mission of her own.

We often think of artists choosing their muses, yet in the case of Gala, it was distinctly the other way round. Not only was she interested in Dalí as a romantic partner; Gala had also spotted talent that needed nurturing. Here was an opportunity for her to assume even greater responsibility in the sur-realist movement than she had already achieved, as Dalí's dominant muse. Over the next sixty years, he painted Gala – who became his wife in 1932 – hundreds of times. The themes of love, desire and worship came to dominate Dalí's paintings, in which Gala appears as various mythological goddesses and the Madonna.

Most often, Dalí painted Gala as herself, frequently from behind as he loved the shape of her back. In the iconic image *My Wife, Nude, Contemplating Her Own Flesh Becoming Stairs, Three Vertebrae of a Column, Sky and Architecture* (1945) Gala is seated, facing away from the viewer, nearly naked, with a white cloth draped only across her lap to reveal her strong, slim back. Staring at a dreamlike landscape in the distance, she looks upon a duplicated image of herself; however, this second surreal body is formed from strong stone columns and a staircase.

Dalí reflected on the metaphor of Gala as an architectural palace: 'I would polish Gala to make her shine, make her the happiest possible, caring for her more than myself, because without her, it would all end.' He recognised his wife's strength, made visible in the image of her as a solid structure, which infused their relationship: 'Gala became the salt of my life, the steel of my personality, my beacon, my double – ME. Henceforth there were Dalí and Gala united for eternity.'

By this time, the artist had started to use the signature 'Gala Salvador Dalí' on many of his works: 'In signing my paintings "Gala–Dalí" I was simply giving a name to an existential truth, for without my twin, Gala, I would not exist any more.' Through this mutual signature, Dalí recognised Gala's critical contribution to his creative output. In contrast to so many artists throughout history, who have failed to acknowledge the hands of their wives in the production of their work, Dalí outwardly declared the shared endeavour between artist and muse by naming her.

Nowhere is the Gala–Dalí collaboration clearer than in a series of black-and-white photographs of the couple working on a pavilion titled the *Dream of Venus* for the 1939 World's Fair in New York. These pictures demonstrate Gala's artistic input, alongside a team of fabricators, in devising the design of this sensational surrealist attraction; the site was turned into a spectacular dream, filled with models dressed as pianos, lobsters and mermaids.

While Gala had worked with artists before, with Dalí she found she could, to a much greater extent, exert her influence in a whole manner of ways.

Beyond working on artworks with him, Gala acted as her husband's agent, promoting his work widely and negotiating contracts with commercial galleries. She was such a confident businesswoman that the artist Giorgio de Chirico asked her to become his agent, too. That Gala navigated all of this, in such a male-dominated society, is testament to her ambition and determination for the Gala–Dalí brand.

Her growing power did not go unnoticed: the surrealists' leader, Breton, began to see her as a rival, resenting her relationship with and influence over artists in the movement. It's clear that he was threatened by this woman. It's true that Gala was certainly difficult at times; Dalí referred to her as 'Lionette', explaining that 'when she gets angry she roars like the Metro-Goldwyn-Mayer lion'. Some of her behaviour was undoubtedly deplorable – she is known to have asked Dalí to sign thousands of blank sheets on which forgers created fake Dalís, which she subsequently sold for huge sums of money.

Gala is also known to have had numerous extramarital affairs with younger men, many of them also artists, throughout her open marriage to Dalí. Much has been written about Dalí's complex relationship with sex and it is widely believed that he derived gratification from watching Gala sleep with other men, rather than engaging in it himself. As he said, 'I tried sex once with a woman and it was Gala. It was overrated.' Dr Zoltan Kovary, a Hungarian clinical psychologist, has even posited that she took on the role of Dalí's mother: 'Gala sometimes called Salvador, "my little son". They never had a "real" sexual relationship,' said Kovary. 'Dalí, although Gala raised deep desires in him, had fear of physical contact.'

Although Kovary's reading is extreme, what is certain is that Gala was awarded a huge amount of control in her marriage to Dalí, which has sparked criticism. In a 1998 essay for *Vanity Fair*, art historian John Richardson labelled her an 'ancient harridan', a 'demonic dominatrix' and 'one of the nastiest wives a major modern artist ever saddled himself with'. These gendered insults say more about his misogyny than about Gala herself, and it's a position perpetuated by art historical narratives, which have turned on her,

attacking her for qualities celebrated in men. Not fitting within the trope of the passive romantic muse, perpetuated by art history for far too long, she became a threatening figure to many.

Feminist art history, too, has somewhat excluded Gala from many of its discussions on surrealism. The movement attracted many women to its ranks, and much has been written about those female muses who were also artists: Dora Maar, Leonor Fini, Frida Kahlo and Lee Miller, among others. Art historians like Whitney Chadwick have brought to life surrealism's women, reasoning that they subverted surrealism to present themselves as the muses of their more complex, layered self-portraits, and thus further their own creative careers.

These women surrealists were undoubtedly using their practice to challenge male artists' portrayal of them. Many of the male surrealists depicted women as idealised sexualised beings, often faceless *femme-enfants*, distorted and doll-like (most famously Hans Bellmer, who constructed life-sized pubescent female dolls). In contrast, these female artists put themselves back together; looking within themselves, as the source of their own inspiration, they fashioned fantastical costumes and presented themselves as enchanted beings, merging the image of feminine muse and maker.

However, if we consider Dalí's paintings of Gala, he also positions her as both an inspiring and creative force. In *My Wife, Nude, Contemplating Her Own Flesh Becoming Stairs, Three Vertebrae of a Column, Sky and Architecture*, he celebrates Gala as a thinking being who looks upon the imagined ivory tower-like vision – it's as if she has dreamt or conjured it up herself. Far from presenting her as a simplified *femme-enfant*, Dalí treats his romantic muse in sacred terms and the empowered protagonist of this narrative.

Of course, it's easy to see why Gala is sometimes forgotten in feminist narratives of art history, which have either underestimated or critiqued her role as an ally to the movement which was in many ways misogynistic. In contrast to numerous other female surrealists, Gala seems content to have worked with and through multiple male artists, at times acting as a silent partner. However, in Dalí she found an artist who declared, in the co-signed works, her immense

contribution. Perhaps, too, he portrayed her as she would have chosen to present herself, elevating her to the status of goddess, recognising the potency of her own imagination, and defining femininity as a source of strength; as such the 'Gala–Dalí' labelled artworks can be seen as her self-portraits.

It's obvious that Gala embraced, rather than resented, the responsibilities of being an artist's muse. She committed to this role fully – even, in effect, abandoning her own daughter for it. In a 2014 interview, Cécile Éluard said of her mother, 'After she met Dalí she was not interested in me anymore. She was never very warm [. . .] she was very mysterious, very secretive. I never got to meet my Russian family. I didn't even know when exactly she was born.' Cecile, who went to live with her paternal grandmother in Paris, saw her mother just once or twice a year. Like 'great' artists, 'great' muses too have behaved deplorably in their personal lives, serving art above all else.

Gala's unwavering commitment to Dalí, and their shared endeavour, was matched by his dedication to her; this is evident in the artist's reverential paintings of his surrealist heroine. Not only did he repay her in immortalising artworks in which she is the focus; in 1969, Dalí bought Gala an incredible gift – a gothic castle, located in the Catalonian village of Púbol. Remodelling and renovating the derelict castle, Dalí curated a final homage to his muse, furnishing it to her taste, complete with a throne by its entrance, and the letter G, for Gala, adorning the ceilings with romantic decoration. As he explained:

Everything celebrates the cult of Gala, even the round room, with its perfect echo that crowns the building as a whole and which is like a dome of this Galactic cathedral. When I walk around this house I look at myself and I see my concentricity. I like its moorish rigour. I needed to offer Gala a case more solemnly worthy of our love. That is why I gave her a mansion built on the remains of a 12th century castle: the old castle of Púbol in La Bisbal, where she would reign like an absolute sovereign . . .

In this light, Dalí's earlier painting, *My Wife, Nude, Contemplating Her Own Flesh Becoming Stairs, Three Vertebrae of a Column, Sky and Architecture*, in which Gala looks upon her second self, imagined as a palace, seems to foreshadow the artist's present to her. Gala's response to this gift also sums up

the power dynamic in their relationship: 'I accept, with one condition, which is that: You only come to visit me at the Castle on invitation. I accept, since I accept everything in principle, on condition that there are conditions. It is the same condition as courtly love.'

In the 1970s, Gala moved into the castle and, when invited by hand-written invitation, Dalí visited her there. When she died in 1982, Dalí was heartbroken: he buried her in the castle, within a crypt designed to resemble a chessboard, thereby honouring her within an artwork once again. This was the ultimate mausoleum for his muse, to whom he was devoted, to the point of subservience. Utilising and exploiting the idea of the romantic muse for her own means, Gala perceived and earned the privilege associated with it.

If we consider Dalí as synonymous with surrealism, we should do the same with Gala too. She was the strong romantic lead for many of the movement's artists, sharing and shaping their lives. Most significantly, she committed to Dalí, acting as agent, champion, inspiration, creative partner and the pro-tagonist of his paintings. In return, he openly acknowledged the agency of his muse – unlike many male artists, and narratives, across history. Nowhere is Dalí's gratitude reflected more than in the gift of this castle, fit for a queen.

PERFORMING MUSE

MORO
Homemade Sushi

Nyotaimori, translated as 'female body arrangement', is the Japanese tradition of eating sushi from the skin of a naked woman. Rolls of raw fish and edible seaweed cover the completely shaved model, who must lie perfectly still and silent, sometimes for hours at a time. The practice has its origins in the Edo Period, when these human platters would be offered in geisha houses to victorious Samurai warriors returning from battle.

In 2010, Chinese artist Pixy Liao took this sensual sushi tradition and turned it on its head. In the photograph *Homemade Sushi*, Liao has framed her dark-haired Japanese boyfriend, Takahiro 'Moro' Morooka, lying motionless and naked on his front, arms by his side, on a stripped white bed. Beneath him is a bundle of strategically folded bedding, which has been bound to his body with a ribbon of green mesh to evoke the appearance of seaweed. Liao's model, who looks directly at the camera, has been transformed into a life-sized sushi roll.

Homemade Sushi belongs to a wider series, entitled 'Experimental Relationship', in which Moro is seen in a variety of vulnerable poses, either half or fully naked, in the couple's home or hotel rooms, with natural light falling through windows to illuminate the scenes. Liao uses photography to explore her personal relationship with Moro, who is five years younger than her and the more submissive partner – a fact they both acknowledge.

In each of the staged images Moro, who refers to himself as a 'house husband', appears acquiescent to the more autonomous artist. At times, Moro appears alone – in one photograph he wears only a blue T-shirt, which clings to a silver railing by a wooden hanger, making him appear to dangle in front of the camera. In others, Moro is held, carried by or even draped across the shoulders of his petite girlfriend, who sports a short, sharp bob of black hair. Frequently, she is clothed; he is not.

The couple met while studying at the University of Memphis. In fact, it was on their very first day – at an orientation for international graduate students – that Liao recalls first seeing her muse-to-be: 'Moro left a deep impression on me when I saw him. Not knowing where he was from, I only knew he was a music student at that time. He attracted me.' Liao and Moro's meet cute echoes legends of art history in which male artists choose female models for their beauty.

One year later, Liao ran into Moro again on campus and immediately asked him to be her model, revealing, 'It was only my excuse to know him.' Moro agreed and she began to photograph him for various university projects. However, responses from fellow students and staff took the artist somewhat by surprise: 'It was not until my classmates and teachers wondered how it was possible for a boyfriend to pose so willingly for my photos, sometimes naked or in very unflattering situations, that I realised that our relationship was uncommon to other people.'

From this point, Liao began to use photography to examine their atypical romantic relationship, in which the woman is the dominant, agentic partner. As the artist has shared, her photos 'explore the alternative possibilities of heterosexual relationships . . . What will happen if man and woman exchange their roles of sex and roles of power?' Nowhere is the couple's inverted dynamic clearer than in *Homemade Sushi* in which Moro acts as a piece of raw fish to be consumed by the female photographer on the other side of the lens.

Liao reflects that her photographs are, in part, a 'rebellion against the society I'm living in'. The idea of a younger and more submissive male partner in a heterosexual relationship is still considered unusual in Western culture; but the couple's relationship contrasts even more sharply with the expected partnership between a man and woman in China: 'In China, it's common for men to be older and women younger in a heterosexual relationship. In a family, the husband is usually the head of the household and the wife takes care of the domestic affairs.' Given her heritage and upbringing, Liao 'always thought' that she 'needed to find a boyfriend or husband who was older and more mature, who would also act as a life mentor.'

In *Relationships work best when each partner knows their proper place* (2008), Liao is clearly subverting the expectations of Chinese culture: the couple stand next to one another in front of three windows shuttered by white blinds. While Moro wears only white underpants and sandals, Liao is fully dressed – in a smart red blouse, pinstriped trousers and red shoes. Moreover, while Moro stands still and looks at his partner, she extends her right hand, with painted red nails, to pinch one of his nipples.

In such erotically charged photographs Liao confronts patriarchal images from art history, too. This image was inspired by the famously odd painting *Gabrielle d'Estrées et une de ses sœurs* (*c*.1594). The anonymous masterpiece portrays two women, Gabrielle d'Estrées, mistress of King Henry IV of France, and her sister, sitting in a bathtub and naked from the waist up; they half-turn towards the viewer, who can see the hand of the woman on the left pinching the nipple of the woman on the right.

In parallel with the painting, Liao has framed the viewer in a deliberately voyeuristic position, offering them an insight into this intimate moment. However, there is a clear distinction between Liao's version and the original artwork: in her photograph, it's the male sitter who has been turned into a sexualised object, touched by his female partner. Liao protests art history's conventional representation of females as passive sites of desire to be painted by male artists, which conceptualises and reinforces expected gender roles.

Liao has also set the scene up as a piece of comedic performance; a long-handled red dustpan stands to Moro's right, adding a droll and playful tone to the photograph. 'Humour is one of the key elements in my photos because I have to enjoy the process in order to work. But I also think that humour is a powerful tool.' As with all of the best jokes, she uses comedy to confront taboo topics and uncomfortable truths. If we return to Moro dressed as a sushi roll, Liao is attacking the sexist tradition of *Nyotaimori*, in which women become a dressed table from which guests dine; she is simultaneously challenging stereotypes of Asian culture, which are packaged up and sold to Western consumers.

Liao's photographs are undeniably performative, and Moro is active in the dramatic process. As he has explained: 'Pixy usually has the basic idea of an image first, like plots, framing and how we pose. But from there, we usually improvise based on the first idea.' Through playful props, exaggerated costumes and make-up – particularly red-painted nails, which Liao often models – Liao articulates to the viewer that these photographs are somewhat constructed in their exhibitionism. 'Experimental Relationship' is quite evidently a parody of domestic bliss, in which a woman is the homemaker, creating a warm and tidy space for her achieving husband to return to.

However, Liao's images are also poignant; they tread a fine line between truth and theatricality. Liao sees the works as a legitimate exploration of her personal experiences and 'a notebook of my thoughts on intimate relationships'. The physical closeness between artist and model in the images elucidates the depth of feeling Liao has towards her boyfriend, who provides her with inspiration: 'Moro is definitely my muse. I am so fortunate to have him in my life. I think a muse is someone who inspires you constantly. It's important that you have strong feelings, emotions and desires for this person in order to have him or her as your muse.'

Moro doesn't necessarily see himself as a muse, shrugging off the term: 'I'm just an ordinary Japanese guy.' It is *this* quality to Moro, who appears as a regular boyfriend, that shatters the otherwise mundane scenes of a man and woman at home together. Appearing as an everyman figure, Moro also allows viewers to see themselves in the situation; these images can be read as a metaphor for all heterosexual couples for whom there is a possibility to break out of expected gender roles.

The ongoing collaboration between artist and muse continues to evolve and it has impacted upon the couple's personal dynamic. In Liao's words, 'The project also reinforced my leading role in our relationship. And when I look at these photos, I will reflect on my position in our relationship and sometimes make changes. And the changes in our relationship will further give me new ideas for the project.' At the same time, Moro gains pleasure from his role as Liao's muse: 'I do enjoy being photographed.'

There are layers of meaning to Liao's forthright 'Experimental Relation-ship'. Firstly, these photographs offer a clear commentary on the couple's real relationship; Liao and Moro honour the camera with truth, broadcasting their intimate dynamic through posed pictures. Liao's images also act as a visual protest against patriarchal power structures, which have come to define male–female partnerships. Using Moro as her muse, Liao demonstrates and celebrates an alternative version of the ways in which a relationship can work between a man and a woman.

Liao's art has received plenty of negative criticism, particularly from older Chinese men. However, she is increasingly finding that people are positive towards her images: 'Take my father, for example – in the beginning, he was worried that this type of work would bring me trouble in China and would hide it from other relatives and friends. But now he truly enjoys my work and sometimes he would even request some particular work and share it proudly among his circle.'

Liao shows us that art and its muses – even 'ordinary Japanese guys' – have the power to challenge expected societal structures, shatter reductive stereo-types and change prevailing opinions.

ULAY

*Breathing in
Marina Abramovic*

M arina Abramović is one of the world's most radical and controversial pioneers of performance art. Since beginning her career in Belgrade in the 1970s, she has consistently explored her own physical and mental limits, using her body as both subject and medium. In durational performances, Abramović has inflicted pain upon herself, drawn blood with whips, carried a skeleton and confronted a dangerous snake. She also demands involvement from her audience, who frequently become an integral part of her performances. In *Rhythm 0* (1974), the artist laid out seventy-two objects on a long table including pens, a feather, scissors, chains and an axe, inviting participants to use them on her as they wished; the performance famously resulted in a loaded gun being held to her head.

In a more recent work, 'The Artist is Present' (2010), Abramović sat in silence for eight hours a day, over the course of three months, at a table in New York's MoMA. This time, she engaged with over a thousand audience members who were invited to sit opposite her, one by one, and look into her eyes. While physical touch was banned, the participants held the artist's gaze, from minutes to hours.

On the show's opening night, a grey-haired man, wearing a black suit and Converse trainers, stepped from the audience to face Abramović, who was clothed in a floor-length regal red dress. A video of this encounter – which went viral – shows the man sit down, straighten his jacket, stretch each leg and, as Abramović opens her eyes to see her next companion, smile. The artist smiles back and, with tears filling her eyes, she breaks her non-contact rule to lean towards the man and hold his hands.

Inside the museum, captivated onlookers from the art world applauded. Who was this individual, who had moved Abramović to tears? What was their relationship? How had he shattered the stoicism of a woman who notoriously

withstands intense and punishing performances, for hours at a time, with complete composure?

The man who had stepped up to the table was the German artist Frank Uwe Laysiepen, better known by the single name Ulay. Having moved from Germany to Amsterdam in the 1970s, he rose to prominence for his Polaroid photographs of the city's community of transvestites, transsexuals and drag queens. Taking the marginalised members of society as his subject matter, Ulay celebrated countercultural expressions of identity beyond socially accepted stereotypes.

At this time, Ulay also turned the camera on himself, using his own face as a canvas in androgynous self-portraits. In one of his most iconic series, 'S'he' (1972), he appears split in two: half of his face is masculine and covered in stubble, the other half is feminine, clean-shaven, painted with make-up and framed by large curls of soft brown hair. Questioning the nature of identity through interrogative photography, Ulay was pointing out that gender is constructed, mutable and performative.

However, Ulay was also coming to the conclusion that photography could only remain to use his words, 'on the periphery of things'. The artist had realised that his real self lay underneath the skin, and so he started cutting, piercing and tattooing his body, all the while documenting these physical self-examinations through a unique style of performative photography. As Ulay's tendencies to perform grew stronger, his experiments became more audacious and ever more exposing. In a disturbing work titled *Tattoo/Transplant* (1974), the artist had a tattoo incised on his forearm before then photographing it being cut out, under local anaesthetic, by a doctor. 'I had to go under my own skin,' Ulay reasoned, as he bridged art with cosmetic surgery in boundary-breaking transformations. The next natural step for him was to perform, not only for the camera, but for live audiences, and in spaces that belonged to the art world: 'I wanted to inject life-like art into the white cube galleries and into the museums.' In 1975, Ulay helped to establish the De Appel Foundation, providing him with the stage for some of his earliest performances, including

Fototot (Photo Death) (1975–76). Using photosensitive paper, Ulay created a series of self-portraits that disappeared after the gallery's lights were switched on. As he later recalled, 'The moment the audience had gathered, we turned on the exhibition light, the halogen light. The images had not been fixed and were put up on the wall wet; because of the power of the light they would lose the images and turn deeper into black in no time. While that was happening, the audience became very nervous and very surprised. I recorded the process and their reaction in additional photographs.'

Ulay recognised that audiences not only brought a new energy to his practice, but could also become an integral part of it. By developing a direct relationship with viewers, he found that he could provoke them into discussion, discomfort and even action. However, he wasn't the only artist disrupting traditional hierarchies between artwork and audience at this time; Ulay was about to meet his female counterpart, Marina Abramović, who was also invoking the powerful phenomenon of the audience through daring body art in her native Serbia.

In 1975, Abramović was invited to perform at De Appel, where she presented *Thomas Lips*. Stark naked, she started by eating a kilo of honey and drinking a litre of red wine, before breaking the wine glass with her hand. Abramović's actions became increasingly violent, culminating in the artist cutting a five-pointed star into her stomach with a razor blade. She then lay down on a block of ice, in the shape of a cross, until onlookers intervened, unable to watch a moment longer. Following this precarious performance, Ulay, who had been in the audience, carefully and tenderly nursed Abramović's bloody cuts. The wounded performer was immediately fascinated by Ulay's looks: he was dressed, as in his 'S'he' photographs, as half-man, half-woman. Abramović also recalls that beyond physical attraction, she felt an 'immediate and strong reaction' and 'trust right away' for the man who was looking after her.

As Ulay cared for Abramović, she revealed to him that it was her birthday.

'It's my birthday, too,' he replied.

'Can you prove that?' she asked.

Ulay pulled out his notebook to reveal that he had torn out the page for 30 November, because he hated the day. Abramović couldn't believe it; she did exactly the same thing. As they continued to chat, the artists began to discover a number of uncanny coincidences, some of which were humorous – they both wore their same-length hair up with chopsticks – and some more profound, including considerable similarities in their confrontational, identity-focused performance art.

The two artists spent the next ten days in bed together and it was not long before they decided to live together in Amsterdam, with Abramović leaving her Serbian husband for Ulay. As the couple's romantic attachment developed, they agreed that they wanted to work together too. As Abramović remembers, 'Some couples buy pots and pans when they move in together. Ulay and I began planning how to make art together.'

But how could these autonomous artists become one united force? It wasn't going to be simple, as Ulay later reflected: 'For two ego-centric driven artists, it's not easy to join forces, to create one and the same work together and authorise the work as one, and that was a difficulty actually.' However, the answer was also obvious; drawing on their previous performative practice, in which both artists used their bodies as sites for art, they would draw on their personal relationship, turning it into a living artwork. The first performance which Abramović and Ulay devised was *Relation in Space*, which they staged at the Venice Biennale of 1976. Standing naked, twenty metres apart, the couple ran at each other repeatedly for one hour, colliding and bouncing apart and then, as they increased their speed, crashing into one another. As Abramović has explained, 'We really wanted to have this male and female energy put together and create something we called That Self. It was very important to collaborate and to mix our ideas together and not ever say to anybody from who idea comes from. It was the mixture that really make sense to us, and create that kind of third energy field.'

This was the first of a series of risky, passionate performances through which the couple played out their romantic relationship. Not long afterwards they

conceived *Breathing In/Breathing Out* (1977), which saw Ulay and Abramović sit intertwined, lips locked in a kiss, as they breathed into each other, both eventually fainting. Visualising their status as mutual muses and united lovers, they performed the physical and metaphorical manifestation of their emotional closeness. The artists' performances also portrayed, and proved, their inter-dependence and total trust in one another. Nowhere was this clearer than in *Rest Energy* (1980), which saw Abramović hold a bow opposite Ulay while he strung, drew and aimed a sharply pointed arrow at her heart. For four minutes and ten seconds, the two artists remained motionless while small microphones, attached to their chests, picked up the sounds of their quickening heartbeats.

Oscar Wilde once wrote that 'life imitates art far more than art imitates life'. What he meant by this is that art affects the way we look at life; our percep-tion of the world around us is changed by it, which makes us appreciate, for example, beautiful landscapes or sensational sunsets. We may notice a view more because it's been framed by artworks telling us this is something sublime, which we should appreciate. In the case of Ulay and Abramović, the couple's staged symbiosis not only reflected their intimate romantic connection but, in turn, strengthened it and demanded that they recognise and honour it. From their very first encounter, art had brought Ulay and Abramović together; and now the art and lives of these conjoint muses had become indistinguishable; life had begun to imitate art, as much as art imitating life.

The couple revelled in their unorthodox and reciprocally inspiring relation-ship. Writing a shared manifesto, 'Art Vital', they set out their tenets: 'No fixed living place, permanent movement, direct contact, local relation, self-selection, passing limitations, taking risks, mobile energy.' They lived in a van together for three years, involving the vehicle in their performances too. At this point, Ulay and Abramović strove for, and achieved, 'oneness' in their art. Although their work was theatrical, it was, at its very core, defined by integrity on both an artistic and a personal level; they were being truly themselves in everything that they did. United by a joint vision and working in the same purposeful direction, they pushed the boundaries of performance art, making history by

staging their intensive collaborative life in galleries and spaces across the world. But dependence can also be destructive and, as they enjoyed success, Ulay and Abramović's shared single identity became problematic. As the performing pair gained notoriety, Abramović began to be seen as the primary star of the show. 'We were a team,' she recalled, 'we were like one person: UlayandMarina. Glue. But at the same time, people – gallerists, audiences – were more and more seeing me as our public face.'

The story of Ulay and Abramović is an unusual one within art history: the female artist had begun to overshadow her male counterpart. Perhaps it played out like this because critics and audiences found it more shocking to see a woman undertaking dangerous stunts than a man, or perhaps it was because Abramović was the more vocal partner in media interviews. Whatever the reason, Ulay began to resent the growing inequality in their work's reception. Once willing to share in a partnership, he now found himself consumed by it. He later described himself, in self-deprecating terms, as 'the most famous unknown artist' in the world; the power balance had shifted. Once again, life was imitating art for the couple. As tension increased in their professional partnership, in their personal life there were conflicts too: both partners indulged in sexual affairs, Abramović refused Ulay's request to start a family and communication broke down. This, in turn, impacted on and became evident in their art.

In 1981, the couple began 'Nightsea Crossing', a series of twenty-two performances during which they sat silent and motionless at either end of a table facing each other. In the middle of one performance, Ulay, who was suffering immense pain, stood up; he could not continue the piece. He told Abramović that she should not carry on without him, but she saw no reason not to and carried on, facing an empty chair. 'Nightsea Crossing was the beginning of the end for us,' Abramović admitted. The last three years of their all-consuming relationship were increasingly difficult for the couple, whose time together was catapulting to a close. However, they had one final performance to stage.

Many years earlier, the couple had wanted, and planned, to get married; in true Ulay–Abramović style, they had devised a public performance of the

union, planning to walk the Great Wall of China from opposite ends and meet in the middle where they would wed. The artists had struggled to gain permission from the Chinese government, and spent years negotiating with them. Finally, in 1988 the authorities gave them the go-ahead. Over the course of three months, Abramović and Ulay walked more than fifteen hundred miles each, from either end of the wall, towards one another in *The Lovers: The Great Wall Walk* (1988). Eventually meeting in Shen Mu, Shaanxi province, where they had originally planned to get married, they embraced silently; a photograph shows the pair saying goodbye in a solemn handshake, marking the end to their partnership – professional and personal – in epic fashion.

Following their break-up, Abramović and Ulay were unable to collaborate as artistic creators. Their work had never been a game; while it was performative, it staged their personal, romantic relationship, with high-stake stunts relying on absolute trust, communication, openness and intimacy – not things you can manufacture. Would Abramović have confidently allowed Ulay to hold the arrow to her heart now? Not a chance. For the next twenty years they barely spoke, beyond negotiating the rights of shared artworks in a bitter court case. In 2015, Ulay brought a lawsuit against Abramović, claiming she had violated a contract regarding their shared work and the court ordered her to pay him US $280,500 in royalties. The case was resolved but the relationship between them didn't improve. As Ulay slowly returned to photography, Abramović reverted to performing alone. Since then, she has only gained celebrity, both in and outside of the art world, further overshadowing her former partner through her hugely successful solo career. This came to a pinnacle in 2010, when New York's MoMA invited Abramović to hold a major retrospective in the museum. She agreed on one condition; naturally, the artist insisted that her exhibition include an original live performance.

And so, on the opening night of her major exhibition, Abramović premiered 'The Artist is Present', inviting audience members to sit opposite her across a table. After two decades apart, this was the public stage upon which Ulay chose to be reunited with his former partner, facing his estranged muse head

on, in front of onlookers. Why now and in this dramatic fashion? Was it fair of him to sabotage Abramović in this way?

The first time Ulay had met Abramović was at one of her performances, when he had been watching from the audience and subsequently stepped in to care for her wounded body. On this memorable night, he once again moved from passive bystander to active partner, in an encounter layered with symbolism and significance. Ulay had always turned to art as a primary means of communication: 'It's through art that people exchange interpretation and meaning and love. You can be without solid food for forty days, you can be without water for four days, you can be without air for four minutes, but you can be only four seconds without impressions . . . that's why art is so important.'

Throughout their shared history, Ulay and Abramović had always performed their relationship with absolute truthfulness and integrity, turning to art to express their deep bond. This unscripted act was no different: a video, capturing the event, shows them both moved to tears in this tender moment of reconciliation – a connection between them clearly remained. Moreover, this performance in particular held meaning for them. 'The Artist is Present' echoed the couple's joint work, 'Nightsea Crossing', from which Ulay had retired early. As he pointed out, 'At MoMA, she just cut the table in half and invited visitors to sit opposite her instead of me.'

Ulay was also asking the art world for recognition. For twelve years, he had collaborated with Abramović, taking performance to new, unexplored realms. Extreme emotional and physical discomfort were themes that he had already started to develop even before meeting his partner. Nevertheless, Abramović has often been presented as the dominant star of the pair's shared works. That opening night of 'The Artist is Present', with a confrontational power, Ulay demanded visibility, acknowledgement and appreciation for his integral part in Abramović's career, from both the artist and audience. To use Ulay's own words, 'You cannot separate my life from art.' You also cannot separate Abramović from Ulay. Holding out her hands to him, Abramović showed acceptance and understanding: Ulay took, and deserved, a seat at that table.

GRACE JONES

Graffiti Goddess

G race Jones has been many things during her years in the spotlight: supermodel, badass Bond villain, provocative performer, singer, songwriter, record producer and style icon. Muse, however, may not necessarily be a word that comes to mind.

Nevertheless, one remarkable day in 1984, Jones joined three of New York's most notorious artists – Andy Warhol, Robert Mapplethorpe and Keith Haring – in Mapplethorpe's studio. After eighteen hours she emerged, completely covered in the trademark 'tribal' symbols of Haring. How had Jones, a self-proclaimed 'man-eating machine', been transformed into an artist's model, muse and canvas?

In 1980s New York, contemporary art was booming. Pop art emerged as the dominant movement, through which artists incorporated influences from popular culture: comic books, Coke bottles, advertising imagery and graffiti. Warhol painted his famous soup cans, while Haring drew giant doodles in subway stations; and Mapplethorpe used black-and-white photography to document queer culture and the gay club scene.

Artists were the stars of the time, and Warhol was king. His celebrity clique included Jean-Michel Basquiat, Edie Sedgwick, Madonna and Mick Jagger, with whom he partied at the legendary New York nightclub, Studio 54. It was here that reigning disco queen Jones joined the artist's inner circle; enjoying the celebrity status which Warhol so coveted, she became a close confidante.

By the 1980s, Jones was already an inimitable icon of fashion, beauty and music. In 1966, at the age of eighteen, she had caught the attention of a scout and been signed to top New York modelling agency Wilhelmina. Moving to Paris in the 1970s, she worked with acclaimed designers including Yves Saint-Laurent, Kenzo Takada and Guy Bourdin. With her unusual androgynous aesthetic, the dark-skinned beauty graced the covers of *Vogue*, *Der Stern* and *Elle* magazines.

As a model, Jones used her appearance to subvert expectations of gender, race and sexuality. From the outset, she would often dress in men's clothing to assume fluid gender roles, declaring, 'I go feminine, I go masculine – I am both, actually. I think the male side is a bit stronger in me and I have to tone it down sometimes. I'm not like a normal woman, that's for sure.' She has also explored her identity on stage, through off-the-wall outfits and fantastical make-up: over the years, her outrageous costumes have included skintight metallic bodysuits, fur capes with fox tails and bondage-style dresses. On other occasions, she has courted controversy by dancing almost entirely naked with thrilling, theatrical props, from whips to hula-hoops.

In 1984, Jones was at the peak of her musical career, having just released the hit studio album, *Slave to the Rhythm*. This was also the year that she first met Haring. The artist, who proclaimed that she had 'the ultimate body to paint', begged Warhol for an introduction to his celebrity friend. Warhol not only introduced Jones and Haring, but also arranged for the artist to paint her body, and for Mapplethorpe to photograph the spellbinding results, for a published spread in *Interview* magazine. Founded by Warhol, the glossy magazine featured interviews with artists, musicians and icons of pop culture, earning its nickname 'The Crystal Ball of Pop'.

Once inside the studio, Jones stripped down to her underwear, allowing Haring to paint directly onto her skin with white paint. From her face to her fingertips and feet, Haring decorated her whole body with his distinctive pictograms and abstracted scrawls; these accented, dynamic patterns perfectly complemented the contours of her towering figure.

But why had Jones allowed Haring to use her, effectively, as a site for one of his installations? What did his symbols mean? And whose agenda did this act of body-painting really meet? Let's start by taking a look at Keith Haring and his vocabulary of 'primitive' signs.

Arriving in New York in the late '70s, Haring studied painting at the School of Visual Arts, although he was influenced more by the city's graffiti artists, and by cartoons and images from popular culture. He began drawing

in New York's subway stations, filling unused advertising spaces with chalk sketches of boldly outlined, simplified figures, from barking dogs to babies to hovering angels. Haring believed pictures could function just like words, and wanted to make art accessible to everyone. He was also attracted to the idea of 'primitivism'. This problematic term, which runs throughout modern art history, refers to Western art that has copied or appropriated artworks and artefacts produced by non-Western cultures, such as African sculptures. Artists, including Haring, evoked the 'primitive' as a raw, pure form of expression, through which they could channel inner emotions, the subconscious and desire into artworks. Haring was particularly interested in native symbols, such as hieroglyphs, because they were often reduced to just a few simple lines: 'My drawings don't try to imitate life; they try to create life, to invent life. That's a much more so-called primitive idea, which is the reason that my drawings look like they could be Aztec or Egyptian or Aboriginal . . . and why they have so much in common with them. It has the same attitude towards drawing: inventing images. You're sort of depicting life, but you're not trying to make it life-like.'

Haring saw a connection between these 'primitive' symbols and his aspiration to create art that could be 'read' by everyone: 'I am intrigued with the shapes people choose as their symbols to create a language. There is within all forms a basic structure, an indication of the entire object with a minimum of lines that becomes a symbol. This is common to all languages, all people, all times.'

Living and working in the East Village, Haring was also inspired by the performers who were part of the underground art scene. Disco, funk, rap, punk, new wave, hip hop and dub converged at multicultural gay clubs, at which he, an openly gay man, was a regular. The exuberant performances of Grace Jones, in particular, had an impact on Haring, who perceived a 'primitive' quality to her costumes, make-up, props and stage personae: 'Of course, I had seen Grace Jones before, because she was the diva and disco queen of the whole Paradise Garage scene. But I really, really want to paint her body,

because she's the embodiment of everything that's both primitive and pop. Being primitive and pop is something I'm into, because my style of drawing is very similar to Eskimo art and African art and Mayan art, and, yes, Aboriginal art. And to me, Grace is all of that put together.'

During the 1970s and '80s, Jamaican-born Jones filled her performances with references to cultural and racial stereotypes associated with the African diaspora, confronting them head-on. She would frequently don totem head-dresses and metal-coil bras, whilst beating drums and dancing in metal-studded skirts. In many ways, her routines can be compared with those by Josephine Baker, whom she cited as an influence in a 1985 interview with Warhol. During the early twentieth century, this Black American-born French entertainer gained fame for dancing topless on stage in a girdle of bananas. She's been critiqued by some for reinforcing racial stereotypes, while others perceive a reclaiming of power in her performances in which she reclaimed harmful caricatures and reinvented them on her own terms.

Identifying with Baker, Jones was flaunting primitivism in front of her audience, mocking Western conceptions of Africa as a land of savagery and African women as exotic objects. She was deliberately fashioning what the art historian Alison Pearlman has referred to as a 'futuristic-primitivist style'. And through such obvious and satirical masquerade Jones could prove that racist stereotypes were constructed, just like her costumes.

Haring wanted to work with Jones, not just because she was spellbind-ingly beautiful, but because he identified with the awe-inspiring, 'primitivist' persona she projected on stage. He prepared for the body-painting session by studying photographs of Maasai men painted with white lines on their naked bodies. Inspired, Haring then transferred his own version of these 'tribal' markings to Jones's skin, blurring the boundaries between ancient and modern.

At the same time, Jones chose to partner with Haring: she had always used her body as a site for spectacle, and recognised the role he could play in cultivating this further, by painting the modern, punk, 'primitive' identity

onto her skin. She also brought with her to the studio conical wire breastplates and a totem headdress, inviting Haring to paint these too. The input from Jones is unambiguous; she asserted herself as an equal collaborator alongside the artist, ensuring that the finished effect was divine. Jones emerged as a crowned, graffiti-covered goddess, evoking a mythical image she was keen to perpetuate: 'Even death won't stop me. It never has. You can find images of me from centuries ago. Faces that look like mine carved in wood from ancient Egypt . . . I have been around for a long time, heart pounding, ready to pounce on my prey . . . tripping, grieving, loving, hunting, conquering, seducing, fighting, dreaming, laughing, and I always will be.'

This presentation echoes artworks by a number of other women artists, who framed themselves with goddess-like imagery. Frida Kahlo frequently painted herself with crowns of flowers, elaborate hairstyles and symbolic jewellery. In her painting *Self-Portrait with Thorn Necklace and Hummingbird* she identifies with powerful iconography from indigenous Mexican culture: her hummingbird pendant is a symbol of Huitzilopochtli, the Aztec god of war.

Haring's daring designs also freed Jones from the masculine-feminine binary, echoing the androgynous image she had cultivated throughout her modelling career, and elevating her to genderless deity: 'It made me look more abstract, less tied to a specific race or sex or tribe,' she said. 'I was black, but not black; woman, but not woman; American, but Jamaican; African, but science fiction.'

This iconic day of body-painting was just the start of Jones's relationship with Haring, who went on to paint her many more times. The pair's next collaboration was for the music video of her single 'I'm Not Perfect (But I'm Perfect for You)'. The video shows Haring at work on the floor, covering a white sixty-foot skirt with his 'tribal' tattoos. In a powerful collision between pop art and outlandish performer, Jones then brings the visual rhythm of his designs to life as she dances in the gigantic skirt on stage before her fans.

The following year, Haring embossed Jones with his white markings once again, this time for her electrifying, subversive performance at Paradise

Garage. Totem poles and African masks flanked the stage, on which she strutted like a warrior queen, to once again confront, perform and explode 'primitive' tropes. Haring next covered Jones in his signature scrawls for her role as Katrina the Queen of the Vampires in the comedy horror film, *Vamp*. With her whitened face, striped body and bright red wig, Jones – albeit in a supporting role – stole the limelight. Haring's designs confirmed and cemented her status as a seductive, sensational icon.

As their partnership developed and strengthened, Jones wore Haring's patterns the way most celebrities don couture by Chanel, Dior or Prada. Haring became her signature look and her latest outrageous outfit. However, he was far from the first artist Jones had worked with, and far from the last. After all, this was the woman whose motto in life is 'Make up rules for yourself.'

Back in 1979, Jones was already working with another artist, Richard Bernstein. This pop artist, who was friends with Warhol, elevated socialites, models and performers to star status on the covers of albums, posters and magazines. It's no surprise, then, that Jones chose him to paint her portrait for the cover of her third studio album, which she called *Muse*. This album cover shows her confident and deliberate self-presentation as a muse. Across her head, shot in profile, is emblazoned 'Muse: Grace Jones' in neon contrasts of pink and green, orange and blue. This is a title which she celebrates and identifies with, and Bernstein's portrait presents her as a technicoloured, airbrushed icon.

Jones also entered into an artist–muse relationship with Warhol. In 1986, Warhol created a grid of nine identical photographs of Jones who, wearing a dark peaked cap and fur coat, stares straight towards the camera. Later that year, he also created several of his signature screen-printed paintings of the star in luminous pink and yellow tones.

Celebrity itself was Warhol's muse; the artist depicted many 'superstars', as he referred to them, including Marilyn Monroe, Mohammed Ali and Bianca Jagger. Jones, too, embodied that star quality and notoriety which attracted the artist. At the same time, joining Warhol's wall of fame validated her as a subject worthy of turning into art, confirming her superstardom.

Grace Jones has always used her body to project her identity: 'One creates oneself' has been her maxim. On stage, she has paraded the 'primitive' persona as a means of shattering and subverting stereotypes. By allowing Haring to paint his daring designs directly onto her skin, she simultaneously parodied and reclaimed 'primitivism' in uncompromising fashion.

Similarly, Jones reclaimed the role of muse. Bringing a compelling, performative agency to her relationships with multiple artists, she has exploited their ability to validate her status as a superstar, and frame her as a powerful deity. Today, the photographs which Mapplethorpe took of Jones, painted head to toe by Haring, belong to the Tate in London. Hanging in a gallery, they immortalise her legacy and image as towering goddess of graffiti.

TILDA SWINTON
Surrealist Shapeshifter

Deep in the Mexican rainforest lies the wild garden estate of Las Pozas. Here you can find waterfalls and ponds, towering concrete columns and stone snakes; dramatic gates swing open and spiral staircases end in mid-air. In 2013, this tropical wonderland formed the backdrop for a series of exquisite narrative photographs, 'Stranger than Paradise', shot by Tim Walker and starring British actress Tilda Swinton.

Recognised by many as one of the world's leading fashion photographers, Walker's work has featured frequently in *Vogue*, *Love* and *W Magazine*, where this series was published. Through photography – in which strange sets, props and costumes collide – Walker tells fantastical fairy tales and surreal stories. Bent mirrors, blue elephants and trees of dangling dresses all belong to his enchanted universe.

However, Walker's extraordinary world relies, above all, on his models; and one of his most photographed subjects is Swinton. He has acknowledged that his attraction to Swinton is, in part, due to her 'androgynous beauty', and the London-born actress is well-known for the ambiguous male–female identity formed throughout her career on screen. A shape-shifting chameleon, Swinton has transformed herself from commune leader Sal in *The Beach* to Ancient One in the Marvel Cinematic Universe, and a gender-bending nobleman in Sally Potter's *Orlando*.

Swinton is also known for possessing an otherworldly, ethereal aura, harnessed by Walker for the 'Stranger than Paradise' shoot in which she appears as a myriad of mythical characters. Framed by the deep green rainforest behind, she ascends a staircase in a long, flowing gown; with blue-gloved hands she covers her face with a golden mask; she poses with black-and-white centipedes crawling on her face.

Who are these characters, cast against the fantastical stage of Las Pozas? What story are Swinton and Walker telling? Also, what motivated them to

work together, as artist and muse? To understand this series of photographs, and the pair's relationship, we need to look further than Swinton's unconventional looks and consider the ways in which she has deliberately avoided Hollywood typecasting and a traditional route to stardom.

Swinton began her acting career in art-house films, making her screen debut in Derek Jarman's *Caravaggio*, a fictionalised re-telling of the life of the baroque painter. She went on to make another six films with Jarman, who became one of her best friends, and has also worked on repeat collaborations with a number of individual directors, including James Robert Jarmusch and Luca Guadagnino, moving seamlessly between experimental indie films and blockbusters. Swinton has also collaborated with fashion designers and visual artists. Most notably, she worked with Cornelia Parker to create *The Maybe* – a performance art piece in which, for seven consecutive days, she slept inside a glass box at London's Serpentine Gallery. Thirteen years later, the pair revived the work at New York's MoMA, presenting Swinton as both a living artwork and an artist – the actress having also originally conceived the idea behind the installation piece. Of the utmost importance to Swinton is developing a meaningful connection and trust with her artistic collaborators, who share in a vision: 'Usually, with me, the project is always the second thing. The film-maker comes first. Films grow out of the relationship.' As she has further explained: 'The collaboration feels clear always, it's sort of my drug, I'm in it for the conversation. The conversation's the most important part of it.'

Walker's approach to making art echoes that of Swinton – 'conversation' is a word which he also uses to explain his methods of working with models. Recognising that portraiture is a two-way process between an artist and their muse, he enters into what he calls a 'total collaboration', inviting the input of his subjects, many of whom he will engage in an ongoing partnership. Walker recognises that it's an active, enduring relationship which differentiates and elevates a muse from his other models: 'A lot of people are models, and I haven't ever made a great picture with a model. But I have made meaningful

work with a muse. Models pose for you. But a muse is someone I can talk to and give a cupboard full of references and explain what I'm trying to do. They take this away and they own what I'm saying.'

Walker's most significant subjects are like silent-movie actors; he not only recognises but also requests their creative hand in defining the final image. Against the backdrop of outlandish sets and extravagant installations, Walker's muses are offered the opportunity to assume a dominant role in the telling of the photographer's story, and none more than Swinton.

'Stranger than Paradise' was shot in the ready-made set of Las Pozas, which translates as The Pools. This magnificent estate was built by Edward James, a hugely wealthy British collector of surrealist art during the twentieth century. James championed and funded a number of surrealist artists, including Salvador Dalí and Rene Magritte, acting as their close friend, collector and confidant alongside being a generous patron.

Following the Second World War, James moved to Xilitla in Mexico. During the 1940s, he purchased a hundred acres of rainforest and set about filling it with strange concrete sculptures and structures that complemented the natural waterfalls and ponds on site. The collector-turned-creator transformed the rainforest gardens into an immersive, surrealist playground, where he subsequently invited artists to stay. One of the surrealist artists who made frequent visits to Las Pozas was Leonora Carrington. The British-born Mexican artist and novelist had also moved to her native country in the 1940s. She thanked James for his hospitality and ongoing patronage by painting murals and creating reliefs on the estate's architecture. These designs echo her distinctive paintings of mythical beasts, fairy-tale characters and strange costumed figures, which populate dream-like landscapes.

In 'Stranger than Paradise' Swinton brings to life Carrington's surrealist characters against the otherworldly location of Las Pozas and the artist's reliefs. Walker explains that 'it was Tilda's idea to look at the female surrealists – Leonora Carrington, as well as Remedios Varo and Leonor Fini. We ran riot with the imagination of the female painters. It was a love letter back to them.'

It's no surprise that Swinton took inspiration from Carrington and the wider group of female surrealists. These women turned to themselves as their own muses – painting, photographing, drawing and sculpting surreal self-portraits; depicting themselves as creative magicians, witches and mythical genderless beings, they explored identity and sexuality beyond stereotypes, and affirmed their own creativity. Swinton had also turned to surrealist imagery before, most notably in her role as Orlando in Sally Potter's film, adapted from Virginia Woolf's novel of the same name. About halfway through the plot, Orlando – born a man – emerges from his deep sleep as a woman. In an interview, Swinton reflected that the vision for her portrayal came from non-conforming artist Claude Cahun who presented herself as gender neutral in photographic self-portraits: 'Cahun looked at the limitlessness of an androgynous gesture, which I've always been interested in.'

Across the female surrealists' practice, costume in particular is seen as an outward expression of a complex inner identity. Much like Cahun, who dressed in men's suits and shaved her hair, Carrington painted herself in androgynous terms. In many paintings she is seen wrapped in floor-length cloaks and wide gowns; in an iconic self-portrait she wears tight white jodhpurs with her knees spread apart, while her long hair stands upright. Carrington is forever playing with polarised gender ideals.

In Walker's photographs, Swinton awakens Carrington's cast of androgynous, self-referential characters. Her ghostly pale skin is suited perfectly to this performance, as she metamorphoses through elaborate costumes and light illuminating make-up. In one image, Swinton wears a large black headdress and long billowing robes; in another she is painted all over a bright, brilliant white, her hair standing on end like that of a troll.

Walker has also explained that 'Tilda was channelling Edward James' himself in this series. A particularly striking photo shows her impersonating the surrealist patron – she stands in a tailored black-and-white suit and dyed dark brown hair is slicked back from her forehead. With white-gloved hands,

she holds up two magnifying sheets of glass in front of her face, enlarging one eye and her smiling mouth, evoking surrealism's emphasis on optical illusions.

In stark contrast, another photograph shows Swinton dressed in an ultra-feminine baby blue Francesco Scognamiglio ruffle top, her hair turned the shade of apricot. Again sporting white-gloved hands, she holds pink roses against a pale sky, and two more duplicate model hands descend into the frame. This image is a recreation of Magritte's painted portrait of Edward James, *Dream of Edward James*, in which the artist had focused on the collector's hands intertwined with roses in a surreal dreamscape, paying tribute to the part he played in supporting the movement.

While Swinton's costumes and appearance change dramatically in each of the photographs, one constant is her hands. Covered in coloured gloves, they demand attention and point to her theatricality. Expressively and intentionally held – outstretched, at unusual angles – Swinton's hands seem to gesture towards unspoken truths from the subconscious. They also show that she is, quite clearly, a performer.

Swinton brings her talent as an actress to the shoot: each image simultaneously evokes a still from a film in which she is the star, a piece of performance art and a painting come to life. Walker has also commented that it is Swinton's 'timing' which stands her apart from other subjects he has worked with: 'With Tilda, I'll point to a space and she knows intuitively what to do – that's what defines a muse. She feels it and lands in the right place. If I told her where to be and what to do that's just modelling, but a muse is answering you, challenging you back and that's way more exciting. And what she does extremely well is timing.'

Although Swinton is acting out Carrington's surrealist characters, Walker – proving his skill as a photographer – also manages to capture something of his muse beneath the layers of costume. As she looks directly down the lens, the actress radiates her essence and truth among the fantasy; within the surrealist matrix, these are portraits of Swinton as Swinton, too.

As a photographer, Walker gives his sitters agency to display their real selves, explaining his desire to frame them 'as they are – that's what you're trying to

document', adding that there should be just as much 'pleasure for them' as there is for him in this process 'because it's life affirming to be seen'. Just as she develops a close relationship with film-makers, the actress has built trust with Walker, allowing both him and his camera in.

In contrast to painting a portrait, which could take many months, photography allows Walker to capture Swinton, as herself, in an instant: 'The camera, the photograph is very immediate – that moment when it is right to take the picture, you can feel it, when the subject is at their most beautiful and articulate.' Framing and finding beauty is a motivating force for Walker, who has reflected on this quest: 'There's something about certain people I get involved with, deeply, gargantuanly beautiful – and this is why you keep going back again and again, because you haven't honoured all of your senses of being around that person. There's a chasing-rainbow quality, you can see a pot of gold in a person, teasing you, constantly.' Like many artists, Walker is driven to distil the very essence and beauty of his muses in an image, a job that is never quite complete and explains his reason for working with Swinton repeatedly.

One year after the 'Stranger than Paradise' shoot, Walker made and directed a short film, *The Muse* (2014), which explores the notion of an artist at the mercy of their muse. Edward Dunstan (played by Ben Whishaw) is a photographer and film-maker beholden to his mermaid-muse. But as legend has it, if a human man falls in love with a mermaid, she will grow legs that will, if she so desires, carry her far away from the man she cast her watery spell upon. Walker tells the story of an obsessive artist who, abandoned by his muse, plays photographs and film of her on a running loop. It's a reflection on the power dynamic between artist and muse, and one which he has experienced personally: 'It's fire, an energy that won't ever end, that drives the muse and the artist, the portrayer of the muse.' Walker counts Whishaw as another muse, among a number of men including James Crewe, James Spencer and Grayson Perry. As he has said, 'Male muses are every bit as inspiring as women. The muse is not just in the remit of female for me. But there is a femininity about

these men. And a lot of female muses, like Tilda Swinton and Karen Elson, have elements of the masculine. I'm interested in the parameter of beauty – and you see this most clearly in Swinton.'

Throughout her career, Swinton has often subverted expectations of gender, taking to the parameters of beauty and using surrealist artists as her inspiration. Nowhere is that more evident than in the shoot at Las Pozas; channelling Carrington's costumed characters, as well as Edward James, she shows that self-representation is limitless.

'Stranger than Paradise' unfolds as a shared lucid dream between Walker and Swinton. Both have agency, united in their surrealist endeavour to tell a story which draws on art history to blur boundaries between male and female, past and present, fact and fiction. Like all the best stories, it enters an autobiographical space too; and as Swinton evokes and exposes her androgynous self, Walker meets her with his camera, holding it up as a magic mirror to frame his captivating muse.

LILA NUNES
Guardian Angel

D ominating Paula Rego's magnificent pastel drawing *Angel* (1998) is a broad-shouldered woman whose black hair has been tied back in a bun. Wearing a full, floor-length golden silk skirt and a long-sleeved black blouse, she stands assertively against a stark grey background. In one outstretched hand she holds a pale-yellow sponge; in the other she brandishes a glinting silver sword. Far from angelic, this provocative figure poses questions for the viewer – above all, why is she starting to smile?

Portuguese-born artist Paula Rego is well-known for telling darkly disturbing stories using paint and collage to create what she refers to simply as 'pictures'. Taking inspiration from traditional folklore, myths, fairy tales, nursery rhymes and even Disney films, she recounts these narratives from a female perspective and with strong psychological force. Reclaiming passive princesses, Rego turns them into active heroines: Snow White straddles the Prince's horse solo, Little Red Riding Hood's mother kills the wolf, and a muscular mermaid drowns Wendy in a black lagoon – Neverland, this is not.

Rego stages each of her stories inside a large studio in London. As art critic John McEwen has pointed out, 'For every artist the studio is a sanctuary, but for Paula it has special importance. Her studio is a playroom as much as a workplace.' Inside this theatrical space, Rego collects costumes, fabric and stuffed toys, and assembles huge props which fill the room. However, this magic realm is only truly awakened through Rego's collaboration with models who – dressing up as eclectic fictional characters – pose within the artist's magical tableaux.

While many sitters have performed just once or occasionally for the artist, there is one model who since the 1980s has played many hugely significant roles for Rego: Lila Nunes. In 1985, then aged twenty-one, Portuguese-born Nunes moved to London to care for Rego's sick husband, the artist Victor

Willing, who had been diagnosed with multiple sclerosis. Rego had first met Willing during the early 1950s, when he was one of her painting tutors at London's prestigious Slade School of Fine Art.

During the last few years of his life, Nunes not only attended to Willing's medical needs, but helped him to work from his wheelchair by mixing paints, and also took him to see exhibitions around London. Nunes never modelled for Willing, but she recalled that Rego soon invited her to, and she gladly accepted: 'I was happy about being involved in the work. It was a new experience. I was living with two artists, so I knew their work was very important for them . . . They considered me part of the family, in a way. Even when I left to do other things, I was always in contact, especially with Paula. There was obviously trust between us and a connection, because we're both Portuguese. There were a lot of things we talked about that I understood because of that.'

One of the first series which Nunes both posed for, and directly inspired, is 'Girl and Dog' (1986–87). These boldly painted pictures feature one, and sometimes two, sturdy dark-haired girls who wear pretty, girlish dresses with long white socks. Nursing a sick, floppy dog, they hold, feed and water, dress and undress the poor creature. In one particularly poignant image the dog lifts his head trustfully, while resting its paws on the lap of the seated girl, allowing her to shave his chin and throat.

Rego was paying tribute to the daily care which Willing, represented as an anthropomorphic dog, received from Nunes, who appears as a little-girl version of herself. Refracting their caregiving relationship through the lens of fiction, Rego's images evoke a colourful children's storybook, making the uncomfortable reality somewhat more palatable. The physically and emotionally exhausting experience of looking after Willing bonded Nunes and Rego, to such an extent that when Willing died in 1988, Nunes remained with her as a studio assistant, primary model and muse.

Since then, Nunes has played a whole cast of characters, transforming from an ensemble of dancing ostriches in tutus and Jane Eyre to a Spanish bullfighter and Snow White. 'She's terribly important working with me. I like

having her there with me,' Rego has testified. Taking on such a diverse range of fictional characters, Nunes defines her involvement as 'acting'; she finds the experience of dressing up and posing both 'fun' and 'hard work because you're up there for hours'. Assuming physically demanding positions, she kneels, crouches and, quite literally, bends backwards for the artist.

While given some direction from Rego, there is also an element of spontaneous improvisation to Nunes's method of working, which comes close to play. 'Playing is the most important thing of all,' Rego has revealed, describing Nunes as both a 'collaborator and playmate' who helps her to shape stories. 'She just takes a position, and I go with it, it grows from there.' Inside the studio, it's as if they are two young girls trying to make sense of the world, particularly as Rego, sitting on the same level as Nunes, will draw her from the floor of the studio as a child would do.

But modelling for Rego is no light-hearted matter, and Nunes has always been prepared to pose for artworks which border on activism. Since the start of her career, Rego has used her work to draw attention to the injustices which she perceives women experience, across personal and political spheres. This is understandable given her upbringing: Rego was raised under the fascist regime of Portugal's dictator, António de Oliveira Salazar, through which the state and the Catholic Church conspired to control their citizens, and especially women.

In 1998, a referendum to legalise abortion in Portugal failed, and Rego created one of her most notable bodies of work, the 'Abortion Series' (1998). For these pastel drawings, Nunes impersonated women kneeling and lying down in backstreet clinics, in order to highlight the fear, pain and dangers of making abortion illegal. In *Untitled No.1* (1998) she sits, holding her bent legs apart, staring at the viewer, almost confrontationally. Rego has explained, 'She is being humiliated and yet she is triumphant, completely triumphant.' The effect of these visceral images was so powerful that they have been credited with helping sway public opinion to form a second referendum in 2007.

The same year that Nunes modelled for the 'Abortion Series', she also transformed into Rego's *Angel*. The idea for this artwork came from José Maria

de Eça de Quierós's controversial nineteenth-century Portuguese novel, *The Crime of Father Amaro*, which shocked original audiences for its unforgiving commentary on the hypocrisy of the Church – a subject which resonated with Rego. Father Amaro, a handsome, charming priest, enters into a sexual relationship with his landlady's daughter, Amélia, whom he gets pregnant. Soon after their son is born, Amaro arranges for the baby to be killed, and Amélia dies due to complications during the birth. While mother and son are framed as disgraced victims, the priest moves to a new parish where he progresses in the Church, having suffered no consequences for his actions.

For Rego's disconcerting drawing, Nunes adopted the role of a new, invented character: an avenging angel. 'I prefer a heroine to a victim any day,' Rego once declared, and here has drawn one into the story. Carrying the Christian symbols of a sword and a sponge, Nunes is posed with reckoning force, having arrived to punish the priest for the wrongs he has done to Amélia and their son. As she fixes viewers with a defiant gaze, there is no doubt that she will exact retribution and take pleasure in it – this is why she is smiling.

Given the care which Nunes took of Willing, this image of her as a guardian angel also resonates with reality: 'They're all personal stories,' Rego has conceded. Portuguese-born Nunes, who grew up as a 'tomboy', recognises herself in images such as *Angel*, in which the female characters have decidedly masculine facial features, thick limbs, olive skin and dark hair. However, she also acknowledges a disparity between many of the subjects portrayed and her own appearance: 'The finished work does surprise me – especially the expressions. When I get up and have a look, I think: "Oh my God, that expression was . . . Where did that come from?" It doesn't feel like it was me.'

There is a very simple explanation for the chasm which Nunes perceives between herself and the completed characters: each of the pictures is not just of Nunes; these women are also a reflection of Rego herself. As the artist's son, Nick Willing, has explained, 'Mum sees herself as Lila. She doesn't see herself in any other of her models. But it's an image of Mum from another time, so it's more accurate than a self-portrait, because she's able to invest in

Lila a role that she once played – so she can put her in the 1950s or 1960s, and that's more important than what Mum looks like now.'

Rego has affirmed this reading: 'She is really myself. I don't like doing self-portraits but she's like a self-portrait.' It's not just in looks or the shared heritage that Rego identifies with Nunes; of equal if not more importance is the fact that Rego feels that Nunes 'understands' what she is trying to say in her work, and can therefore pose suitably. 'She knows exactly what to do, she can read my mind. She knows what I want, and she does it.'

Nunes recognises this crucially important connection too: 'I'm also a woman, so I understand a lot of things. When you're talking to a woman, and you mention something, you don't even need to go into detail. You know what that person means . . . Sometimes it's frustrating because Paula can't get what she wants; she keeps working until she gets there. Things come out that she didn't expect. I think, in a way, that's because I'm relaxed: she can go through me and find whatever she's looking for.'

Rego has expressed her need for Nunes to 'stand in' for her. Nowhere is this more pronounced than in the 'Dog Woman' (1994) series, which features women behaving like dogs; drawn in the wake of Willing's death, they express Rego's grief at her loss. For these pastel pictures, Nunes bowed down on all fours, performing and channelling the artist's pain for her through demanding poses and even sounds. As Rego remembers, 'I don't know why, I just said to her: "Now crouch there, and growl." And she did.' In these charged images Nunes, whose head is thrown back, relays Rego's pain and anger in the form of a dog's guttural call.

Nunes even assumes the role of a sculptress sitting smoking her pipe in *The Artist in Her Studio* (1993), surrounded by strange objects, drawings and an assortment of cabbages. This picture clearly alludes to Rego's own fantastic studio space; but again, it is not a self-portrait in the traditional sense, since Nunes posed for it. Although it could be argued that Nunes is simply a body double onto which Rego can cast her own self-image, is there not also a great honour in being entrusted with this role? Just as Rego forever blurs fantasy

and reality, so too there is a conflation of artist and muse here, indicating the intimacy between the pair. As Rego once said, 'You have to become the figures you're drawing.' Here, she seems to be paying a fitting tribute to Nunes, the protagonist of her pictures, who brings her world to life.

Like all great storytellers, Rego uses fiction to tell great truths, including those that are uncomfortable and taboo. As the artist's trusted co-conspirator and leading lady for more than three decades now, Nunes has performed roles which broadcast women's experience in unflinching terms and reclaim femininity as something quite ferocious. Channelling anger into action, Nunes is Rego's imaginary angel, playmate and real-life ally. Moreover, as the artist's constant muse, she holds up a magic mirror to Rego herself – a fearless artist who paints to avenge all women who have been wronged.

MUSE OF A MOVEMENT

ELIZABETH SIDDALL

Ophelia Awakes

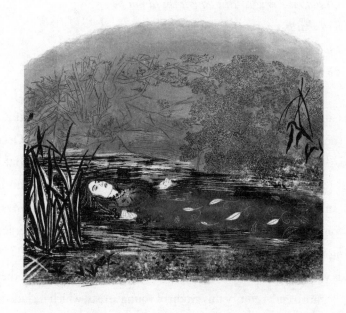

When down her weedy trophies and herself
Fell in the weeping brook. Her clothes spread wide,
And mermaid-like a while they bore her up,
Which time she chanted snatches of old lauds
As one incapable of her own distress,
Or like a creature native and indued
Unto that element. But long it could not be
Till that her garments, heavy with their drink,
Pulled the poor wretch from her melodious lay
To muddy death.

In Act 4 Scene 7 of Shakespeare's *Hamlet*, Queen Gertrude announces that the play's tragic heroine Ophelia has drowned in a river. Occurring off stage, the scene is left to the minds of the audience, but it's also one which has sparked the imagination of many artists – most notably, Sir John Everett Millais. In his exquisite painting *Ophelia* (1851–52), Millais portrays the young woman in an embroidered gown, framed by flowers and her long red hair, lying pale and lifeless in her watery grave.

Millais was one of the founding members of the Pre-Raphaelite Brotherhood. During the nineteenth century this group of young artists, which included Dante Gabriel Rossetti, William Holman Hunt and Frederic George Stephens, were disenchanted with the academic approach to painting currently being taught at London's Royal Academy of Arts. Wanting to revive British art, they advocated a return to the vividly painted, symbolic narrative scenes of medieval art.

Turning to myths and legends, the plays of Shakespeare and Romantic poetry for inspiration, the Pre-Raphaelites often portrayed doomed damsels: Proserpina, Medea, Dante's Beatrice and the Lady of Shalott. Art history has

also told us, time and time again, how these male artists relied on their beautiful flame-haired female muses; and among them, none is more famous than Elizabeth 'Lizzie' Siddall, immortalised by Millais in his painting of Ophelia.

Modelling for Millais's painting almost killed Siddall: over a period of several months, and for hours at a time, she lay in a bath full of water which was heated by oil lamps placed beneath it. However, on one occasion, these lamps went out; and the muse, who did not complain at the icy conditions, subsequently became very ill with pneumonia. Although she eventually recovered, the painting foreshadows Siddall's own unhappy life: she died aged just thirty-two from a laudanum overdose.

The archetype of the tragic muse has been cemented by the Pre-Raphaelite movement's paintings of haunted heroines; and the image of Siddall as the drowned Ophelia has been held up as the paradigm of a misused female model falling victim to an egotistical male artist. But was Siddall exploited, or did she embrace the role of muse for the Pre-Raphaelite Brotherhood? Was she a sacrificial lamb or is this version of events as fictional as the tale of Ophelia?

First, we need to understand how Siddall came to pose for the Pre-Raphaelite painters. Many narratives tell us that she was working in a London hat shop in 1849, when she was discovered by Millais's friend and fellow painter, Walter Deverell. Struck by the distinctive beauty of this twenty-something working woman, the artist plucked her from obscurity to take her as his muse.

However, it's likely that this version of events, which frames Siddall as a Cinderella-style figure in need of rescuing, is nothing more than a fairy tale. Instead, Siddall, who was herself an aspiring artist at this time, decided to show some of her drawings and watercolours to the director of London's Government School of Design. He was the father of Deverell, and it was through this encounter that Siddall was introduced to the painter, subsequently agreeing to pose for his canvas, *Twelfth Night* (1850).

Deverell's painting illustrates the scene in which Duke Orsino, who is hopelessly in love with Countess Olivia, orders his clown, Feste, to sing the song 'Come away, come away, death'. Sitting beside the Duke is his handsome

page, Cesario, who is actually a woman – Viola. Completing the comic love triangle, she has secretly fallen for him too. Siddall, who sat for Viola, appears disguised in a medieval pageboy's dress and tights, leaning intently towards her master.

After modelling for this painting, Siddall soon met the wider circle of Pre-Raphaelite painters, including Holman Hunt and Millais, and posed for them too. These men were attracted to her striking looks: not beautiful by Victorian standards, Siddall was tall and boyishly thin, with pale eyelashes, protruding teeth and unusual auburn locks. While masquerading as various characters from Viola to Ophelia, one constant in these pictures is Siddall's long red hair, which the painters kept in a tribute to her individuality. Not only was she these artists' ideal muse, but her unique look also came to define the movement.

However, it wasn't just her appearance that attracted artists to paint pictures of Siddall. The model inflected the multiple partnerships she entered into with her deep knowledge of and interest in art and literature – writing her own poetry as well as painting. She would, therefore, have been well versed in the stories which were brought to life by the Pre-Raphaelites, and was willing to impersonate characters with understanding and dedication; in the case of Ophelia, to the point that she made herself seriously ill.

The artists also valued Siddall's demeanour; she demanded respect from them. As Holman Hunt once wrote, 'She's like a queen . . . she behaves like a real lady, by clear commonsense, and without any affectation, knowing perfectly, too, how to keep people respectful at a distance.' This veneration of Siddall courses through canvases in which she appears idolised as a heroine and divinity, even featuring as Jesus in Hunt's majestic painting *The Light of the World* (1851–53), once again with her red hair prominent.

One common misconception is that muses, such as Siddall, provided artists with inspiration for free. In her feminist essay 'The role of the artist's muse', Germaine Greer writes that 'A muse is anything but a paid model', using the term as an unflattering euphemism for unpaid female labour. In the case of Siddall, this is far from the truth; for her commitment to the Pre-Raphaelites,

she was paid well. Initially, she modelled part-time alongside her job in the hat shop, but over time, she turned musedom into a profitable career on its own.

We can therefore see that becoming a muse offered Siddall real opportunity. In Victorian society, a woman of her standing – she came from a lower-middle-class family – could work but only in a limited number of sectors that were deemed 'feminine', including seamstressing or retail, and they were paid far less than their male counterparts. Professions, including the law and medicine, were closed off to women.

Furthermore, once married, a woman was expected to focus upon her role as a wife, mother and 'Angel of the House'. Although there was progress in women's rights, with debates around education, employment and voting rights – it wasn't until 1918 that the House of Lords gave approval for women over the age of thirty to have the right to vote – women were considered subordinate to men.

This power structure was also felt within the patriarchal art world: although women were encouraged to be creative in the domestic setting, they weren't expected to pursue a serious artistic career. If you were an aspiring female artist, you could attend some art classes, although no life drawing, and were prohibited from enrolling at the Royal Academy Schools. Women, therefore, struggled to gain formal qualifications with which they could pursue a professional career in the arts.

Taking up the position of muse allowed Siddall a significant role at the heart of an artistic community, which she longed to join, and from which she would otherwise have been excluded. Aspiring to be a professional artist, modelling was perhaps the clearest pathway through which Siddall could collaborate with, learn from and make art with her male counterparts. Given the societal restrictions placed upon her, she used her position as muse to bypass them as best she could.

At the same time, the choice to model for artists was not without risk. Firstly, to pose unchaperoned was regarded as far removed from appropriate female behaviour during the nineteenth century. Typically, it was either prostitutes and servants who sat for artists, or else close family members, such as wives and sisters. It would have been extremely risqué for a young,

unmarried, lower-middle-class woman like Siddall to pose alone in a painter's studio. As Dr Serena Trowbridge explains, 'Her father was certainly anxious about propriety when she began modelling, perhaps fearing it would make her unmarriageable.'

Furthermore, the Pre-Raphaelites' daring narrative paintings, in which women appear outside traditional beauty standards and expected behaviour, were considered scandalous. For example, when Millais exhibited *Ophelia* in 1852 a critic from *The Times* of London condemned the artist's 'perverse' placement of her in a 'weedy ditch'. Likewise, the Athenaeum's critic judged Ophelia's face as entirely inappropriate: 'The open mouth is somewhat gaping and gabyish'.

Similarly, Deverell's *Twelfth Night* was met with contempt when first shown. The critic William Michael Rossetti – younger brother of a founding member of the Pre-Raphaelite Movement, Dante Gabriel Rossetti – complained that the head of Viola was 'not physically beautiful enough' and her 'short dress' was 'immodest'. Siddall was complicit in the creation of this shocking new modern art, which railed against Victorian standards and upset contemporary audiences.

Although initially Siddall modelled for multiple Pre-Raphaelite artists, this soon changed. In 1849, she met Dante Gabriel Rossetti, who invited her to pose for him too. Siddall did, willingly; but this wasn't enough for Rossetti who, wanting her all to himself, insisted his new muse work for him alone.

While Siddall's involvement with Deverell, Holman Hunt and Millais was defined by mutual respect and professionalism, the dynamic with Rossetti was altogether different: the pair had fallen in love. From the very start, they entered into an unstable, on-off relationship, and Siddall – once the muse of many – agreed to model just for Rossetti. In turn, the artist drew and painted her thousands of times, both as fictional characters and, pointing to his infatuation, as herself.

On many occasions, Rossetti created intimate portraits which show his muse caught deep in thought, reading or painting. In a particularly striking

drawing, *Elizabeth Siddal Seated at an Easel* (1850–60), her long hair has been tied back, a full-length gown hides her feet and, as she leans forwards, the focus of the composition is on her hand, which stretches out to make the first mark on a blank canvas.

This artwork reflects a hugely important aspect of Siddall's relationship with Rossetti; he encouraged his muse in her own painting. Treating her as his pupil, he shared his paints and studio with her, took her to art galleries, and taught her privately. Rossetti also invited her to collaborate with him on paintings, including murals on the walls of William Morris's Red House in southeast London.

Rossetti championed Siddall's work, wanting to ensure that she was taken seriously by the art world. Most importantly, he introduced his partner's portfolio of paintings and drawings to the leading art critic of the time, John Ruskin, in 1855. Ruskin was so impressed by her 'genius' that he bought the lot and took on the role of patron, giving Siddall a generous annual allowance. As the art historian Lucinda Hawksley points out, 'If she had not been Rossetti's lover, it is unlikely Lizzie would have had any chance of being noticed by the established art world. As a female artist, even one of brilliance, it was a Herculean task to infiltrate that patriarchal sphere – but the backing of a man such as John Ruskin was the stepping stone she needed to help bring her to the forefront and to be taken seriously as an artist.'

With Ruskin and Rossetti as her advocates, Siddall began to show her work – a remarkable feat given that in 1850s Britain women were rarely allowed to exhibit publicly. She exhibited paintings and drawings alongside the male Pre-Raphaelites, including at a salon at Russell Place in London in 1857. She also had work sent in a group show to America and, with the help of Ruskin and Rossetti, secured an exhibition for her paintings at a gallery in London's Charlotte Street.

Her paintings and sketches are typically Pre-Raphaelite in subject matter and style. Like her male counterparts, she featured heroines from literature within enchanted medieval worlds. In her drawing *The Lady of Shalott* she takes her inspiration from Tennyson's poem: the Lady, forbidden to leave her

tower, is only allowed to see the outside world through a mirror or else suffer a curse. Siddall shows the protagonist weaving tapestries, under the yoke of fate.

This drawing is typical of Siddall's art, in which we find active heroines who embody her own creative force. In another picture, she has drawn the witch Sister Helen burning a wax figure of her unfaithful lover. Turning inwards for inspiration, Siddall used herself as her own muse, as well as Rossetti; he appears alongside her in works in which they play couples from literature, including Macbeth and Lady Macbeth – with him prising the knife from her hand.

With Ruskin's support, Siddall achieved financial independence from Rossetti – she could now buy her own art materials. As well as giving her an allowance, Ruskin paid for Siddall to travel to Europe, although joined by a suitable chaperone; at this time, an unmarried young woman was expected to be accompanied, for propriety's sake, by an older married woman in public.

Siddall's trip to Europe was intended to improve her ill-health, and Ruskin specifically advised her to stay away from Paris. But Siddall refused his advice and, joined by Rossetti, spent six weeks in the city, where she saw Millais's painting of herself as Ophelia hanging pride of place in the Exposition Universelle.

Returning from Paris, Siddall also attended classes at Sheffield School of Art from 1857 to 1858. At this point, she gave up her allowance from Ruskin, and used her savings to pay for lodgings nearby the school. This move illustrates her ambition and desire to become an artist in her own right, beyond the control of any men. However, her burgeoning career was short-lived.

Throughout her life Siddall suffered from poor physical and mental health, including severe depression. A doctor's letter says she had curvature of the spine, and that she was potentially hysterical. Over time, she increasingly self-medicated with laudanum, an opium concoction widely used in the nineteenth century as a painkiller. In 1861, she became pregnant, but it sadly ended with the birth of a stillborn daughter, possibly due to her drug addiction. Left with post-partum depression, Siddall never quite recovered from this tragedy.

Rossetti, too, added to her anxiety. While he supported her professionally, he often failed to treat her fairly. He demanded exclusivity from her as his muse,

but he continued to take other models, including Fanny Cornforth, Jane Morris and Fanny Eaton. He also repaid Siddall's loyalty with serial infidelity: taking several of his muses as mistresses, he invoked great jealousy in his partner.

In addition to this, for ten years Rossetti remained 'engaged' to Siddall without setting a wedding date – a hugely unfair position to put her in given Victorian attitudes towards unmarried models. Finally, in 1860, the couple married in a simple ceremony in Hastings. But, by this time, Siddall's health was deteriorating – some researchers have proposed that the wedding only happened after Siddall's family called Rossetti to her sickbed and, understanding the urgency, he agreed to marry her. Just two years later, while pregnant with their child, Siddall died from an overdose.

What Siddall's story makes clear is that when a romantic element is added to the relationship between artist and muse, it complicates matters – particularly when the muse is also an artist. This is a pattern seen throughout history, in which artist-muses, especially women, have poured creativity into their romantic partners' work; and male artists have leveraged their status to control their female muse – just think of Picasso.

In the case of Rossetti and Siddall, their relationship was, without doubt, emotionally turbulent. For many critics, this volatility is reflected in Siddall's melancholic poetry, in which she often evokes unattainable love and frames herself as a doomed romantic heroine. In her poem 'Worn Out' the narrator, lying on her lover's chest, experiences tension between finding comfort and distress in their union:

> *Thy strong arms are around me, love*
> *My head is on thy breast*
> *Low words of comfort come from thee*
> *Yet my soul has no rest.*

However, to read such poems in a purely biographical light does Siddall a disservice as a poet: suggesting that she projects her own emotions, rather than create characters, lessens her credibility as a writer.

Just as we must separate Siddall's poetic persona from her as a poet, so too must we detach Rossetti's frequent representation of her, as a tragic romantic muse, from reality. After her death, he took inspiration from Dante's semi-autobiographical *La Vita Nuova* – in which the Italian poet mourns his late muse, Beatrice – to paint his notable canvas *Beata Beatrix* (*c*.1864–70). Seated with her eyes closed, enveloped by a hazy mist and surrounded by symbolic images from Dante's narrative, Siddall has been conflated with the idealised image of Beatrice, portrayed through Rossetti's lens of longing. As Dr Trowbridge points out, 'In *Beata Beatrix*, Rossetti memorialises his dead wife, so that Siddall becomes a vehicle for masculine yearning, which obscures her as a creative figure in her own right.' An allegorical figure of Love, portrayed as an angel, holds in her palm the flickering flame of the muse's life; it's as if Rossetti is extinguishing Siddall's image as an artist, too.

We must remember, however, that Siddall was far more than a tragic character to be looked upon with pity. Her story is not as straightforward as the legend of a passive fairy-tale princess plucked from obscurity to be framed as art history's heroine, used for her looks alone. Before meeting Rossetti, she had collaborated successfully with many of the movement's artists on a professional basis, playing a whole cast of characters from Ophelia to Viola. Acting as a co-conspirator within the Brotherhood, not only did Siddall become the face of this radical new movement, but she also went on to exhibit alongside her male counterparts as a key member of the group.

Moreover, exalted as a muse by Millais, Rossetti and others, Siddall remains in the spotlight. Of course, it's essential that we distinguish the real woman – artist, poet and performing model – from fictional depictions on canvas. But, Deverell's early image of her as Shakespeare's protagonist Viola, deliberately masquerading as her brother, does reflect Siddall's strategic place within the Pre-Raphaelite Brotherhood: she donned such disguises with real purpose, manipulating her position as muse to overcome the constraints of her time and infiltrate the patriarchal art world.

SUNDAY REED
In the Paradise Garden

In 1945, Australia's most famous artist, Sir Sidney Nolan, painted *Rosa Mutabilis*. Beneath a wide, blue sky and inside a large, abstracted green garden stands a single bush of white roses, from which emerges a young woman. Intertwined with the flowers, she appears to belong to this idyllic realm. In truth, it belonged to her, as did the white house, visible in the distance.

The figure in this picture is Sunday Reed; within the walls and gardens of her estate, called Heide, she entered into a creative and romantic partnership with Nolan, of which her husband John approved. However, Sunday's pivotal role in the painter's career also led to a dramatic dispute over ownership of Nolan's most famous artworks. To whom did they belong: artist or muse?

Seven years before painting *Rosa Mutabilis*, Nolan had sought out Sunday and John Reed. By 1938, the couple had established their reputation as influential patrons of contemporary Australian art. Sunday came from a wealthy family, and John was a successful lawyer; they poured their collective wealth into buying art from Melbourne's galleries, and they also began to back a small group of emerging artists, providing them with financial and moral support.

Nolan, on the other hand, was a shy young artist and writer, from a working-class background – he was the son of a Melbourne tram driver – and more than ten years younger than the Reeds. Yet he had enough self-belief to take his portfolio to John's law office, hoping to impress him. That same night, John took Nolan's art home to show Sunday, and the next evening they invited him to dinner at Heide.

Heide was a large Victorian farmhouse which the couple had bought in 1934. Located on the outskirts of Melbourne, in Heidelberg, Victoria, it came with six hectares of land. This was the spot where the Australian impressionists had come to paint, and it was ideal for what the Reeds had in mind; they

wanted to create a retreat where artists could stay, paint and share in their vision of creating a radical new style of modern Australian art.

Sunday and John worked hard to renovate both the house and its surrounding land, which backed onto the Yarra River. It was Sunday who took on the responsibility of cultivating and caring for Heide's extensive gardens; earlier in life, she had wanted to be an artist and treated the soil as a canvas, planting in it wild flowers, herbs, an orchard of fruit trees, vegetables and, most significantly, hundreds of rose bushes.

In their role as patrons of the arts, the Reeds created a haven for Australia's avant-garde artists: Albert Tucker, Sam Atyeo, Joy Hester, Charles Blackman, Mirka Mora and others. Sunday tended to the artists as she did the garden, with creativity and care. She embraced a reimagined, influential role of home-maker and hostess, cooking dinner for her guests, inviting them to engage in intellectual debates and welcoming them to stay for weeks, months and even years.

At times, the Reeds' attachments to their artists also became romantic, as they began to experiment with an open, loving marriage. Their first affair was with the modern painter, Sam Atyeo: Sunday and Atyeo became lovers, as did John and Atyeo's girlfriend and fellow artist, Moya Dyring. This casual arrangement paved the way for another, more significant partnership, between Sunday and Nolan.

The Reeds saw in Nolan an important blend of ambition and talent that they could foster, and accepted him into their circle of artists at Heide. He was soon visiting the couple on a regular basis, and spent his days reading in their impressive library, exploring the modernist art collection which hung on Heide's walls, and discussing literature with them.

During this time, Sunday and Nolan discovered a shared interest in the free-spirited nineteenth-century French poet, Arthur Rimbaud. His Symbolist writings expressed a guiding principle which both individuals subscribed to – that 'one must be absolutely modern'. Nolan helped Sunday to translate poems by Rimbaud, which they published in Australia's leading modernist journal, *Angry Penguins*, alongside reproductions of art by Heide's painters.

At the same time, Sunday deliberately steered Nolan, who was then keen on pursuing a career as a poet, away from writing and towards painting. She would read poems by Rimbaud and ask him to make art in response; this gave birth to abstract portraits of the poet, such as *Head of Rimbaud* (1939), in which Nolan celebrated the literary muse, whom he and Sunday shared, in simplified, geometric shapes, echoing the cubism of Cézanne.

Under the direction of Sunday, Nolan chose to pursue a career as a full-time painter. Sunday had carved a critical role for herself in his life, assuming responsibility as his mentor, champion and intellectual partner. It was also clear to everyone at Heide that Sunday and Nolan had fallen in love. Nolan was not long married, but within a year, in 1938 he left his wife and baby to live with the Reeds.

Nolan entered into what the French call a *ménage à trois* with the couple; Sunday shared her time between the artist and her husband. This arrangement was not without its difficulties, and resulted in tensions between John and Sunday. However, John never attempted to prevent the growing affection between Sunday and Nolan, and had affairs of his own, with artists at Heide as well as his legal secretary.

The artist Joy Hester wrote perceptively about Sunday's relationships with those around her at Heide, 'Sun has a power over everyone, which she uses very subtly to its fullest extent. She has the power of Nolan over John, he daren't make a false move if he wants to keep her, she has the power of "giving" over Nolan, also he is in love with her and cannot see lots of things. She has the power over me, that I cannot answer her back.'

Although Sunday was dominant, she did also have a softer side, which was what drew artists to her. As Hester went on to explain, 'Sun . . . gives a lot of love and I have the greatest admiration for the sensitivity that she possesses, which is on a high level, higher than I have ever met before . . . with a high degree of intelligence . . . at her best she is unbeatable for insight and sensitivity.'

Nolan captured this sensitivity in his poignant painting *Rosa Mutabilis*, in which he portrays Sunday as his inspiration and romantic muse. She appears as a vision of loveliness: her distinctive blue eyes shine out, lighting up the

composition. Nolan surrounds her with pale yellow and white rose petals, consciously evoking art history's long-standing, symbolic association between the rose and lovers.

This painting simultaneously shows Nolan celebrating Sunday's power as an inventive gardener. He clearly depicts her against the backdrop of Heide, with the white farmhouse she had redecorated, framed by pine trees she had planted. In the foreground, Sunday emerges from one of her rose bushes; she appears as an icon of her own domain, goddess-like, with her hair melting into the green grass and the Heide soil.

Numerous other Heide artists painted portraits of Sunday, often accompanied by roses, as their muse. Hester, with whom it is believed that Sunday also entered into a romantic relationship, painted a psychologically charged watercolour, *Lovers with Rose*, in around 1947. It shows the head and torso of a naked male figure; his lover is cut from view, but her arm hangs across his chest, and in her hand she holds a pale pink rose. This anonymous couple epitomises the multiple romantic affairs which took place at Heide, centred around Sunday and her beautiful rose garden.

From 1942 to 1944, Nolan had to leave Heide, as he was conscripted into the Australian Army and stationed in the Wimmera, which was over three hundred kilometres away. He wrote daily, sending separate letters to both Sunday and John, with whom he maintained a close, intimate friendship. In this earnest correspondence, Nolan refers to Sunday as his 'blue rose' and discloses his desire to be reunited with her: 'I do tremble for you sometimes girl you are not aware of how much you have given me.'

The correspondence from this time clearly demonstrates the intellectual stimulus which Nolan sought, and received, from both John and Sunday. In long letters, he posed questions and reflections on art history, artists past and present, poetry, politics, exhibitions, music and philosophy. Nolan respected and valued Sunday's judgements and observations across all of the arts, and it's evident that they were committed co-conspirators in developing a new language of modernism in Australian art.

Sunday had encouraged Nolan, like all of the Heide artists, to paint the Australian landscape in experimental terms. This is evident in his *Rosa Mutabilis* painting, which is bold in colour, abstracted and light-filled. However, while Nolan lived in rural Wimmera, he imagined the landscape in ever more vibrant colours, developing an increasingly exuberant style. He was looking both to Aboriginal art and its people, who feel a deep sense of belonging to the land, and towards a new type of painting, which defined the Australian outback in a raw, direct manner.

In August 1944, Nolan illegally deserted the army and retreated to Heide, where he was welcomed by the Reeds. Within the walls of this house, he painted twenty-seven works which are now recognised as the most important paintings of his career. Once again, he focused on the motif of the parched Australian landscape, but he also brought an iconic figure into his images: Ned Kelly.

Kelly was a nineteenth-century Australian outlaw, bushranger and gang leader, who has become an infamous, and controversial, figure in the country's history. While Kelly was a much-feared criminal in the eyes of many Australians, he was also a symbolic, anti-establishment hero who fought against the British colonists and corrupt police government. Nolan perceived of him, and portrayed him, in this light: 'Obviously, I have treated Ned Kelly as some sort of hero,' the artist later reflected.

Throughout the series of Ned Kelly paintings, Nolan re-tells the story of this Australian rebel hero, who was eventually captured, tried and executed. In his paintings, Kelly appears against the stark, simplified backdrop of the bush, in his homemade armour, often on horseback. These images are a celebration of Australian history as indelibly tied to its landscape. Just as we can see in Nolan's earlier painting of Sunday, who is surrounded by roses in her garden, people and place are inextricably interconnected. As Nolan famously explained, 'I find the desire to paint the landscape involves a wish to hear more of the stories that take place in the landscape . . . which persist in the memory, to find expression in such household sayings as "game as Ned Kelly".'

Many art historians understand Ned Kelly as the alter ego of Sidney Nolan. Australian researcher, David Rainey, points out important similarities between the painter and his subject: 'Both were fugitives from the law – Kelly a bushranger with a price on his head, Nolan absent without leave from the army; both had Irish roots, although Nolan's much-vaunted Irish heritage was Northern Ireland Protestant, not the Catholic roots of Ned Kelly. Nolan never bothered to correct this misapprehension – over time it would serve him well.'

There is no doubt that Nolan imagined Ned Kelly as his criminal counterpart, but could he also be the alter ego of Sunday Reed? Like Nolan, Sunday was a rebel, having defiantly turned her back on the traditional, middle-class life expected of her. Before meeting and marrying John, Sunday had been briefly married to an American man, Leonard Quinn, despite her family's disapproval, and spent her early twenties travelling around much of Europe with him. But, early into the marriage on this extended trip, Quinn was unfaithful – he gave Sunday gonorrhoea and an emergency hysterectomy to prevent the disease from spreading further left her infertile. Abandoned, Sunday subsequently sought and found comfort within an alternative, bohemian community of artists in Paris, before returning to Australia. This early streak of rebellion, as well as such betrayal, undoubtedly informed Sunday's second and thoroughly modern marriage.

During the early stages of their relationship, Nolan and Sunday had connected with the poetry of Rimbaud, which inspired the artist's experiments into abstract portraiture. Now, the couple identified with another free-spirited figure, Ned Kelly. They had a shared vision – to create a new, progressive language of Australian painting – and Kelly was the ideal icon who could serve this purpose, particularly when portrayed against the sparse outback.

It's impossible to separate Nolan's Ned Kelly series from his relationship with Sunday: all but one of the twenty-seven paintings were made on the kitchen table at Heide, where Nolan worked with her by his side. He refuted the idea that Sunday had come up with the idea for his Ned Kelly series,

though he did acknowledge her critical role in its conception, referring to her as a 'catalyst'.

Art historian Janine Burke also proposes that Sunday helped Nolan to paint some of these seminal works: 'She moved at that stage from being the studio assistant who was priming canvases and framing things to painting sections of the work.' Burke suggests that Sunday, once an art student, painted the red-and-white tiled floor in *The Trial* with a stencil and the patchwork quilt in *The Defence of Aaron Sherritt*. Her evidence is a watercolour painting of a woman by Nolan with the dedication, 'For the one who paints such beautiful squares'.

Without further proof, it is impossible to ascertain if Sunday painted parts of the Ned Kelly works. Nevertheless, without her, Nolan would not have created this seminal series; she was intimately involved in its creation and her vital input was recognised by other artists at Heide. In a letter written by Mirka Mora, the muralist acknowledges Sunday's contribution: 'Dear Sunday, the Nolan painting is so beautiful . . . And I realise it is not the painter who is the genius – for he is merely an instrument – but the person who sees it is a great painting . . . You are the genius for having seen at the time how beautiful the Nolan paintings were.'

Nolan, too, recognised that profoundly personal currents run through the canvases: 'I suppose I have to say that the Ned Kelly series, when I see them I feel that is a kind of rather important point in my whole painting career and a break through . . . they have an inner content which is known to me which is rather different to what seems to be their meaning . . . The Kelly paintings were done at a very critical stage of my personal life . . . In a way there are a lot of characters in the Kelly paintings that are related to my own life at the time.'

Imagery of Heide, and its gardens, is certainly embedded in the series. Years later, Nolan spoke about his work *The Trial*, revealing, 'The tiled floor in red and white was in a house I was in once.' Outwardly, his paintings tell the story of Australia's legendary outlaw, but the saga is equally about the artist's relationship with Sunday. Themes of injustice, love and betrayal pervade these paintings, echoing his affair with Sunday, which was coming to an end.

After the Ned Kelly series was completed, Nolan left Heide and never returned. By this time, Sunday had another person in her life – not a romantic partner, but a child. Unable to have children of her own, she took over the care of, and eventually adopted, Hester's son Sweeney after Hester was diagnosed with Hodgkin's Lymphoma in 1947. Nolan also had a new woman in his life, the sister of John, Cynthia Reed, whom he married in 1948, cementing the end of his affair with Sunday.

Nolan left the Ned Kelly paintings to Sunday, writing to John with a clear reason why: 'I do not feel that the Kellys belong to anyone other than Sun.' The feeling was mutual; she also felt that they belonged to her. If we return to the concept of the artist's patron: as she had not only financed Nolan, but also supported his creativity with emotional, intellectual and practical support, it's easy to see why the artworks were assigned to Sunday at this time.

Nolan's decision to leave the paintings with the Reeds also enabled them to continue on their mission. The couple remained committed to championing Nolan, as an individual artist, but also as a figure within their wider aim to promote Australian art on an international stage. In 1948, the couple showed the Ned Kelly series at Velasquez Gallery in Melbourne. The following year, they took them to Paris for an exhibition at the Musée National d'Art Moderne in 1949.

However, as Nolan achieved international success, his stance on the ownership of the Ned Kelly paintings shifted, and dramatically so. He wrote to the Reeds, demanding the return of his paintings, so that they could be shown in exhibitions; Sunday refused to let them go, perceiving herself as their co-creator. When the Whitechapel Gallery in London formally requested the paintings for his solo show in 1957, the Reeds were adamant in their rejection of the application.

John wrote to Nolan, 'For Sun there is no change . . . your paintings are just the same in relation to herself as they ever were.' Nolan mounted his Whitechapel retrospective without the Ned Kelly series. The British Council was next to approach the Reeds, requesting the paintings in 1959. This time,

the couple sent over two hundred paintings and numerous portfolios of drawings – but again, they kept the Ned Kelly series at Heide.

This argument over the paintings' ownership dragged on. The Reeds continued to exhibit the series internationally, sharing Australia's new modernism with the world, but they would not return the paintings to their maker. During the 1960s John wrote to Nolan on several occasions, making clear the couple's reason for claiming their rights to the paintings: 'Your life and ours were inextricably woven in a pattern of complete mutuality and intimacy. Each made his own contribution to the life we all led together, and your paintings were part of your contribution, even though you said Sunday painted them as much as you did. These paintings became in their own way as much a part of the total life we lived as Sunday's cooking, as the trees I planted, as the books we all read . . . without your life at Heide, a great many of them would never have been painted.'

In 1953, aged thirty-six, Nolan left Australia and settled in Britain, where he continued to paint the Australian landscape. Meanwhile, in 1956, the Reeds established the Gallery of Contemporary Art in Melbourne, with Sunday assuming the role of curator and critic. Two years later, the Reeds re-branded this gallery, reopening as the Museum of Modern Art of Australia, donating a huge number of works from their art collection by Hester, Tucker and others. Among this gift, they included Nolan's Ned Kelly series.

Nolan, however, could not let the dispute go. In 1971, he published a book of poems, with accompanying illustrations, titled *Paradise Garden*, in which he expressed his distress and 'shame' at the ongoing argument with the Reeds over his paintings.

> *SKY-BLUE*
> *Tremulous and painting*
> *she found me,*
> *mixing on the table*
> *the mountains*

and the mist,
where can I exist
she asked
how sit mutually
gazing for eternity
at the hard
blue canopy,
along with first-born
flowers she came
and the paintings
never spoke again
except in shame

Nolan's poetry frames Sunday as a toxic partner; he compares her to a 'snake' and writes of 'original sin' within the gardens of Heide, imagined as an Edenic realm of evil temptation, in which he should have avoided the forbidden fruit. He later reflected on the publication of these poems, which hurt Sunday deeply: 'As a human being I didn't want to do the book but, as an artist, I had to exorcise something and comment on it in this way.'

Nolan, looking back, considered himself the victim of abuse at the hands of the Reeds. We often think of the muse as the exploited party in their relationship with an artist, but on this occasion was it, perhaps, the other way round? Did Sunday – who was significantly older, richer and an influential patron – deliberately misuse her position of power? Nolan certainly seems to think so, as their relationship crossed the line from professional patron-artist into an intimate and increasingly tangled romantic partnership.

Nolan remained bitter towards the Reeds until the end of his life. On one occasion he questioned in his diary, 'Who has the Rosa Mutabilis painting? Barrie Reid? What is the point of that. I will repaint it. with a skeleton of the girl in the tree. Ern Malley as a virus. Roses also in Sole Arabian Tree.' Luckily, Nolan never repainted *Rosa Mutabilis*. Today, the painting still hangs

at Heide, now transformed into the Heide Museum of Modern Art and open to the public.

Rosa Mutabilis was painted as a pure celebration of Heide in its heyday, during which time Sunday was Nolan's patron and romantic partner, his muse, mentor and ally. At this point in their lives, Nolan and Sunday needed one another as they collectively strove to develop an original, avant-garde Australian art, which reached its pinnacle in Nolan's seminal Ned Kelly series. In his sixties, Nolan once again reflected on his time at Heide, remarking that his life had been 'indelibly influenced by the Melbourne experience'.

Until the ends of their lives, John and Sunday remained committed to cultivating and championing a new style of modern Australian art. Today, Nolan's Ned Kelly images are understood to be one of the greatest series of Australian paintings of the twentieth century. Sunday never returned the paintings to Nolan but, in 1977, donated them to the National Gallery of Australia. Far too infrequently do muses have a say in the ownership, exhibition and sale of an artwork. However, in this case, and as both John and Sunday would have wished, the paintings, impossible to divide between artist and muse, belong instead to Australia.

LADY OTTOLINE MORRELL

MORRELL

Bloomsbury Bohemian

T he central flame of one's personality has to be alone,' wrote Lady
Ottoline Morrell, 'but the outer pearls of this flame can touch others
and radiate out into life and art.'

In 1919, Welsh artist Augustus John painted a dramatically lit portrait of
Lady Ottoline, in which she wears a white pearl necklace, a deep green velvet
dress and a huge black hat. From beneath its brim, she peers out formidably,
her head held upright and blue-green eyes glancing sideways; abundant auburn
hair, cut to her strong jawline, frames her thin, aristocratically angular face.

John's remarkable portrait pays tribute to an extraordinary woman. At six
foot tall, Lady Ottoline was an imposing figure, who exaggerated her stature by
wearing high-heeled shoes, extravagant hats and colourful silk gowns. A rich
heiress with a love of art and literature, she fashioned herself as an enthralling
muse for artists, inspiring over five hundred portraits. Yet in none of these
artworks is she ever smiling, and there is a significant reason why.

Much of Lady Ottoline's life was spent in her sprawling manor home in
Oxfordshire: Garsington. Here, she and her husband Philip Morrell, a Liberal
MP, invited artists, writers, intellectuals and philosophers to join them for
dinners, drinks on their terrace and dancing in the garden, which was filled
with sunflowers, marigolds, lavender and roses. Writing in her journal, Lady
Ottoline described Garsington in romantic terms, as 'a far-away castle on a
hill'. Much of what unfolded within its walls was enchanting, although – and
like any good fairy tale – there was also a darker side to the mistress of this
mansion.

The Morrells left London for Garsington in 1915, which was partly a reac-
tion to the outbreak of the First World War. For Lady Ottoline, who was a
pacifist, it was important that she live 'away from London, the horror of the
War'. In 1916, military service was announced as compulsory for all single

British men, and those who objected to the war and thus refused to fight earned the formal status of conscientious objectors. Seen to have rejected conventional British society and everything it stood for, this small minority was required to work as labourers. The heiress recalled in her journal the community of creatives, a good number of whom were conscientious objectors, whom she welcomed: 'We have had many, many people here. It seems to me crowds come and go, the house full every week-end, and overflowing . . . In July Vanessa Bell and Duncan Grant came and Lytton Strachey, who stayed on some time and indeed has spent most of this summer here.' At Garsington she created a haven for these like-minded people to 'meet and think and talk freely', while providing employment on their estate's farm to those objectors who would otherwise have been prosecuted.

Among Lady Ottoline's guests were members of the notorious Bloomsbury Group, a collective of English writers, intellectuals, philosophers and artists, which formed at the start of the twentieth century. The name was born from their weekly meetings at Vanessa Bell's London home, which she shared with her sister, Virginia Woolf. At their gatherings, the group discussed a range of topics, stemming from their shared interest in literature, a commitment to the arts, liberal political views and an anti-war stance – Duncan Grant, Lytton Strachey and David Garnett were among those who became conscientious objectors. The members were also united in their rejection of strict Victorian ideals; instead, they embraced a culture of sexual freedom. Today, the group are just as well-known for their interwoven love lives and multiple affairs as they are for making art or writing novels.

It's not surprising that Lady Ottoline – a woman who in her own words aspired to live 'on the same plane as poetry and as music' – was entranced by the Bloomsbury Group. While living in London, she took tea with Vanessa Bell and Virginia Woolf at their home; in her own words, she was 'dazzled' by them. Similarly, Woolf was impressed by Lady Ottoline, and later confessed that their relationship was like 'sitting under a huge lily, absorbing pollen like a seduced bee'.

Lady Ottoline welcomed the Bloomsbury bohemians to dinners and soirées at Garsington. In her memoirs, Lady Ottoline remembered specific evenings, including a memorable 'hot moonlit night, when we all went into the garden and some of the young people, who were staying, amongst them Duncan Grant, Bunny Garnett, Carrington and Gertler, were dressed up in fancy clothes, of which I had a store, and danced a wild and lovely ballet on the lawn'.

A dazzling oil painting by Grant brings this enthralling journal entry to life. In the picture, he depicts Lady Ottoline wearing a bright yellow dress which sweeps the floor, along with an enormous yellow hat to match. Her arms are outstretched, performatively, as if she has just been caught dancing by the artist; she exudes some serious stage presence. Similarly, a painted portrait by Simon Bussy shows her in a striking green headdress, against a turquoise backdrop, looking like a colourful peacock or butterfly. These portrayals of Lady Ottoline illustrate the great pleasure which she took in dressing up; she invented herself through fashion, constructing the image of a fanciful, free-spirited heiress through an extensive array of ostentatious outfits, all made from luxurious fabrics.

Lady Ottoline's theatricality extended throughout her home, which was filled with silks, oriental furnishings, paintings, bowls of potpourri and colourful flowers in the garden. Bloomsbury Group writer Garnett later detailed his overwhelming, visual experience of staying at Garsington: 'The oak panelling had been painted a dark peacock blue-green; the bare and sombre dignity of Elizabethan wood and stone had been overwhelmed with an almost oriental magnificence: the luxuries of silk curtains and Persian carpets, cushions and pouffes.'

Lady Ottoline recognised that she had turned her home into a dramatic stage: 'Sometimes I felt as if Garsington was a theatre, where week after week a travelling company would arrive and play their parts.' Taking to the floor in showy costumes, she was, in many respects, a performance artist, and Garsington the backdrop to her production. It makes perfect sense, then, that she was featured as a melodramatic muse in the paintings of the artists she supported.

If there is one portrait which tells the true story of Lady Ottoline, however, it's a black-and-white photograph by Adolph de Meyer from 1912. The shot shows her self-consciously posed for the camera, hand on hip, looking directly down the lens. Her long dress balloons and folds itself around her, while her pale face is framed by thick, wavy hair, which we know she dyed red. The light catches her expression – it is entirely serious.

Although few people are found smiling in portraits from this time, the stern intent on Lady Ottoline's face is illuminating. This photograph exposes a woman who deliberately constructed herself in the image of a magnificent Pre-Raphaelite muse, like Elizabeth Siddall or Jane Morris. She wanted artists to use her as their model, thereby explaining the remarkable, defining feature of every single portrait of Lady Ottoline: you never once see her smiling.

The solemnness of Meyer's photo indicates just how seriously Lady Ottoline took her job, as patron-muse of the Bloomsbury Group. A generous hostess, she treated her guests to much more than entertainment; she also provided them with practical aid, offering them space to focus on their creative endeavours and a refuge during World War One. 'A woman must have money and a room of her own if she is to write fiction,' wrote Woolf, and this is exactly what Lady Ottoline gave to those whom she supported, transforming Garsington into a safe retreat for artists and writers.

It was not just the Bloomsbury Group who benefited from Lady Ottoline's benefaction. She and her husband assisted numerous young, aspiring writers, including Aldous Huxley, Siegfried Sassoon and T. S. Eliot, whose modernist work expressed their anti-war sentiment. The novelist Henry Green also recognised her commitment 'to literally hundreds of young men like myself who were not worth her little finger, but she took trouble over them and they went out into the world very different from what they would have been if they had not known her'.

One of the most famous writers to stay at Garsington was D. H. Lawrence – he and Lady Ottoline shared an interest in novels, poetry, politics and museums, which they visited together during day trips into Oxford. In

intimate letters to her, Lawrence reflected that 'there is a bond between us, in spirit, deep to the bottom'. The manor was not merely a guesthouse for the author, but it had become his 'spiritual home'. While he may have been flattering his hostess in return for future favours, these letters seem heartfelt and the words genuinely meant.

It's clear that there was an intellectual connection between this mistress-muse and her artists. Far beyond offering financial support and a practical space to write, and on top of hosting parties where they could meet similar-minded individuals and other wealthy patrons, Lady Ottoline offered her guests the opportunity to engage in intellectual discussion and share ideas. She was an important contributor to these debates, revelling in her role: 'The best and most exciting talks we had, were as we filed up to bed at night. These talks always seemed to have an essence and an exciting quality of their own. Slowly, lingering step by step up the old oak staircase, each bearing and waving about our old-fashioned flat silver candle-sticks, talking, talking, and then in groups in the wide matting-covered passage, with its old cabinets and chests of drawers and oriental porcelain, we would stand, having perhaps come to the most exciting knot of our discussions . . . a few generally followed me into my bedroom, and crouched round the wood fire . . . those fire-lit talks wove a web of intimacy and understanding between us.'

Backing up Lady Ottoline's account, the British biographer and historian David Cecil, who had stayed at Garsington, recognised her indispensable contributions to those who surrounded her: 'In the company of her distinguished friends she seemed of their spiritual kin, and in force and originality of personality wholly their equal. One looked at her and listened to her and remembered her as much as them.'

It is evident just how much the circle of artists and writers around Lady Ottoline meant to her. As she reflected, 'I was interested in them all, and threw myself into their lives.' At times, friendship evolved into romantic relationships; we know Lady Ottoline had affairs with Augustus John and philosopher Bertrand Russell, among others. She also recalled her attraction to

Woolf: 'This strange, lovely, furtive creature . . . comes and goes, she folds her cloak around her and vanishes, having shot into her victim's heart a quiverful of teasing arrows.'

There was genuine affection, on both sides, between Garsington's guests and their benevolent hostess. She felt a deep connection with many of them, becoming involved in their lives beyond what is usually expected of an artist's patron. A keen artist in her own right, Lady Ottoline also photographed her famous contemporaries, typically seated at work in the sanctuary of her house and gardens, or standing posed for her camera, clutching handwritten papers. She kept these images in a personal photo album, held very dear to her, proving their great importance in her life.

But Lady Ottoline was not always repaid kindly. In D. H. Lawrence's novel *Women in Love* the character of Hermione Roddice is unmistakably a caricature of Lady Ottoline: 'Her long, pale face, that she carried lifted up, somewhat in the Rossetti fashion, seemed almost drugged, as if a strange mass of thoughts coiled in the darkness within her.' Lady Ottoline was horrified to find herself represented in this manner, and by a man she considered her friend: 'I read it and found myself going pale with horror, for nothing could have been more vile and obviously spiteful and contemptuous than the portrait of me that I found there.' After reading the novel, she broke off contact with Lawrence for a decade.

Huxley, too, caricatured Garsington in his first novel, *Crome Yellow*, which tells the story of a house party at Crome, a parodic version of Lady Ottoline's manor. She found this equally upsetting: 'When I read in it the description of our life at Garsington, all distorted, caricatured and mocked at, I was horrified.' Lady Ottoline had been betrayed by the writers whom she had supported.

While she could control her own appearance, she couldn't dictate how artists or writers depicted her, and didn't always like what was reflected back. Perhaps it was because she tried so hard to fashion herself in the image of a muse that Lawrence and Huxley poked fun at her through caricature. Lady

Ottoline – and quite rightly so – felt that these portrayals were unfair, especially since she considered both men to be close friends.

Her hurt at these critical portrayals demonstrates that, beneath her extroverted exterior, there was a more sensitive side to her character. Despite hosting lavish parties and welcoming a constant influx of guests into her home, Lady Ottoline also craved time alone. In solitary moments, she wrote extensively in a journal in which she remarked on the huge amount of 'support and sympathy and encouragement' she gave to those who stayed at Garsington and who, at times, emotionally drained her with their demands for constant praise and affection.

We can also see from Lady Ottoline's writings that she suffered, on occasions, from depression. She frequently imagines herself as a bird in a gilded cage, 'longing to get out and fly away, away far from the batterings and harshnesses of those around me'. With the creation of Garsington as a shelter and nurturing environment for artists, particularly those who held conscientious objector status, came great responsibility from which she could not simply flee.

Lady Ottoline's suffering at the cruel caricatured representations of her also shows just how much musedom meant to her, and the extent to which she committed to it. Yes, Lady Ottoline manufactured her image as a larger-than-life, bohemian model for multiple artists, enjoying the theatricality of the part. However, she also entered into this position with sincerity, consideration and the utmost respect for the duties it required.

Countless artists and writers recognised the immense contribution that Lady Ottoline made to their careers. Lawrence even later apologised for the upset he had caused, reflecting on the heiress's positive effect on his life: 'You've been an important influence in lots of lives, as you have in mine: through being fundamentally generous, and through being Ottoline. After all, there's only one Ottoline. And she has moved one's imagination.'

Lady Ottoline invited artists to immortalise her through their work, encouraging them to see her as an auburn-haired, Pre-Raphaelite model, dressed in long, flowing gowns. In contrast to many muses from art history,

she enjoyed a financial position of power; but this alone could not dictate how an artist or writer depicted her. In contrast to a paying client, able to stipulate their representation in a commissioned portrait – Lady Ottoline was at the mercy of their imaginations; but this does, of course, also prove that she had succeeded in her aim: to become a true muse.

We do also know that Lady Ottoline liked many of her portraits, which she endorsed by hanging them in her home. Among the approved portraits was John's painting, *Lady Ottoline*, which she positioned above her mantelpiece. John has captured both sides of her – the majestic, magnificent mistress and a more vulnerable individual. If you look closely at her eyes, they are watchful; this is not an invincible woman, even if she wants you to believe it. This sensibility is what enabled her to truly connect with the artists and writers at Garsington, who were moved to portray this complex character across art forms.

Becoming a muse entailed much more than game-playing and dressing up for Lady Ottoline. Instead, she was driven by a serious intent to inspire some of the most important artists of the twentieth century, both in and beyond the Bloomsbury Group. Flouting social conventions in a subversive act of allyship, she created a paradise for other pacifists, conscientious objectors and a wider group of creatives, successfully influencing their modern lives and careers in her own determinedly sensational style.

MARCHESA LUISA CASATI
Medusa's Stare

At the start of the twentieth century, the residents of Venice could catch sight of a strange apparition. As night fell across the city, a six-foot-tall, skeletal-looking woman with short red hair, ghostly white skin and dark eyes would be seen strolling between the canals, wearing nothing but a fur cloak and holding the jewelled leashes of two cheetahs which followed at her heels. But while phantom-like, this woman and her exotic pets were no hallucination; Venetians had glimpsed the wealthy Milanese heiress, Marchesa Luisa Casati.

In 1910 Casati had leased and moved into the Palazzo dei Leoni – now the Peggy Guggenheim Museum – on the Grand Canal. In 1903 she married the Marquis Camillo Casati Stampa di Soncino, with whom she had a daughter, but just three years after her wedding Casati became the lover, and the muse, of the writer Gabriele D'Annunzio. D'Annunzio wrote her into his 1910 novel, *Forse che sì forse che no (Maybe yes, maybe no)* as the rich widow Isabella Inghirami, and introduced her to a new world of artists and writers. Casati had been given her first taste of musedom, and she was hooked. Turning her back on conventional society and the life expected of her, Casati declared the sole purpose of her life: 'I want to be a living work of art.'

Now leading an exclusively independent life from her husband, Casati set about transforming her Venetian palazzo into a fantastical realm, fit for a muse. Retaining the romantic, crumbling waterfront facade, she hired a team of designers, builders and carpenters to refurbish and redecorate its interior with black-and-white marble floors, chandeliers and curtains of gold lace. Meanwhile, Casati began to fill the gardens with a menagerie of unusual animals: peacocks painted white, monkeys, cats, greyhounds, parrots, snakes and, of course, her pair of legendary cheetahs.

Portraits of Casati frequently represent her accompanied by these strange pets. In Giovanni Boldini's early painting, *Portrait of the Marchesa Luisa*

Casati, with a Greyhound (1908) she stares alluringly – with wide dark eyes and a mischievous smile – at the viewer from beneath a huge black hat adorned with feathers. Wearing a matching floor-length black satin dress and with an expressively outstretched white-gloved hand, she holds the leash of her black greyhound; dog and owner are entirely coordinated. Similarly, in Boldini's *The Marchesa Casati with Peacock Feathers* (1914) Casati sits within a bed of expressively painted peacock feathers, which also adorn her headdress; it's as if she is metamorphosing into one of her birds.

The Italian artist had been commissioned to paint such portraits of the heiress; Casati effectively paid to become Boldini's muse, stage-managing sittings and sending him countless photographs. However, it wasn't merely through her association with curious animal companions that Casati created an outlandish image of herself. Though not considered beautiful according to conventions of the time, she created herself in the image of an enthralling actress – she dyed her hair flame red, powdered her skin to a bleached white and wore long false eyelashes. She would line her famous green eyes with dark kohl and regularly use drops of Belladonna, a plant-based potion with the power to dilate pupils, evoking the pitch-black eyes of her pet snakes.

Casati didn't stop there: she also commissioned the most daring designers and couturiers, from Paul Poiret to Romain de Tirtoff (better known as Erté), to dress her in increasingly extravagant outfits for parties across Europe and the themed costume balls she threw at her own palazzo. On her guest list were socialites, renowned writers and avant-garde artists, including Pablo Picasso and Jean Cocteau. But the star of these parties was always Casati herself, as writer Robert Fulford remembered: 'Exhibitionism was her art form. By entering a room, she turned everyone else into a spectator.'

Casati, who became infamous for her decadent costumes, dressed as Roman Empress Theodora, Lady Macbeth with a bloodstained hand attached to her throat, a glittering sun goddess and Eve with a drugged snake around her neck. She wore a Paul Poiret-designed 'fountain dress' made from three tiers of pearls and wire, and transformed into St Sebastian complete with a suit

of silver armour pierced by brightly lit electrified arrows, which accidentally electrocuted her. Through such endlessly inventive outfits, Casati was undoubtedly advertising herself to any artists in attendance as a muse to be admired.

Casati soon caught the attention of a new artistic and social movement which was then gaining momentum in Italy: Futurism. In 1909 the poet Filippo Tommaso Marinetti published the founding *Manifesto del Futurismo* in which he denounced the past and traditions in favour of the modern world. The Futurists celebrated, and aimed to capture, the dynamism, power and speed of the new age across all art forms, including fashion. It's no surprise, then, that this group of young artists were enthralled by Casati's modernist attire, which embodied the ideals of their movement.

But the Futurists also broadcast loudly, in a series of manifestos, their open hostility towards femininity: 'We scorn women when conceived as the only ideal, the divine receptacle of love, woman as poison, woman as the tragic plaything, fragile woman, haunting and irresistible, whose voice, weighted down with destiny, and whose dreamlike mane of hair extend into the forest and are continued there in the foliage bathed in moonlight.'

It's astounding and ironic that Casati managed to become the muse of such a misogynistic movement. However, she was far removed from the image of feminine sentimentality which the Futurists rejected. By 1914 Casati, who cut her hair dramatically short in a shockingly androgynous style for that time, had also divorced her husband. Disregarding all expectations of a noblewoman, she instead threw herself into cultivating and championing those artists who could grant her wish of musedom. Firmly displaying her credentials as a Futurist, it's clear that – at least in the eyes of these artists – Casati existed beyond their notions of traditional womanhood.

As she had done with Boldini, Casati commissioned numerous portraits by the Futurists, including painter Alberto Martini, who portrayed her wearing various costumes, from that of a ferocious archer atop the Grand Canyon to the cunning Cesare Borgia who inspired Machiavelli's *The Prince*. In his colourful painting, *Marchesa Luisa Casati as Euterpe* (1931) she even appears

as the muse of music from Greek mythology, complete with instrument in hand – although depicted with six eyes to evoke notions of dynamism, Casati comes closer instead to the look of a mythical beast than a feminine goddess.

From deliberately positioning herself as Boldini's model, numerous other Futurist artists, including Giacomo Balla, Umberto Boccioni and Fortunato Depero chose to portray Casati in Futurist terms. Balla, for instance, created a playful moving bust, titled *Marchesa Casati with mica eyes and a wooden heart* (1915) from various materials, including painted wood and sheets of cardboard. When visitors turned the model's heart, the abstracted face of Casati came to life – her eyes blinking, like a marionette.

Casati not only inspired, but was also idolised by, the Futurists. Marinetti, with whom she became close friends, credited her with keeping the movement alive during the First World War when she hosted the group at her home in Rome. He subsequently dedicated his 1917 *Manifesto of the Futurist Dance* to her, and even identified Casati as a member of the group when he gifted her a portrait of himself, painted by Carlo Carrà, with a dedication to 'the great Futurist Marchesa Casati with the languid satisfied eyes of a panther that has just devoured the bars of its cage'. As Casati's biographers Scot D. Ryersson and Michael Orlando Yaccarino write, 'Unlike the typical society patron, Casati was fearless in becoming an eager accomplice to the talent she supported. For them, she became a tangible and effective promotion of their radical artistic experiments.'

However, Casati did not champion and collaborate with the Futurists alone. The heiress made frequent trips to Paris, where she would stay for months at a time, usually at the Ritz as it allowed her to bring her pet boa constrictor, Anaxagoras, which is said to have escaped into another guest's room on one occasion. It was during one of her stays in the French capital that Casati met the surrealist artist Man Ray, whom she proposed photograph her. As Man Ray recalled in his memoirs, 'I received a visit from a tall imposing woman in black with enormous eyes emphasised with black makeup. She wore a high headdress with black lace and bent her head slightly as she came through the

door, as if it were too low for her. Introducing herself as the Marquise Casati, she expressed the wish to have herself photographed.'

Fascinated by this larger-than-life figure, Man Ray obliged and, at first, seems to have regretted his decision to shoot Casati as she couldn't sit still: 'It was trying work – the lady acted as if I were doing a movie of her.' But, exploiting her restlessness, and using the technique of double exposure, he captured his sitter in a blurred black-and white-photograph, *Marchesa Casati* (1922). In this closely cropped, uncanny image the heiress emerges from the dark, with her mass of tangled hair and six eyes, appearing as a mystical being.

Man Ray, taken aback with the result, remarked that Casati was 'a Surrealist version of the Medusa'. Many of the surrealists, who were focused on picturing the subconscious, drew inspiration from Sigmund Freud's psychoanalytical writings, in which he had proposed that mythology was a means of revealing the human psyche. Casati had presented Man Ray with a ready-made image of the snake-haired Gorgon from Greek mythology whose stare could turn anyone she looked at to stone; in the photograph her piercing eyes offer an opening into her inner self.

Casati, too, recognised that Man Ray had 'portrayed her soul' in his image; thrilled with it, she sent copies to D'Annunzio and numerous friends. Equally impressed, they wanted their photograph taken by this emerging French artist: 'Sitters began coming in – people from more exclusive circles, all expecting miracles from me,' Man Ray remembered. Taking Casati as his muse had been an excellent career move for the surrealist; not only had he created an iconic image in the spirit of the movement, but he had also gained new supporters and patrons. Moreover, from this point onwards, eyes became a recurring symbol, and double exposure a trademark, of his dreamlike photography.

Man Ray was among several artists who regarded Casati as a monstrous figure, and represented her as such. After meeting her at a luncheon in London, American-British sculptor Jacob Epstein invited the heiress to model for him. 'We began the sittings and her Medusa-like head kept me busy until nightfall,' he reminisced. 'The winter light had failed and I had many candles brought

in. They formed a circle round my weird sitter with the fire in the grate piled high to give more light. The tireless Marchesa, with her over-large blood-veined eyes, sat with a basilisk stare.'

The result of this evening rendezvous between artist and muse was the almost life-sized bronze bust, *Marchesa Casati* (*c.*1918). In contrast to Man Ray's pulsating picture of Casati as a writhing Medusa, Epstein mounted her head upon a black base, recalling the moment in the myth when the Greek hero Perseus successfully beheaded her. Although motionless, the imposing heiress confronts viewers with a mass of wild hair and wide snake-like eyes, an image of dangerous beauty to be controlled.

Casati's unconventional allure stopped many artists in their tracks, including Welsh painter Augustus John. He remembered in his autobiography the moment that he first set eyes on the Marchesa at a party in Paris in 1919: 'A lady of unusual distinction had entered. Her bearing, personality, and peculiar elegance seemed to throw the rest of the company into the shade . . . She moved about the ballroom with supreme ease, while looking about her with an expression of slightly malicious amusement. Our eyes met. Before leaving I obtained an introduction; it was the Marchesa Casati.'

It was not long after that John painted *The Marchesa Casati* (1919). The first of four portraits of Casati, here she is dressed in creamy silk pyjamas, standing before an abstracted blue-green landscape which contrasts with her curled red hair and full lips. With hands clasped before her waist, she turns her body and dark, heavily made-up eyes, towards the viewer with a sultry look. Although posing provocatively, there is an intimacy to this painting, in which Casati has been stripped of her theatrical costumes. Instead, viewers encounter her as a romantic muse, indicating the short love affair she had begun with John, following on from which the pair became lifelong friends.

Casati also appears in the image of a sensual romantic muse in the paint-ings of Dutch Fauvist painter, Kees van Dongen, who wrote enthusiastically in a letter to the French art critic Félix Fénéon about his desire to take her as a muse: 'I know La Casati. Her type is immediately agreeable to me and I

would be very happy to paint her portrait.' Van Dongen frequently portrayed wealthy women on his canvases, transforming them into slender, wide-eyed princesses, imagined in a palette of vibrant colours. He understood exactly what they wanted from him, commenting, 'The essential thing is to elongate the women and especially to make them slim. After that it just remains to enlarge their jewels. They are ravished.'

But Casati, naturally tall and thin, required very few flattering altera-tions in the eight known portraits he made of her. In *The Bowl of Flowers* (1917), she appears before a mirror, dressed only in a pearl necklace, red stilettos and a gauzy grey shawl which she has deliberately dropped to her thighs to uncover her slender frame. On the floor a white greyhound dozes, adding to the dreamy and relaxed atmosphere of the painting, in which Casati appears behind the closed doors of her own boudoir.

Casati wasn't the romantic muse of exclusively men, either. Travelling to the island of Capri in 1920 – where a community of queer artists congregated – she met American artist Romaine Brooks. A wealthy heiress herself, Brooks had the freedom to paint whoever she liked and in whatever manner she pleased; in a distinctive palette of muted tones, she expressed her sitters' gender non-conforming identity through fashion, famously painting herself with a cropped haircut, top hat, tailored riding coat and white shirt in her 1923 work, *Self-Portrait*.

Learning that Brooks was on the island, Casati was determined that this painter – who renounced restrictive ideas of how women should look and behave – should immortalise her on canvas. She proposed a commission which, according to Casati's biographers, Scot D. Ryersson and Michael Orlando Yaccarino, the artist at first declined: 'Brooks invented a number of feeble excuses to avoid it. But the Marchesa was indomitable.'

Brooks not only gave in to Casati's demands, but she also painted her in the nude – stirring jealousy in her long-term partner, the writer Natalie Barney, who must have guessed that the pair had also entered into a sexual relationship. In *Portrait of Luisa Casati* (1920) the heiress stands naked, with

the exception of a dark cloak draped over her right arm, which falls to the floor of craggy grey rocks below. Her other arm, outstretched at full length to evoke the large wingspan of a predatory bird, ends with her hand gripped tightly like a claw. Staring straight at the viewer, in an almost antagonistic manner, Casati appears in the image of a cruel siren; in Greek mythology these hybrid bird-women lured sailors to their deaths on the rocks with their enchanting singing.

Although Casati had commissioned this portrait, Brooks refused to give it to her. Instead, she held on to the painting of her muse – imagined as a wicked femme fatale – for herself. Perhaps she wanted a memento of their affair, particularly given the magnificent canvas which she had created. But it's also possible that Brooks – who is said to have kept the canvas rolled up under her bed – held on to it for another reason. Although she came to admire Casati, Brooks found the process of working on the portrait all-consuming, and wrote to Barney, 'I am exhausted, I am losing weight, I am losing my hair, I am afraid, I need my rest.' Perhaps she also wanted to preserve the painting, which could act as a warning sign against taking on other such romantic muses.

While we often think of artists possessing power over their muses, in the case of Brooks and Casati these stereotypical roles were entirely reversed, and the effects of their partnership were detrimental to the painter. Brooks certainly wasn't the first artist to have been obsessed or haunted by their romantic muse. When Alma Mahler left Oskar Kokoschka in 1918, he famously commissioned the doll-maker Hermine Moos to create a life-sized replica of her, from which he drew, painted and photographed again and again.

Like Mahler, Casati entranced many of the artists she modelled for, not least Brooks. But she also seems to have bewitched herself. In fact, just like Kokoschka, Casati commissioned Catherine Barjansky to create a life-sized wax mannequin in her own image, with a wig made from her hair and green glass eyes – she clothed this body double in fantastical outfits and brought it to dinner with her, as well as to dress fittings in Paris. In a reversal of the Pygmalion story from Ovid's *Metamorphoses*, in which the sculptor's artwork

Galatea is brought to life, Casati chose to cast herself as a lifeless statue. Obsessed with creating herself again and again, she acted as an artist, taking herself as her own muse and preserving herself in wax.

Without doubt, Casati's lifelong fixation with becoming a muse took its toll on her. Her entire life was a choreographed performance, into which she poured not only time and energy but all of her vast inheritance. By 1930, she had amassed a personal debt of US $25 million; unable to pay her creditors, her personal possessions were auctioned off. Among the bidders was Coco Chanel, who acquired a pair of bronze deer which she displayed in her sitting room.

Casati spent the last years of her life living in a small flat in London, where she was supported by friends including Augustus John. When she died in 1957, at the age of seventy-six, she was financially bankrupt. Twenty years after her death, Erté created an enchanting art deco illustration, *Alphabet L for Luisa and Leopard* (1976) in tribute to the woman he had dressed. Wearing a figure-hugging leopard-skin dress and jewelled collar, she is chained by the neck to the leopard which lies at her feet, almost like a slave to her overwhelming desire to become a spectacle.

But Casati had undoubtedly succeeded in her aim to become a muse – she appears in over two hundred known portraits. The Marchesa's unconventional appearance and spectacular way of life sparked inspiration for some of the most significant modern art movements: surrealism, Futurism, Fauvism. At the same time, the likes of John, van Dongen and Brooks captured the complexities of this extraordinary woman beneath her costume. Throughout her varied portrayals, from femme fatale to eccentric lover, Casati's prominent eyes show her seeing just as much as she is seen, reflecting the fact that she took herself as her own muse, too.

In the legendary Greek myth of Medusa, even after the hero Perseus had cut off her head, the Gorgon's powerful stare could still turn people to stone. Like Medusa, Casati has continued to inspire countless artists and fashion designers, from John Galliano to Alexander McQueen, while British designers

Georgina Chapman and Keren Craig created the Marchesa fashion house in her name. She is buried at Brompton Cemetery, where her small unassuming tombstone is inscribed with a poignant epitaph from Shakespeare's *Antony and Cleopatra*: 'Age cannot wither her, nor custom stale her infinite variety.' Casati didn't just achieve her aim to become a living work of art, she also surpassed it – in life and in death.

MUSE AS MESSAGE

ANNA CHRISTINA OLSON

Christina's World

One of the most popular paintings in New York's MoMA is *Christina's World* (1948) by American realist artist Andrew Wyeth. Lying in an empty treeless field of dried-out grass, with her back turned to the viewer, is a young woman. Her slightly dishevelled dark hair has been tied back in a ponytail and she wears a pale pink dress pulled in to her slender waist by a soft black belt. At first glance, it looks like she's awaiting the arrival of someone – a lover, perhaps?

If you look more closely at this seemingly romantic image, however, it becomes clear that the reclining figure is far from relaxed: one thin arm stretches towards an old, grey farmhouse which is visible in the distance, while the other seems to prop the woman up, making her appear surprisingly alert. Since the painting was first exhibited, viewers have been drawn in by this solitary sitter and the questions she raises: who is she, what is she doing here, and why has Wyeth painted her?

In order to determine the identity and significance of Wyeth's muse, we must first meet his wife. On 12 July 1939, the twenty-two-year-old artist was invited by Merle James, a fellow artist and printer, to visit him at home in Cushing on the coast of Maine. It seems that Merle may have had an ulterior motive for the visit, as he introduced Wyeth to his three daughters, including the youngest, seventeen-year-old Betsy James, whom the artist would marry the following year. Having recently learned to drive, Betsy offered to take Wyeth to see a nearby nineteenth-century saltwater farm; instantly struck by the vision of this weathered three-storey building on a hilltop, Wyeth leant against the hood of her car to take a quick watercolour impression of it.

During this trip, Betsy also introduced Wyeth to the owner of this isolated farmhouse, as well as his sister and her close friend since childhood, Anna Christina Olson. As a young girl, Olson had developed a degenerative muscle

condition – likely to have been Charcot-Marie Tooth (CMT) disease which causes weakness and a lack of coordination in the limbs – leaving her unable to walk. It is Olson who inspired *Christina's World*, and appears as if lying in the grass, pictured in front of the farmhouse, now known as Olson House, where she lived with her brother Alvaro.

This famous artwork is one of four paintings, as well as a large number of drawings, in which Wyeth took Olson as his muse. Explaining his decision to paint her, the artist stated that he wanted 'to do justice to her extraordinary conquest of a life which most people would consider hopeless. If in some small way I have been able in paint to make the viewer sense that her world may be limited physically but by no means spiritually, then I have achieved what I set out to do.' It's undoubtedly a worthy goal, but did Wyeth, an able-bodied man observing Olson from his own perspective, deliver it?

Although they met in 1939, it took Wyeth until 1947 to paint his first portrait of her. However, he did depict Olson House and the surrounding farmland hundreds of times before then, remarking, 'I just couldn't stay away from there. I did other pictures while I knew them but I'd always seem to gravitate back to the house . . . It was Maine.' Following the first introduction by Betsy, Wyeth developed a close friendship with the Olson siblings, who allowed him to turn one of the upstairs rooms into a studio from which he painted the view repeatedly, indicating the special place it occupied in his heart.

One mesmerising painting, *Wind from the Sea* (1947), frames the sun-bleached windowsill in the studio opening up on to the dry, stark landscape. A rush of hot air blows the curtains, on which are embroidered small birds which swoop into the room; you can almost feel the heat of summer in Maine. Two parallel dirt tracks across the field hint at human presence: even before appearing in Wyeth's paintings, Olson's existence on the farm is intimated. 'In the portraits of that house, the windows are eyes or pieces of the soul almost. To me, each window is a different part of Christina's life,' he once accounted.

It was that same year that Wyeth made his first direct painting of Olson, titled simply *Christina Olson* (1947), in which he visualised the connection

between his muse and her home. Dressed in a short-sleeved, deep green casual cotton dress, with her hair tied back, Olson leans against a wooden door, propped open, which leads out to the farm. Gazing across her land, she straddles both the inside shadowed house and the outside world, illuminated by a geometric shaft of light, the wind catching her hair. Wyeth had discovered Olson, sitting in this quietly contented pose, by chance: 'One day I came in and saw her on the back door step in the late afternoon. She had finished all her work in the kitchen, and there she was sitting quietly, with a far-off look to the sea. At the time, I thought she looked like a wounded seagull with her bony arms, slightly long hair back over her shoulder, and strange shadows of her cast on the side of the weathered door, which had this white porcelain knob on it. And that was the beginning of the painting. She didn't mind being disturbed at all, actually she enjoyed it.'

Wyeth never instructed Olson to pose for him, and for good reason. As a young artist, he had hired men and women who sat for life-drawing sessions in his father's studio. He remembers that these people 'would come for maybe three, four hours a day and pose in a position I would fix them in', but it was when he would instruct them 'to have a rest for fifteen minutes or so' that he'd 'really begin to work'. He explains, 'That's when they would sit or stand or relax in odd, truly human positions. That was really the human figure. That taught me action, taught me to capture them in movement.'

Wyeth's preference for portraying his muses, moving or resting naturally, is evident in his portraits of Olson who, by this time, would have been at her ease around him as the artist became more of an honorary family member than a guest. When he wasn't working, Wyeth would comb her hair and wash her face; he also recalled with admiration that she 'was a very intelligent person', whose company he enjoyed. They would spend hours discussing books and, when apart, the pair sent one another letters – Olson wrote frequently about the wild animals she spotted on the farm. The nature of this close relationship, based on mutual friendship, trust and respect, is evident in Wyeth's unstaged images of Olson, including his most celebrated painting, *Christina's World*.

It was while he was upstairs, painting another picture from his studio, that he spotted her outside, crawling across the grass: 'I saw her in the field . . . She was out getting some vegetables and she was pulling herself slowly back toward the house. It was late afternoon, and I happened to look out of the third-floor window, where I was finishing the picture called "Seed Corn", and there she was.' Olson refused to use a wheelchair, choosing instead to navigate her property and its land by crawling across it.

Therefore, in *Christina's World*, Olson is not static or lying on the ground, as she may first appear, but moving, using her arms to both prop herself up and push herself forward – a technique she had learnt on her own. Wyeth's portrayal is, in many respects, a truthful one: he has represented Olson dragging herself along the ground. But the painting is not without its problems: although Wyeth says that he was committed to doing 'justice' to Olson, there is one immediately obvious issue with the artist's representation of her. Why does Olson, who was aged forty-five at the time, appear as a much younger woman? Was Wyeth, perhaps, sanitising her body for viewers?

During the early twentieth century in America, people with disabilities faced significant segregation and oppression. Considered by the medical and political establishments as 'unfit' for normal roles in society, disabled people were excluded from many jobs. We see this in John Steinbeck's 1937 novella *Of Mice and Men* in which Candy, having lost one of his hands in a work accident, knows that he will soon be fired and replaced by a non-disabled worker. Moreover, until 1974 many cities across America enacted an 'ugly law', which banned people considered 'diseased, maimed, mutilated or in any way deformed' from public spaces. This provided a legal basis for deliberately removing disabled people from sight; Olson would therefore have been physically, as well as emotionally, segregated from mainstream society.

This poor treatment of disabled people is reflected in art history, which abounds with celebratory images of idealised, athletic bodies. Simultaneously, artists have been responsible for intentionally framing disabled people as criminals and sinners, further subordinating disabled people through

negative depictions. Most famously, modern American photographer Diane Arbus was criticised for her exploitation of disabled sitters, including those with dwarfism and Down's syndrome, in her black-and-white images from the 1950s, '60s and '70s. By encouraging her models, whom she referred to (shockingly by today's standards) as 'freaks', to pose awkwardly, she exaggerated their 'otherness'.

It's clear that Wyeth was in no way drawing attention to Olson's body in order to present her as a 'freak'. But was he, perhaps, airbrushing out her disability? Although Wyeth based *Christina's World* on Olson, and that moment he had spotted her from his studio window, we know that he used another model to complete the artwork: his wife, Betsy. At this time, Betsy was still in her twenties, and this is evident in the modelling of the slim, attractive, small-waisted figure. It could, therefore, be argued that Wyeth replaced parts of Olson with Betsy for the sake of his own notions of beauty.

Furthermore, it could also be argued that Wyeth was creating what we would today term 'inspiration porn'. Coined by the late Australian disability activist Stella Young, the label has been issued to critique images which frame disability through the lens of sentimentality or pity, focus on an uplifting moral message which is primarily aimed at non-disabled viewers, and anonymously objectify, and thus exploit, the sitter.

Respected art historian Randall C. Griffin certainly finds Olson's position on the field – as if viewed from above – problematic and exploitative: 'Given her attractive figure, vulnerable pose, and isolation, the picture constructs her as an object of possible assault, and the viewer as either possible rescuer – or ravager. The viewer's elevated vantage point, that of a standing person looking down at this prone figure, itself connotes power.' However, there is another possible reading of *Christina's World* if we consider it from the point of view of the muse. Olson, who is pictured from behind, invites us to see things from her perspective; with her thin outstretched hand, tinged grey, she points towards her farmhouse, as if inviting her audience home with her. If we follow her gaze, it's also as if she is watching Wyeth, whom she invited to paint pictures, including

this one, from the upper studio with its window overlooking the land. Granted agency by Wyeth, Olson is actively looking at and moving towards her house, as if engaged in the very moment that the painting was created.

Portraying disability in art is not easy to get right; in fact, many artists have got it very badly wrong, including Jake and Dinos Chapman. In 1995 the British duo created a three-metre-tall fibreglass sculpture of Stephen Hawking in his wheelchair, perched perilously atop a tall rocky mountain. The work, rather than stressing the intellectual brilliance of the theoretical physicist, emphasises the physical impact of motor neurone disease on Hawking's body in crude and emphatic terms.

In contrast, Wyeth's painting doesn't forefront Olson's disability in either a condescending or salacious way. Instead, there is a quietness to it through which he not only banishes negative stereotypes of frailty, but also wipes out any romantic myth of the weak damsel in distress. He is not inviting viewers to feel pity for his friend, nor is he painting her in an aspirational manner – she has not been elevated to the status of an inspirational heroine within a dramatised scene. In fact, when the canvas was first exhibited, Wyeth received hundreds of letters from viewers who, unaware of Olson's disability, identified with the figure in his everyday image of life on a farm.

At the same time, the artist did identify his muse through the poignant title of the work, *Christina's World*, revealing his endeavour to paint from her viewpoint. We know that Wyeth was determined to get the final image just right – there are pages and pages of sketches which preceded the painting, explaining in part why he needed Betsy as a stand-in model as he worked on it 'from eight o'clock until five-thirty every day for weeks'. Wyeth also took this considered approach to the painting of the picture since it was intended – beyond representing the spontaneous sighting of Olson from his studio window – as a tribute to her life more widely. As the artist later reflected, '*Christina's World* is more than just her portrait. It really was her whole life and that is what she liked in it. She loved the feeling of being out in the field, where she couldn't go finally at the end of her life.'

Blending the image of the two women, Wyeth was also able to capture a more youthful version of Olson, whom he and his wife had known for many years by this point. Particularly during the last few years of her life, when she was confined to the first floor of her home due to progressive weakness in her limbs, this painting represented an earlier freedom for Olson. She accompanied Wyeth to see his paintings – including those of her – once they were framed and exhibited in local galleries, and she is said to have loved this artwork. 'Christina's World was her favourite,' he recalled.

Wyeth has placed Olson's body centre stage. Far from being framed as a tragic figure or 'other', whose difference is exploited for an artist's masterpiece, she is celebrated in sensitive and humanising terms. As Dr Donna McDonald, whose research areas include deaf identity, disability policy, and representations of disability in the visual arts, points out, narratives such as these 'offer us alternative means of understanding, contesting and re-configuring what we think we know about disability, and the everyday life experiences of people with disability. The power of a single visual arts image, let alone a body of works over time, to illuminate a theme such as disability cannot be underestimated.'

Wyeth was paying tribute to the everyday experience of his close friend and muse, whom he admired on many levels. While he shows her separated from the outside world, the viewer is invited to share a moment in Olson's life, almost feeling the wind which catches her hair as she looks upon her farmhouse and fields. This is her domain, to which Wyeth has been given access. While there is some sentimentality to the painting, Wyeth has done justice to his muse, situated naturally within the world she created around her. As Wyeth once explained: 'I've seen Olson's from the air on the way back by plane to Pennsylvania – that little square of the house, dry, magical – and I think, My God, that fabulous person. There she is, sitting there. She's like a queen ruling all of Cushing. She's everybody's conscience. I honestly did not pick her out to do because she was a cripple*. It was the dignity of Christina Olson. The dignity of this lady.'

* This outdated word, now considered offensive, is part of the original quote.

In the winter of 1967–68, Christina and Alvaro Olson passed away within a month of one another, and were buried on their farmland. One year before he died, Wyeth told the *L.A. Times* that he, too, wished to join them there: 'I want to be with Christina.' With his request granted, today Wyeth lies beside the Olsons, as well as Betsy, who had first introduced her husband to this remarkable muse; all four of them, united, belong to Christina's World.

DOREEN LAWRENCE

No Woman, No Cry

In 1998, Chris Ofili became the first Black artist to win the Turner Prize. Over the years this award, which was established to celebrate British artists working in the same innovative spirit as J. M. W. Turner, has gained notoriety for creating debate around controversial contemporary art. Ofili certainly shocked audiences with his provocative paintings – which were made in part from elephant dung. One man even dumped a wheelbarrow of cow dung on the steps of the Tate gallery, planting a placard of protest in its midst: 'Modern art is a load of bullshit.'

Some have accused Ofili – with his signature use of elephant dung – of being gimmicky; but among his shock tactics the artist had something important to say. One of his winning works on show was the painting *No Woman, No Cry*: taking its title from Bob Marley's famous reggae song, the large canvas depicts a Black woman weeping. The head and shoulders of this life-sized figure appear against a vibrant green-and-yellow background, divided up by a black fence-like pattern reminiscent of batik-dyed West African fabrics. As the woman cries pale blue tears, an orange flame creeps up from her heart and across her neck, emblematic of an all-consuming grief.

If you look closely at the artwork's inscription, you can see that the woman is identified as Doreen Lawrence (now Baroness Lawrence of Clarendon OBE), the mother of murdered teenager Stephen Lawrence. In 1993, the eighteen-year-old was stabbed to death in an unprovoked racist attack by a gang of white youths, while waiting at a bus stop in south-east London. It took years of campaigning from the boy's family, with the support of Nelson Mandela, to get justice for their son.

In 1999, a judicial inquiry concluded that the initial investigation into the murder of Lawrence had been harmed by 'a combination of professional incompetence, institutional racism and a failure of leadership' within the

Metropolitan Police. Crucial evidence went undetected; Duwayne Brooks, Lawrence's companion on the night he was killed, was treated as a suspect, not a victim; arrests were delayed; and the relationship between police and the family broke down completely.

It was while he was living in London, in 1998, that Ofili painted *No Woman, No Cry*. Descriptions of the horrific murder of Stephen Lawrence had appeared across the media, and there was a massive outcry about the police's failings to properly investigate the case, particularly in Black communities in the city. Ofili was moved to create his uncompromising artwork in tribute to Doreen Lawrence: 'This kid had been killed by white racists. The police had fucked up the investigation, and the image that stuck in my mind was not just his mother but sorrow – deep sorrow for someone who will never come back. I remember finishing the painting and covering it up, because it was just too strong.'

Born in Manchester, England, to Nigerian parents, Ofili went on to study at the Chelsea School of Art and the Royal College of Art in London. Emerging as a young graduate in the '90s, he soon became a prominent member of the London-based group of Young British Artists (YBAs), alongside Damien Hirst and Tracy Emin, who shocked the art world with conceptual art – in terms of both their message and anti-establishment materials: stuffed sharks, unmade beds, neon lights.

In contrast to his contemporaries, Ofili became best known for his paintings, in many respects traditionally made on canvas. However, he mixed media – oil and acrylic paint, graphite, polyester resin, newspaper, glitter, map pins and elephant dung – to break traditional rules, build up layers of meaning and expand representation. The artist also developed his very own contemporary iconography by combining cultural sources, from hip hop and Zimbabwean cave paintings to biblical imagery, in intricate kaleidoscopic paintings.

From the very start of his career, Ofili has used his art to celebrate Black culture and people. In an early composition from 1996, *Afrodizzia*, the artist has pasted images of well-known Black figures, from Nelson Mandela and

Tupac to Will Smith, adorning their heads with hand-painted Afros. As he has explained, 'Sometimes . . . I'm just blindingly obvious, an example being *Afrodizzia*, 1996. Like, bang, there it is. Afro head – celebration of Afrocentricity.'

Between 1995 and 2005, Ofili went on to create a series of 181 watercolours, titled 'Afro Muses', featuring busts of Black male and female figures, which almost entirely fill the space of rectangles painted a pale daffodil yellow. Women, who face the viewer, appear clad in colourful African clothing with richly painted jewellery, bright make-up and ornate natural hairdos: braids, bangs, side-swept twist outs, flipped-out ends. Similarly, the men sport natural Afro hairstyles and beards, while wearing abstractly embroidered robes.

These portraits, which came from Ofili's imagination, parade the 'Black is beautiful' philosophy and aesthetic. Reflecting their African heritage, each of the figures is attractive without being eroticised, as is often seen in the media. The 'Jezebel' stereotype – the lascivious, uninhibited Black woman – often depicted in film, specifically Blaxploitation films of the 1970s and music videos. Instead, Ofili's 'Afro Muses', who are accompanied by tropical flowers and bright-feathered birds, personify powerful creative visions borne from a Blackness that has not been caricatured or exploited.

With this series, Ofili revels in the reality of Black identity beyond resilient and reductive racial stereotypes. While imagined, his figures are represented as a spectrum of inspirational individuals, identifiable through their unique expressions and countenances, distinctive outfits and original hairstyles. Ofili is also playing on the cliché that all Black people look alike to someone outside their racial group.

Similarly, with *No Woman, No Cry*, Ofili explodes another trope – that of the Strong or Angry Black Woman, popularised in films and TV shows. On screen, the likes of Mammy in *Gone with the Wind* or Minny Jackson in *The Help*, are presented as strong, sassy and fearsome women not to be messed with. The steely, resolute Black woman struts confidently, hand on hip; but she definitely doesn't cry.

Since the death of her son, Doreen Lawrence has shown remarkable resilience and bravery. She has continued to campaign for justice for victims of racist crime, founding the Stephen Lawrence Charitable Trust, which she has now left to launch her new charity, the Stephen Lawrence Day Foundation, to advance social justice and tackle racial inequality for future generations. She has been awarded an OBE for services to community relations and in 2013 was made a life peer in the House of Lords, where she continues to act as a voice for the marginalised: 'There are positives that have come from my son's death. Laws have been changed in his name, which have made life better for people. Then there's the fact that I'm in a position to talk to the prime minister and I'm now sitting in the House of Lords able to talk to judges. It's positive that I've got a voice that I can use.'

However, she has also reflected on the insurmountable pain which drives her actions: 'To say that I've been dignified and strong all the time would be far from the truth. On the outside people think that I've not crumbled, but I have. I've had to step up to the plate because if I hadn't, Stephen and his legacy would be forgotten, and I don't ever want my son to be forgotten.' As if granting Doreen Lawrence's wish, Ofili has inscribed the words 'R.I.P. Stephen Lawrence' – discernible beneath the layers of paint and elephant dung – in the poignant picture. Ofili also represents his muse's vulnerability and pain, which flows from her eyes in tears, each containing a tiny collaged photograph of her son's face. The painting can be read as a modern-day pietà: meaning pity, the pietà is a popular subject in Christian art, which depicts the Virgin Mary sorrowfully contemplating the dead body of her son. Echoing the grief-stricken figure of Mary, Ofili's figure is treated with tenderness and intensity, invoking compassion in viewers for both Doreen Lawrence and all mourning mothers.

No Woman, No Cry is a dedication to all victims of racist injustice as well as Doreen Lawrence. The emotive expression of Ofili's figure embodies the true pain of Black people harmed by racist stereotypes, discrimination and violence. Moreover, the power of this piece is in the muse's tears: she acts as a powerful political statement, a form of visual activism and an enduring site of protest.

SUE TILLEY
Supervisor Sleeping

O n the evening of 13 May 2008, in a crowded saleroom at Christie's New York, Lucian Freud's painting *Benefits Supervisor Sleeping* (1995) sold for a record-breaking $33,641,000. At the time, this was the highest price ever paid for a painting by a living artist. The monumental masterpiece depicts an overweight female nude lying on a couch, sleeping. As the hammer came down on this artwork, its model was at work, worlds apart, in a job centre in London. How had this unlikely muse come into the life and art of Lucian Freud?

Freud was one of the greatest British painters of the twentieth century. Grandson of the famed psychologist Sigmund Freud, he is best known for raw and frankly painted portraits, including of nude figures, which he made from his London studio. The artist's intention was always to capture the essence of the people he painted: 'I am only interested in painting the actual person, in doing a painting of them, not in using them to some ulterior end of art.'

Throughout his career, Freud had many models; among his favourite was the flamboyantly dressed, colourful make-up-wearing performance artist, Leigh Bowery. Freud became fascinated by Bowery, after seeing him perform at the Anthony d'Offay gallery, and invited him to pose for several paintings over a period of four years. These pictures show Bowery in a series of contorted poses, wearing none of his characteristic costumes; instead he is completely exposed, with the focus on his bare folds of flesh.

Bowery loved to model for Freud, and decided to introduce the artist to one of his best friends, a job centre supervisor called Sue Tilley, as a potential next subject. Tilley remembers first encountering Freud on a night out, following which he invited her to meet him one on one: 'He summoned me to a lunch at the River Café, a fancy restaurant in Hammersmith. I enjoyed myself – he was really trying to make a good impression on me, so he started telling filthy jokes . . . he was trying to make himself charming and funny.'

Freud was attempting to flatter Tilley, having already decided that he wanted to paint her. He didn't ask his new muse directly, but after their lunch meeting had Bowery speak to Tilley, offering her the opportunity to model; she agreed. The pair of friends even had a practice run in Tilley's flat, as she remembers: 'Leigh made me strip off. I had to take my clothes off on my settee, so I could practise what it would be like for Lucian.'

Tilley also recalls her first impression of Freud's studio, inside his large Victorian town house in Holland Park. She felt like she had stepped into one of the artist's paintings: 'There was a Rodin statue propped against the door, which he used as a doorstop. Then inside the studio there was paint all over the walls, because he used the walls to clean his brushes on, so they were just covered in a coat of oil paint in the colours he painted in.'

Freud's studio became the backdrop for all four paintings of Tilley: *Evening in the Studio* (1993), *Benefits Supervisor Resting* (1994), *Benefits Supervisor Sleeping* (1995) and *Sleeping by the Lion Carpet* (1996). Tilley spent a huge amount of time there, posing for Freud three times per week; for the first painting she modelled at night, from 7.00 in the evening until 1.00 in the morning, and then for later works she posed during the day. Sticking to this strict schedule, each painting took nine months for Freud to complete.

Freud asked Tilley to lie down for each of the pictures: as she came to the studio either before or after work as a job centre supervisor, Tilley remembers that she quite naturally closed her eyes and really did, at times, fall asleep. For the first picture she reclined on the floorboards, which she says was 'agony'; but by the next Freud had bought her a second-hand sofa so that she could make herself comfortable for paintings such as *Benefits Supervisor Sleeping* (1995).

Tilley's pose – that of a reclining female nude – is one that appears repeatedly throughout art history. During the Renaissance it was popularised by Giorgione (1477–1510) with his painting *Sleeping Venus* (1508–10); the young woman's soft, sensual curves mirror those of the undulating hills in the background. Other painters, including Titian, followed suit. These artists used the image of a nude Goddess of Love to represent idealised female

beauty and femininity which, in fifteenth-century Europe, was a slim, white, smooth-skinned woman.

With his paintings of Tilley, Freud took on this trope of the flawless, naked deity. The title is an immediate play on the tradition: Venus has been replaced by Supervisor. Here we are presented with a real, ordinary woman who is reclining horizontally, but in a rather more unflattering pose than the one seen in Renaissance paintings; Tilley's face is scrunched into the arm of the sofa and her left foot is tucked into its soft back. Most obviously, Freud has also inserted a voluptuous body into clichéd compositions of the slim female figure. He captured her curves on curves, stretching stereotypical views of femininity. It's important to note that Freud painted this portrait during the 1990s, when Western society was holding up thinness as an unrealistic ideal for most women and critiquing the overweight as lazy and unhealthy.

Freud's collaboration with Tilley called into question the narrow definitions of beauty which had so far been framed within art history and the media. As Tilley has said, 'I made him appreciate the fuller figure woman.' Today, these paintings of Tilley are held up by many as a celebration of 'real women' and diversity of appearance in the face of the thin ideal, which still pervades social media.

But Freud's primary focus, despite his fixation on Tilley's naked body, was not on external appearance or expressions of beauty at all. He painted the exposed human figure, in compelling detail, as a means of exploring what makes us human. In his captivating portraits of Tilley, Freud captured every contour and blemish on her skin, in a search for her psychological make-up.

As Freud revealed, in relation to his sitters, 'I'm trying to relay something of who they are as a physical and emotional presence. I want the paint to work as flesh does. If you don't over-direct your models and you focus on their physical presence, interesting things often happen. You find that you capture something about them that neither of you knew.'

Under his unflinching gaze, Tilley developed a deep friendship with and closeness to Freud: 'We chatted all the time, about everything under the sun. The news, gossip, scandal, his past, his hatred of his brother, what we'd done

the night before, where we'd been and who we'd seen, his history. I liked it
when he told me about the olden days.'

Freud took an interest in Tilley's life, too, even asking to meet her parents
in order to know her better; the artist was trying to epitomise the essence of
his models. 'He wasn't just painting what he saw, he had to paint what you
were. You know, he could do the floorboards or a bit of the sofa while you
weren't there but he never did because he felt that your aura affected every-
thing else in the room.'

Freud also spoke about his drive to portray an individual's impact on the
space around them: 'The aura given out by a person or object is as much a
part of them as their flesh. The effect that they make in space is as bound up
with them as might be their colour or smell . . . Therefore the painter must be
as concerned with the air surrounding his subject as with the subject itself.'

Tilley recognises the 'collaboration' which took place between artist and
muse. She has also pointed out that there was never any romantic attachment,
on either side: 'When people say muse I think of those poor women who hung
around with the Pre-Raphaelites, all mad in love with them and laid around
in pools of cold water. But luckily I was never in love with Lucian, as many
models seem to be, so that was a relief. I think that's why we got on because
there wasn't that sexual tension between us. It was amazing.'

Tilley was a considerable, critical presence in Freud's painting career. It
was his notorious portraits of the nude 'Supervisor' sleeping which catapulted
him to international acclaim. As Tilley acknowledges, 'I think me and Leigh
changed everything.' The paintings of her have been exhibited in museums
and galleries, including Tate Britain and the National Portrait Gallery. They
have also paved the way for feminist painters, including Jenny Saville who
portrays the powerful force of fleshy female figures.

Just as Tilley transformed the trajectory of Freud's career, so too did he
alter her life for ever. Christie's record-breaking auction in 2008 brought
her to the world's attention; the media wanted a piece of this million-dollar
muse, as Tilley remembers: 'I was at work at the job centre and I got a call:

"The *Evening Standard* are here to see you." So I went down. I thought it was about work. And they said, "Did you know your picture's about to be sold for millions, for a world record?" Next day, my phone wouldn't stop ringing from papers, it was so peculiar. People were clutching the *Metro* and I was on the cover. From that day my life changed.'

Since then, Tilley has modelled for six artists, including fashion-designer-turned-sculptor Nicole Farhi. Today, she models for Portuguese artist Rui Miguel Leitão Ferreira, whose recent series of self-portraits 'Posing for Sue' explores the connection between artist and muse. In these paintings, Ferreira intentionally positions himself as a naked figure, in front of his model to switch their roles. He wrote in a letter to Tilley, 'I wanted to put you in the place of an artist and me in the role of adoring muse, venerating you, wanting to be adored and observing the experience'.

Ferreira's paintings also point to the fact that Tilley herself is an artist and trained art teacher. Today, she calls herself 'a jobbing artist', taking opportunities that come her way. She has worked on commissions, including portraits of the late Leigh Bowery, and collaborations with the likes of fashion brand Fendi. She's also exhibited her paintings, including self-portraits in which she has become her own muse. Sue Tilley has one of the most famous bodies in the world. She has been held up as an icon of body positivity and recognised as Freud's most significant muse, immortalised in his psychologically charged paintings of her sleeping. Today these artworks hang in the homes of the super-rich, and Tilley's been invited to see herself in situ by several collectors. The muse was particularly pleased to find that she was positioned opposite the TV, 'lying around watching telly', in one lavish living room.

While Tilley has not received a single penny from the sale of Freud's paintings, the subsequent fame has presented her with a whole range of opportunities. Some she's declined, refusing to pose naked for the *Daily Mail* shortly after the Christie's sale; others she has seized, capitalising on her status with integrity to enter into meaningful and creative collaborations in which she is at times muse, and others artist, but always on her terms.

OLLIE HENDERSON
Start the Riot

In April 2015, two years before Australia's same-sex marriage law was passed, one of the country's most popular TV presenters, Faustina 'Fuzzy' Agolley, took to Twitter: 'As black as my skin, as Chinese as my blood, and as Australian and British are my nationalities, I'm also a proud Gay Woman.' In an accompanying blog post titled 'I'm gay' Agolley reflected on the relief she felt at coming out on her thirty-first birthday, as well as the joy of finding her 'tribe' – a group of women she 'could truly connect to'.

The 'tribe' Agolley talks about is one which features in the instantly recognisable paintings of Kim Leutwyler. The Australian artist, who is queer herself, creates heroically scaled canvases of LGBTQIA+-identified and queer-allied women. Her subjects – represented on their own, embracing in pairs or allied in groups – are painted with exquisite realism. They are also positioned against abstracted decorative backgrounds, painted in a palette of luminous rainbow colours to celebratory effect.

Since coming out publicly, Agolley has had her portrait painted by Leutwyler on numerous occasions. The first time was for a large oil and acrylic on canvas, *Faustina the Fuzz* (2019) in which she stands, hands on hips, wearing a strappy red dress. Presented in a relaxed pose, Agolley wears her natural Afro hair loose and smiles slightly; this is an assured woman, portrayed on her own terms. She is also brought to life by surrounding shapes painted expressively in bright blue, white and red: 'Welcome to the tribe,' the affirmative painting seems to shout. By sitting for the portrait, Agolley joined Leutwyler's diverse cast of queer muses, including the openly gay athlete Michelle Heyman, who proudly represented Australia at the Rio Olympics in 2016, drag queen Trixie Mattel, and Teddy Cook, the manager of trans and gender diverse health equity at ACON, Australia's largest HIV prevention, HIV support and LGBTI health organisation.

Leutwyler says she feels a significant connection to each of her subjects: 'I paint people who are thought provoking to me, and who have impacted my life in some way.' The choice of who she takes as a muse also carries a crucial message:

'My paintings are absolutely a celebration of the queer community. LGBTQIA+-identified and allied people are massively under-represented in the history of portraiture. In historical art, queer people are often erased, or when seen, reduced to tropes as opposed to the individuals they are/were. Queer women have largely been left out altogether. My hope is that my work will spark dialogue and action, and help raise the profile of queer people in the arts by amplifying voices and diversifying representation.'

It's not just *who* she paints, but *how* she paints them, that matters to Leutwyler. While painting a community, she is interested in capturing the individuality of her sitters beyond stereotypical ideals. She therefore picks out defining features, such as Agolley's Afro hair, to depict her subjects with intricate levels of detail; the artist's close physical observation demands the viewer's attention and appreciation for each muse's unique characteristics.

At other times, Leutwyler focuses on the fashion choices of subjects, including the Australian model, Ollie Henderson, who she painted in 2015. Standing before a wallpapered backdrop of abstract shapes painted lime green, pink, white and baby blue, Henderson is dressed in a sharp black blazer and white shirt, buttoned to the very top. Her dark hair is slicked back in a ponytail, although a single strand falls onto her pale face, framing her intense green eyes which stare directly out at the viewer. In many respects, Henderson has embraced the classic androgynous business-woman look. However, she has also given it an edgy makeover. Bringing her hands together, Henderson's fingertips touch in front of her, making visible an unusually large white ring. Her neat collar is studded with one silver spike on each side and joined by a neck chain which falls in four fine strands. As light falls on Henderson's jewellery, it is illuminated and shines prominently out of the canvas; Leutwyler cleverly draws attention to her muse's playful, punk aesthetic.

'Androgyny, body art, gender confirmation surgery and piercings are not uncommon among the people you see in my work,' says Leutwyler. Many members of the queer community – as we see in the portrait of Henderson – turn to body modification, tattoos and alternative accessories to express their unique identity, align themselves with marginalised subcultures, and oppose more dominant heterosexual ideals. Turning her own queer gaze on subjects such as Henderson, Leutwyler often picks up and hones in on subcultural signifiers, from studded punk jewellery to short haircuts and symbolic tattoos. Using chiaroscuro effects to dramatically light details that deserve attention, Leutwyler emphasises the individuality of her subjects and the fluidity of gender beyond societal expectations of femininity:

'Over the years my work has evolved to deconstruct gender-based power dynamics of "the gaze". Queer people are not depicted as sexual objects for the pleasure of the heterosexual viewer. My desire is that my subjects are accepted and seen for the things that make them unique. This creates space for plural identities and possibilities.'

So often across art, the media and popular culture, queer stories have been forced to fit into heteronormative narratives – just think of the trope of the gay best friend, always a sidekick to the straight female lead in films like *My Best Friend's Wedding*. Instead, Leutwyler holds up her queer muses as protagonists and frames them as heroines in their own right.

Additionally, Leutwyler deliberately uses paint, 'because of its primarily masculine history in the western art canon' – women had to fight for access to painting academies and life modelling classes – to upend heterosexual norms of identity and sexuality. Art always has the power to either echo conventional ideals or question gender norms, as Sylvia Sleigh did with her paintings of undressed male muses in the '60s. Without doubt, Leutwyler uses her disruptive gaze to validate sexuality and gender identity beyond the status quo.

Despite this, Leutwyler is honest with herself about the gaze she turns onto her muses: 'By the very nature of a painting being on canvas the portrait itself becomes an object, and thus objectifies the sitter.' To combat this inevitable

objectification of her models, she deliberately creates an environment that is collaborative between artist and sitter, inviting the painted subject into the process of portraiture. After an initial live sitting, Leutwyler takes a series of photographs – at times hundreds – of her muses from which she will work alone in her studio. But, unlike many artists, she allows her models into the artwork's development; as Leutwyler works up the canvas, she will send photos to the sitter, asking them for their thoughts and direct feedback, which she will then take on board.

The artist also invites her subjects to wear what they want, and feel most comfortable in, for their portrait. For her photo shoot, Henderson chose to wear no make-up, pull her hair back in a ponytail and don the sharp suit embellished by its distinctive silver studs. As a model, Henderson is used to performing through fashion and playing to the camera; however, on this occasion, she wanted to represent herself. As we have seen, her choice of clothing clearly makes a statement on gender body politics.

There is another message coded in Henderson's choice of outfit, one which is hinted at in the painting's title. Leutwyler typically names her paintings, such as *Faustina the Fuzz*, after the sitters. However, in the case of Henderson, she used three punchy words, *Start the Riot*. Why was this? What does this title refer to? What riot had Australia's young model started?

Born in Creswick, central Victoria, Henderson's entry into modelling was what many young hopefuls dream of; she was scouted while shopping for a dress in Melbourne, at the age of sixteen. By the age of twenty, she was walking runways for the likes of Calvin Klein, and shooting covers for leading fashion magazines, from *Vogue* to *Harper's Bazaar*.

Through her modelling work, Henderson soon perceived that the clothes we choose to wear are an expression of both our individual and collective identity, stating: 'Fashion is a reflection of society.' She also recognised, perhaps more importantly, that clothing 'has the power to catalyse societal change. It's a great medium to use because fashion involves everybody.' Henderson decided to take action – using her platform as a model and fashion as her medium – to start productive conversations about social change in Australia.

At Australian Fashion Week 2014, Henderson hand-painted one hundred T-shirts with positive messages on topics from feminism and marriage equality to ethnic diversity and the climate crisis: 'Love is Love' read one; 'Reject Racism', 'Welcome Refugees' and 'Save the Reef' were scrawled on others. The model distributed these T-shirts to friends, fellow models and the public who wore them for the event – bringing activism to the catwalk. Henderson received national, and then international, attention for her stunt: the catchy T-shirts were featured in fashion magazines, including *Vogue*, and it was not long until stores wanted to stock the items.

Monopolising on this success, Henderson launched her own fashion label, which she called House of Riot, with a focus on utilising fashion to encourage young people to become both aware of, and involved in, social and political activism. The name of the label evokes the Riot grrrl movement, which was born out of America's underground music scene in the '90s, with bands such as Bikini Kill and Bratmobile. It originally focused on encouraging women to become more involved in the male-dominated punk scene, but grew to stand for a new kind of feminism fuelled by rebellion and creativity. The movement opened up spaces for frank views and discussions on sexuality and body politics. At the very heart of the Riot grrrl movement was fashion: women pushed gender stereotypes by dyeing their hair bright colours, modifying their bodies with piercings and dressing in deliberately unfeminine outfits. Members and allies wore studded boots and ripped T-shirts with anarchic messages, harking back to Vivienne Westwood's political slogan-plastered punk clothing from the '70s. Like Westwood and the Riot grrrls, Henderson had found her voice through fashion, realising its power to raise awareness of social and political issues, particularly among a younger generation, and lead to tangible action. For the portrait, she had chosen to wear the sharp black and silver-studded blazer because, as she explains, it captured her move from teenage model into a 'more adult place' and a specific point in her life which had brought about real 'responsibility'.

As a portrait painter, Leutwyler also feels a sense of responsibility. She is mindful that she captures truthfully, and with integrity, each muse's reality:

'I want to make something that the model will be proud of.' This she does successfully, positioning queer women as unique individuals, centre stage in canvases which celebrate non-conformity, legitimise queer sexualities and validate the perspectives of the LGBTQIA+community.

Like Henderson, Leutwyler wants to use her platform to share these important messages with the wider world. This is why it meant so much to her that *Start the Riot* was selected for the Archibald Prize in 2015. Awarded annually in Australia, the contemporary art prize aims to foster portraiture, as well as support artists and perpetuate the memory of great Australians. The prize is a big deal, as the artist has explained: 'The hype of Archibald Prize is hard to explain to people outside of Australia. Exhibited annually at one of Australia's most prestigious museums, the Archibald Prize is often referred to as the exhibition that stops a nation. Nearly everyone in the country has an opinion about which portrait is most deserving of the $100,000 prize!'

Exhibiting her portrait of Henderson through the Archibald Prize was an act of intervention for Leutwyler – she had brought queer art, and her queer muse, to the heart of Australia. Inclusive representation matters, including in galleries where the queer community has historically been woefully underrepresented. Her selection for the final was a culturally significant moment and one of personal significance for the artist, who, as a gay woman herself, has experienced homophobic discrimination:

'There is still a long way to go for true equality for the LGBTQIA+ community. In short, the next step is anti-discrimination protections for all sexual orientations and gender identities. I can't speak for the role that all artists can play, but I'd like to continue making portraits of individuals who are making positive impacts on the community individually, locally and nationally. I hope that my work will stimulate a dialogue about equality and human rights in Australia and beyond.'

In 2017, Leutwyler was once again in the running for the Archibald Prize with her portrait of Michelle Heyman. Two years later, in 2019, her painting of *Faustina the Fuzz* made the final. 'A powerful moment for the Archibald

Prize: could a portrait of a black woman win?' wrote Shantel Wetherall in the *Guardian*. 'Change can only happen if artists can feel hopeful enough to take part', she continues, reflecting on the prize's 'power to transform outsiders into insiders'.

Leutwyler didn't win the prize but she'd won a battle – for the bold and public representation of queerness on a national stage. By painting LGBTQIA+ muses, she gives pride and power to these women, both as individuals and as members of a marginalised community. Sparking conversations on the mutability of gender, spectrums of sexuality and identity beyond stereotypes, Leutwyler – like Henderson and Faustina and so many others before – is a riot girl, using the muse to amplify her statement of solidarity with the queer community.

SOULEO
Icon of Harlem

On 21 March 2015, actor Lupita Nyong'o, best known for her Oscar-winning debut role in *12 Years a Slave*, uploaded a photograph of an exquisite artwork to her Instagram account. Painted on a dark wooden board and framed by antique-looking panels decorated with gold leaf, it features the bust of a beautiful young Black man.

Rendered in a highly realistic manner, and standing before an idealised landscape imagined in bright blues and greens, the sitter stares out of the painting with wide eyes and an enigmatic expression. Long dreadlocked hair has been pulled back from the man's striking face, and one escaped loc falls onto his chest, creating a shadow on his simple white vest. Despite his casual appearance, the subject is resplendent: beams of golden light illuminate his bare shoulders and strong arms.

Earlier that day, Nyong'o had found this magnificent painting hanging on the traditional white walls of New York's prestigious Brooklyn Museum. Compelled to post on her personal Instagram page, she accompanied the image with a moving poem about her visit:

> *I went to the #BrooklynMuseum*
> *and what did I see?*
> *Beautiful Black men*
> *looking at me.*
> *Painted by #KehindeWiley,*
> *they were gilded and grand,*
> *Modern images*
> *in ancient artistic land.*
> *There were women too,*
> *of equal size and style,*

And a video of men
showing how long they could smile.
I gasped, I sighed
and I laughed out loud,
So I hope you go see it,
it'll make you proud.

Nyong'o had seen sixty portrait paintings and several sculptures, included in a startling show titled 'A New Republic' by Kehinde Wiley. The young African-American artist had portrayed contemporary Black men and women using the conventions of 'Old Master' European portraiture. Wiley's sitters wore hip hop street fashions – sneakers, bandanas, baseball caps and hoodies – while adopting the heroic poses often seen in historical paintings of saints, soldiers, kings and aristocrats.

Inside the exhibition, Nyong'o found herself surrounded by huge billboard-sized canvases, in which full-length subjects brandished gold-encased swords and sat on horseback, framed by ornately patterned backgrounds and encircled by hovering cherubs. With each artwork, Wiley re-staged a famous painting from art history; in *Napoleon Leading the Army over the Alps* (2005) a youthful Black male straddled a strong horse rearing up on its hind legs in an imposing revision of Jacques-Louis David's nineteenth-century equestrian portrait of the French emperor.

The exhibition also included a group of eight works painted in much smaller scale, on wooden panels featuring young Black men at bust-length. In contrast to Wiley's grand decorative portraits, these sitters had been depicted in simpler, stripped-back terms. Wearing casual clothes, without armour or accompanying angels, they were positioned before natural landscapes. Among them was the young man in *After Memling's Portrait of a Man in a Red Hat* (2013) – the painting featured on Nyong'o's Instagram page.

Legendary fifteenth-century artist Hans Memling inspired this artwork. The Flemish master painted portraits of men and religious figures in the

manner of the triptych altarpiece; typically found in Christian art as a devotional object, it consists of three oil-on-oak panels, hinged together. Displayed open, it reveals a figure – usually the Virgin Mary or Christ – painted prominently on the central board. Once again riffing on art history, Wiley had inserted contemporary subjects into masterpieces. But who were these men?

When Nyong'o uploaded *After Memling's Portrait of a Man in a Red Hat* to her social media page, it was soon flooded with likes and positive comments; among them, one woman wrote simply, 'This is Souleo.' She had recognised, and acknowledged, the young male model in the painting: Peter Wright.

Souleo, as he is known, is a native New Yorker, and has modelled for three paintings by Wiley. In *Antoine, 'The Grand Bâtard de Bourgogne'* (2011) he wears the same vest, positioned against a patterned background of red with blue birds, while in *Albert and Nikolaus Rubens, the Artist's Sons* (2006) he dons a red hoodie emblazoned with the simple moniker 'New York'. In each composition, it looks as if Souleo has casually stepped straight off the city's streets and into the painter's majestic compositions; and it looks this way because it's not far from the truth.

Since the start of his career, Wiley has found many of his models while walking through New York; in fact, the first of his muses he came upon purely by chance. During the early 2000s Wiley, who had recently earned his MFA from Yale University, was an artist-in-residence at the Studio Museum in Harlem. On his way there one day, he came across a crumpled piece of paper blowing across the street; unfolding it, he realised that it was a mugshot – issued by the New York Police Department – of a young African-American man in his twenties.

Wiley took the creased image of this man back to his studio where he flattened and pinned it to the wall. It made him consider portraiture as a potent way of framing a person's identity: 'I began thinking about this mugshot itself as portraiture in a very perverse sense, a type of marking, a recording of one's place in the world in time. And I began to start thinking about a lot of the portraiture that I had enjoyed from the eighteenth century and noticed

the difference between the two: how one is positioned in a way that is totally outside of their control, shit down and relegated to those in power, whereas those in the other were positioning themselves in states of stately grace and self-possession.'

These reflections inspired Wiley to turn the printed mugshot into a portrait, *Mugshot Study* (2006). The emotive painting features the young Black man, wearing just beaded necklaces around his neck and a white tank top, and positioned above his New York State ID number: 99826970. Surrounded by a stark and symbolically white background, and tilting his head to one side to look at the viewer with wide eyes, he seems to pose a question: will this always be the way in which Black men, operating in an inherently white country, are framed?

Moreover, Wiley has softened the image of his male subject in contrast to the mugshot; light falls upon his youthful skin, highlighting the fragile V-shape of his neck and delicate structures of the collarbone. Humanising the figure from the wanted poster, Wiley presents him as a wounded boy, rather than hardened criminal. Vulnerability is a dominant theme in the work of the artist who, as an African-American man himself, understands the prejudice and powerlessness that Black people experience based on their appearance: 'I know what it feels like to walk through the streets, knowing what it is to be in this body, and how certain people respond to that body. This dissonance between the world that you know, and then what you mean as a symbol in public, that strange, uncanny feeling of having to adjust for . . . this double consciousness.'

Following the completion of *Mugshot Study*, featuring his first accidental muse from New York, Wiley began to paint portraits of other ordinary men from the city. However, in contrast to the earlier work, which is almost ghostly in tone, he began to use portraiture to rebuke the negative and damaging stereotypes of Black men by society; instead, he inserted African-American subjects into renowned art historical paintings, such as those seen by Nyong'o in the Brooklyn Museum, in order to hold them up as empowered heroes.

During the early 2000s, Wiley found many of his models through a method which he refers to as 'street casting' – he approached young Black men, aged between eighteen and thirty-five, who were passing by or hanging out on the streets of Harlem. While many refused to pose for this relatively unknown artist, suspicious of his aims, others felt excited to be 'discovered' by the painter and accepted the invitation to model for him, particularly when he explained his intentions.

Wiley also placed advertisements for models online, which is how he came to work with Souleo. At this time Souleo, who was studying English at Brown University, was taking on modelling jobs while aspiring to be a journalist. He remembers responding to the artist's advert: 'It's a totally unromantic story – years ago I came across an ad on Craigslist for paid models and applied with a selection of my photos. I didn't realise who the artist was. I then looked him up but had no idea how big of a deal he'd become.'

Successful in his application, Souleo was one of 'around ten young Black men' who were invited to spend 'about half a day' in the artist's huge loft-style studio in New York, posing for photographs from which Wiley worked up his paintings. He recalls how the artist, who has always taken a collaborative approach with his models, described to the group 'what he was trying to do'. With a long interest in art history, Wiley wanted to position his models within reworked 'Old Master' paintings, which he showed to them through reproductions.

Having described his intention, Wiley then invited the models to take turns posing for him on their own, under professional lights, from which he took multiple photographs. Souleo had previously modelled for commercial shoots and, although this was his first time working with an artist, he treated it in the same way: 'I was there to perform – this was work and I wanted to do a good job.' In modelling for the artist and his camera, Souleo recalls that the focus was on his facial expression and body language: 'A lot of the direction was about the actual pose – he wanted a vulnerability within the image, that youthful emotion in the eyes and the way in which I was standing. There

was so much attention to detail in how I held my hands and fingers – it was very precise.'

This emphasis on Souleo's countenance and posture is evident in *After Memling's Portrait of a Man in a Red Hat*. Wiley's muse raises his graceful hands slightly, bringing them in front of him to dominate the foreground of the composition. Natural light catches the model's gold ring, which gleams from one finger, illuminating and bringing attention to his soft youthful skin. At the same time, the focus is on his large eyes, directly in line with his hands, with which he looks directly and engagingly at the viewer.

There is a pointed shift in Wiley's version from Hans Memling's fifteenth-century masterpiece *Portrait of a Man in a Red Hat* (1465–70) on which it is based. The original oil-on-oak panel painting features a middle-aged white man, wearing a rounded, red wool-fabric hat and black gown, who gazes off into the distance and, although his hands are visible, they are placed to one side, rather passively. Where Memling's sitter is contemplative, Souleo is posited as active force and involved collaborator in the portrait.

What Souleo wears – a simple white vest – is also important. Typical of the way in which Wiley works, the artist had invited his models to choose clothing from a box of street fashions, including hoodies and baseball caps, or keep their original outfits on, as in the case of Souleo. Through this method, the artist allows his subjects to be seen truthfully on their own terms; it also shows Wiley wanting to showcase ordinary African-American men, who have historically been omitted from Western museums, as both visitors and subjects of artworks hanging on their walls.

However, Souleo's dress does also resonate with the original masterpiece on which Wiley's work was modelled. The Flemish master was among the first to paint individuals who were not royalty, religious figures, biblical characters or members of the clergy. Instead, Memling painted portraits of an overlooked but increasingly influential sector of society: the merchant class. Memling's pictures can, therefore, be understood to celebrate a quiet revolution of social mobility within Flemish society. Similarly, in his work Wiley focuses on ignored

members of contemporary American society, who are defined not just by class, but by race. Replacing the original sitter's hat with Souleo's distinctive dreadlocks, the artist also brings his model's racialised identity into the picture and, like Memling, elevates him to the status of a painted icon.

When Wiley exhibited his portrait of Souleo at 'A New Republic' at Brooklyn Museum, it was one of the smallest artworks on show. Exhibited alongside huge canvases of mighty Black men on horseback, it could easily have been overshadowed. However, in contrast to Wiley's epically scaled paintings, the intimate portrait of Souleo, painted in the devotional triptych manner, requires the viewer to come close, entering into a powerfully sacred space. Locating his sitter within a gold-leaf gilded altarpiece, Wiley presents Souleo as an individual worthy of worship.

In some ways, this portrait of Souleo also recalls Wiley's *Mugshot Study*: like the early muse, he has been treated with sensitivity and humanity, and the work demands contemplation from the viewer. As the artist has reflected on such portraits in an interview ahead of the museum exhibition, 'In my work I try to slow down and see individuals. I'm standing on the shoulders of all those artists who came before me but here there's a space for a new way of seeing black and brown bodies all over the world.'

Through his staged interventions in art history, Wiley invites audiences to share in this 'new way of seeing'. Working with young African-American muses such as Souleo, he asks viewers to recognise the absence of Black figures in Western art, from altarpieces to mural sized masterpieces. Before collaborating with Wiley, Souleo had rarely entered into a museum or gallery beyond the occasional school trip: 'I had no interest in the art world because there is no representation of people like me. From a Black perspective, museums are not very diverse. Kehinde definitely altered my way of thinking about the art world.'

With his artworks, Wiley also critiques the demeaning portrayal of Black masculinity in society, popular culture and art. Meaningful change often comes from within, which is exactly how Wiley operates. Inserting his subjects into masterpieces, he positions them as powerful protagonists to be seen

anew. While Wiley has since gone on to paint the rich and famous, including former President Barack Obama, it is his deliberate focus on the nobility of the everyday Black man that remains his most poignant work to date.

The artist's paintings of Black muses straight from the streets of Harlem have also taken on a sharp new relevance following the death of George Floyd, which sparked protests around the world. On 25 May 2020 the unarmed Black man died in Minneapolis after white police officer Derek Chauvin, who had just detained him, knelt on his neck for nearly nine minutes – four of which he was unconscious for – as fellow officers stood by. Floyd's death set off a series of Black Lives Matter protests against police brutality and racial profiling, about which Wiley spoke out in an article published in *The New York Times*: 'It's a wake-up call to the white population in America. It's what so many Black Americans have known and been trying to communicate for centuries. It comes as no shock or surprise to us that Black bodies are under assault on a daily basis. What comes as a shock is that so few have listened.'

In his early *Mugshot Study* Wiley shows viewers the assault which Black men experience, framed frequently as aggressive thugs, killers, criminals and a threat to be knelt upon. In contrast, his portraits of muses such as Souleo challenge this view of Black men. Following the death of George Floyd, murals appeared around the world featuring his face and name. One memorial in Minneapolis, near where he was murdered, lists the names of other Black lives lost to police brutality and reiterates the importance of 'saying our names'. Similarly, in each of his portraits, Wiley inscribes the name of his model in the frame, ensuring that they are identified, valued and given recognition as individuals beyond stereotypes.

Through his creative collaboration with Wiley, Souleo has found celebratory images of him hung on museum and gallery walls, and shared on social media. Who we see represented in artworks is of huge importance – we all need to see role models who look like us – and this positive impact can only be heightened if you are the one in the painting, affirming your identity and allowing you to be truly seen.

We often consider the ways in which inspiration travels from muse to artist; but Souleo demonstrates that it also flows back from artist to muse. As he has reflected, 'With Kehinde, I was selected, I inspired him, he saw something in me and I'm inspired by his work. I see the importance of Kehinde's work, the mission behind it, it's inspired me. It reminds you to create your own narrative, your own pathway.'

Since working with Wiley, Souleo has created both a powerful narrative and a pathway of his own. The painter not only opened up the art world as a space in which Souleo could enter into as a visitor, but somewhere he has also been empowered to play an active part. Staying in touch with Wiley, whom he refers to as a 'warm and gracious man', Souleo has been invited to the artist's home and introduced to his connections, giving him the means and confidence to embark on his own creative career. Souleo, who now works as a curator, has featured as a model in commercial shoots, staged exhibitions and public programmes, and collaborated as a muse for numerous other photographers and artists, including his partner and creative artist, Beau McCall.

Wiley's portraits offer audiences a new vision and narrative, within which Black men have status and grace conveyed upon them. In turn, this power and inspiration has been internalised by muses such as Souleo, evident in his successful journey into the art world as a visitor and major contributor. Today, *After Memling's Portrait of a Man in a Red Hat* has a permanent home at Phoenix Art Museum in Arizona, where it can continue to inspire new visitors – invoking in them a new way of seeing. Inspiration, as Souleo has manifested, ripples out. Moreover, his portrait shows us that Black Lives Matter.

Epilogue
The Muse Manifesto

If, as the saying goes, every picture tells a story, there's often a greater real-life narrative hidden beyond the frame. But over time, many of these have been forgotten, ignored or, perhaps worse, mythologised. Among the most romanticised accounts are those which frame the artist's muse as a passive female victim, and perhaps none more than Elizabeth Siddall. Having posed for Millais's famous painting *Ophelia*, she has since been fixed in the image of Shakespeare's tragic heroine, floating lifelessly among the wilted flowers of her watery grave. Distorting fact into fiction, Siddall has been held up by many as a symbol of the mistreated, suffering muse.

But, if Siddall signifies all sacrificial muses, she thus also proves the need to emancipate them all from misleading legends and reductive narratives. Having awakened the real woman behind Millais's painting, it's apparent that Siddall was not passive, but an active protagonist of paintings for which she performed, bringing not just beauty but creativity to the role. At a time when women faced many barriers in the art world, it also gave her an opportunity, which she seized, to further her career as a painter and poet. Separating Siddall from Ophelia demonstrates that we must reverse conventionally accepted ideas of the muse.

Unsurprisingly, the concept of the muse has long been critiqued and condemned by feminist art historians, who have called out the word for its associations with patriarchal power dynamics between female muses and male artists, particularly in cases where muses, such as Siddall, are also artists. This loaded label has undeniably cast a shadow over such individuals, diminishing their own creative practice. Consequently, not only has the term been protested, but there have also been strong calls for it to be cancelled.

But the word 'muse' is not going anywhere and nor should it. Ever since the Ancient Greeks celebrated their divine muses, the term has been invoked

by artists, written into history books, perpetuated by popular culture and cast onto our screens. Over time, our modern idea of the muse has gained unfair connotations of feminine passivity and romance, perpetuated by patriarchal narratives which have sought to celebrate the genius of the great male artist who possesses a muse, or several.

If we are to challenge such outdated stereotypes of the muse, we *need* the term. It enables nuanced discussions around the inspiring individuals who have made immense, but often overlooked, contributions to art history. As this book has shown, we must replace reductive narratives with a much wider picture of who and what the muse is, broadening our understanding of their true input and unique influence. By offering more accurate and complete accounts, from the perspective *of* the muse, we can, and must, banish reductive tropes and restore the original power of the term.

It's time to reclaim the muse.

As early as the seventeenth century, Artemisia Gentileschi had already reclaimed the concept of the muse from her male counterparts. In a powerful act of control, she presented herself as Clio, the Muse of History, to take possession of her own body and paint herself into history. Meanwhile, the likes of Amrita Sher-Gil have played with notions of the sensual 'exotic' muse to critique such stereotypes from within. Frida Kahlo, who famously asserted that she was her 'own muse', went one step further in her paintings – not only exposing but cutting open her naked body to analyse, release and treat the pain within.

Like Kahlo, many artists have harnessed the power of self-portraiture to tell their own personal stories, using art as a powerful form of therapy, self-acceptance and even activism. In introspective photographs, Sunil Gupta interrogates and openly shares his identity as a gay Indian man living with AIDS to shatter the stigmas which exist around the disease, while Nilupa Yasmin weaves together family photographs as a means of exploring, reconnecting with, and preserving, her rich South Asian heritage.

Given the special bonds which exist between parent and child, family members frequently feature as deeply personal muses, while reflecting the

culturally specific contexts within which they live. Most notably, Fukase Sukezo playfully posed for his son within the family's photographic studio. The resulting images both parody and elevate the traditional Japanese portrait to 'art photography'; Fukase Masahisa was paying a powerful tribute to the man who created, taught and inspired him. Meanwhile, Marlene Dumas has investigated the complex emotions, including fear, which a child can stir up; portraying her daughter Helena, she created a protective barrier between viewers and her young muse through layers of abstraction.

Romantic love, too, has been a great driving force for many artists and muses: the shadow of George Dyer haunts the most menacing paintings by Francis Bacon, who attempted to capture the destructive dynamic of their relationship on canvas. In contrast, Ada Katz, who gave up a successful career as a scientist for the role of muse, cuts a smart, sophisticated and fashionable figure in her husband's paintings, which denote their shared American Dream throughout the decades. As his act of love, Salvador Dalí co-signed his surrealist paintings with the name of his wife, Gala Dalí, awarding recognition to the woman who brought business acumen, ambition and creativity to the position.

Throughout modern art, in particular, we have seen the phenomenon of mutual muses, particularly in pairings of artists who have sparked reciprocal creativity in one another: *Guernica* wouldn't exist without the photography and politics of Dora Maar, nor would Gustav Klimt have acquired his signature style without the trail-blazing fashion designs of Emilie Flöge. Such partnerships prove that muses are not always models, although these women featured in two of the world's best-loved paintings. Meanwhile, many of Marina Abramović's most heart-stopping performances would not have been possible without her trusted Ulay. Acting as allied collaborators in a shared endeavour, these muses have defied expectations and conventions, to break new artistic ground together.

While some muses have fallen into the role unintentionally, others have sought the status in an act of subversion, manoeuvring it, strategically, to inspire entire movements and ensure their own legacy. The Bloomsbury Group was formed around the formidable Lady Ottoline Morrell, who befriended,

supported and hosted artists and writers, who in turn depicted her in the theatrical images she fashioned. Similarly, Sunday Reed mentored, funded, championed and modelled for many of Australia's most notable modern artists, including Sidney Nolan, whom she housed at Heide. In Venice, Luisa Casati transformed herself into a living work of art, enthralling and advocating for artists such as Italy's Futurists, who claimed her as one of their own.

Numerous muses have also collaborated with artists to broadcast both personal and political messages. By posing nude for the pioneering, gender-swapped paintings of Sylvia Sleigh, curator and critic Lawrence Alloway was both actively complicit in, and a powerful ally for, his wife's feminist interventions in art history. Contemporary artist Pixy Liao has continued such conversations with photographs of her boyfriend, Moro, in which he lies naked, transformed into a life-size sushi roll. Through these subversive images, the pair poke fun at, and protest, the expected gender roles in heterosexual, romantic partnerships. Moro points to the fact he is just 'an ordinary Japanese guy', which allows him to stand for the everyman. But this muse also brings wit, willingness and humility to the role, without which Liao's staged photographs would not be possible.

This same sense of performance has defined numerous collaborations, particularly where the muse is an actor or entertainer. Most notably, power-art couple of the 1980s, Grace Jones and Keith Haring, brought the street artist's doodles to the stage, where Jones revelled in her image as a graffiti goddess. Deep in the Mexican jungle, meanwhile, Tilda Swinton awoke Tim Walker's enchanted dream-world to enact expressions of androgyny with demanding presence. Despite the long hours and exhausting work of modelling, carer-turned-model Lila Nunes has taken great pleasure in performing as an entire cast of magical characters inside the studio of Paula Rego; connected by their shared Portuguese heritage and gender, artist and muse have united to tell gripping stories of women taking revenge.

Similarly, Sue Tilley has not just enjoyed, but benefited from, the hours she spent asleep in Lucian Freud's studio, using her association with the British

painter to launch her own creative career. From job centre supervisor to Freud's most famous sitter, Tilley exploded all conventional ideas of who could be a muse in the 1990s. But she was far from the first; Diego Velázquez elevated his enslaved assistant to the status of free man with the dignifying portrait *Juan de Pareja*, before freeing him in real life. Such paintings demonstrate the diversity of muses, who exist far beyond limiting stereotypes.

While de Pareja stands centre stage, many other muses have historically remained in the shadows, anonymous, and awaiting discovery. No muse has been more overlooked than the Black maid in Édouard Manet's masterpiece, *Olympia* (1863). For decades, scholars fixated on the central white female muse, Victorine Meurent, who posed as a nude Parisian sex worker, gazing directly at the viewer, from her bed. However, during the 1990s, post-colonial and feminist accounts began to focus on the figure of the maid, who brings her mistress a bouquet of flowers, likely from a client.

For many critics, Manet's canvas is characterised by oppression and racial stereotypes: 'Olympia's maid, like all other "peripheral Negroes", is a robot conveniently made to disappear into the background drapery', writes Lorraine O' Grady. Although Laure does undoubtedly assume a traditional position of servitude in Manet's painting, she also moves beyond stereotypical representations of Black figures, prevalent in nineteenth-century French painting. Curator and art historian Denise Murrell, whose research draws attention to art history's Black muses, points out that Manet has broken with hypersexualised representations of Black women, popular among his peers: 'She's not bare-breasted or in the gorgeously rendered exotic attire of the harem servant'.

Instead, dressed in contemporary fashion, Laure appears as a member of the new free Black community who had come to Paris following France's abolition of slavery fifteen years earlier. Within the composition, she is also directly engaged in the action, symbolising her status as a working-class woman. As Murrell argues, 'she almost seems to be a friend of the prostitute, maybe even advising her'. Both women play an equally important role in the painting, through which Manet was offering a snapshot into the realities of

modern Parisian life in the 1860s. As Murrell concludes, this painting 'shows the limits of freedom in a society which is still essentially racist and sexist, those limits of freedom for both these women'.

Identifying, and understanding the lived experiences of, depicted muses adds real depth to our understanding of renowned artworks, such as *Olympia*. Laure, who lived just a short walk from the artist's studio, appears in another two paintings by Manet, who referred to her as 'very beautiful' in his notebook. But, given Eurocentric notions of desirability still abound in art history's narratives of the muse, many Black sitters have been overshadowed by their white counterparts. Just as Meurent has eclipsed Laure, the preoccupation with Siddall has meant that other Pre-Raphaelite muses, including Jamaican-born Fanny Eaton, have been overlooked. Meanwhile, a deeply personal poem, written by artist and performer Oroma Elewa in 2011, has been misattributed to Frida Kahlo:

I am my own muse. I am the subject I know best. The subject I want to better.

Since sharing her words online, Elewa's poem has been posted across the internet alongside paintings by the Mexican artist, printed on merchandise, and woven into the constructed and commodified Kahlo brand.

While Elewa reclaims her poignant words, many other contemporary artists deliberately challenge, deconstruct and replace outdated tropes with an expanded vision of the muse. Not only has Awol Erizku framed Beyoncé as a divine figure of fertility in her pregnancy photoshoot, but he has repeatedly inserted Black sitters into the frames of famous works with photographs such as *Girl with a Bamboo Earring* (2009) and *Elsa* (2013) in which an Ethiopian sex worker replaces Manet's white model. Similarly, the likes of Kehinde Wiley, Kim Leutwyler and Chris Ofili form collaborations with muses as a means of carrying important messages about race, identity and gender. In turn, their subjects feel proud to have been represented; to be seen and have others see you is an empowering form of validation.

As we leave behind misrepresentations of the muse, it's crucial that we all play a part in recognising, applauding and commemorating the real and varied

contributions that these individuals have made. As this book has demonstrated, each muse brings their own talents, qualities and personality to dynamic artistic partnerships; given this level of commitment and input, we must also advocate for muses to be treated with fairness and respect, and acknowledge their rights. Therefore, as we enter a new era for the emancipated muse:

❋ May the artist–muse relationship be one of mutual benefit to both parties involved;

❋ May artists treat their muses with respect, considering them as equal partners in a collaborative relationship;

❋ May the muse be free to enter into, stay and leave the creative partnership on their terms;

❋ May the muse be given rightful credit for their contributions and, where appropriate, rights in the ownership of artworks, as well as input into how, when and where their portraits are exhibited;

❋ May muses be celebrated and recognised for the value they bring, including in gallery texts and displays, and art historical narratives;

❋ Where the muse is included as a character in a piece of original work, be it a book, film or script, may the creator distinguish between fact and fiction;

❋ May a more diverse and inclusive cast of muses be acknowledged, researched and given a platform.

The myth of the muse – sitting pretty, silent and submissive – has been exploded. Instead, this book has shown that we must see the muse as a crucial and active agent of art history, who inspires one or more artists in their own unique way. From changing the course of an artist's career to defining movements, muses have assumed an active and influential role, at times using it to their own advantage. Rather than abandoning outdated and reductive ideas of the muse, we must reclaim it in all of its increasingly diverse realities.

There is no doubt, we still need the muse.

Bibliography

Introduction

Boardman, J. (2001). *The Oxford History of Classical Art*. Oxford University Press.

Chevalier, T. (2009). *Girl With a Pearl Earring*. HarperCollins.

Homer, & Wilson, E. (2017). *The Odyssey*. W. W. Norton & Company.

Jiminez, J., & Banham, J. (2001). *Dictionary of Artists' Models*. Routledge.

Jones, J. (2016). *Cara Delevingne: More than a mere muse for male painters*. The *Guardian*. https://www.theguardian.com/artanddesign/jonathanjonesblog/2016/mar/21/cara-delevingne-jonathan-yeo-portraits

McCabe, K. (2020). *More than a Muse: Creative partnerships that sold talented women short*. Quadrille Publishing Ltd.

The Artist as Muse

Juan de Pareja

Fracchia, C., & Macartney, H. (2012). *The Fall into Oblivion of the Works of the Slave Painter Juan de Pareja. Art in Translation*, 4 (2).

Lugo-Ortiz, A., & Rosenthal, A. (2016). *Slave Portraiture in the Atlantic World*. Cambridge University Press.

Mehretu, J. (2016). *How do you paint your own slave?*. The Met, YouTube. https://www.youtube.com/watch?v=8tYwRWdKR-U

Palomino de Castro y Velasco, A. (1987). *Lives of the Eminent Spanish Painters and Sculptors*. Cambridge University Press.

Rousseau, T. (1971). *Juan de Pareja by Diego Velazquez: An appreciation of the portrait. The Metropolitan Museum Of Art Bulletin*, 29(10), 449.

Vinci, L. (2013). *Leonardo's Notebooks*. Black Dog & Levanthal.

Dora Maar

Amao, D., Maddox, A., Lewandowska, K., Ades, D., Agret, A. & Allain, P. et al. (2019). *Dora Maar*. Tate Publishing.

Caws, M. A. (2000). *Dora Maar – With and Without Picasso: A Biography*. Thames & Hudson.

Crespelle, J., Baldick, R., & Picasso, P. (1969). [*Picasso: les femmes, les amis, l'œuvre.*] *Picasso and his Women*, translated by Robert Baldick. Hodder & Stoughton.

Emilie Flöge

Alison, J., & Malissard, C. (2018). *Modern Couples: Art, intimacy and the avant-garde*. Prestel.

Fischer, W. G. (1992). *Gustav Klimt and Emilie Flöge: An artist and his muse*. Lund Humphries.

Husslein-Arco, A. & Weidinger, A. (2012). *Gustav Klimt and Emilie Flöge: Photographs*. Prestel.

Lloyd, J. (2011). *Vienna 1900: Style and identity*. Hirmer.

Peter Schlesinger

Hazan, J., director (1974). *A Bigger Splash Featuring David Hockney* [Film]. Buzzy Enterprises. Circle Associates Ltd.

Hockney, D., & Stangos, N. (1988). *David Hockney by David Hockney*. Thames & Hudson.

Schlesinger, P. (2004). *A Chequered Past*. Thames & Hudson.

Sykes, C. S. (2011). *Hockney: The Biography: A rake's progress. Volume I: 1937–1975*. Century.

The Self as Muse

Artemisia Gentileschi

Garrard, M. (1980). *Artemisia Gentileschi's Self-Portrait as the Allegory of Painting*. The Art Bulletin, 62(1), 97.

Nochlin, L. (1989). *Women, Art, and Power, and other essays*. Westview Press.

Treves, L., Barker, S. & Gentileschi, A. (2020). *Artemisia*. National Gallery/Yale University Press.

Frida Kahlo

Antelo, F. (2013). *Pain and the Paintbrush: The life and art of Frida Kahlo*. AMA Journal of Ethics, 15(5), pp. 460–65.

Carr, S. M. D. (2014). *Revisioning Self-identity: The role of portraits, neuroscience and the art therapist's 'third hand'*. International Journal of Art Therapy, 19:2, pp. 54–70.

Grimberg, S. (2008). *Frida Kahlo: Song of herself*. Merrell Publishers.

Herrera, H. (2018). *Frida: The Biography of Frida Kahlo*. Bloomsbury Publishing.

Lomas, D., & Howell, R. (1989). *Medical Imagery in the Art of Frida Kahlo*. BMJ, 299(6715), pp. 1584–87.

Lowe, S. M., Fuentes, C. & Kahlo, F. (2006). *The Diary of Frida Kahlo: An intimate self-portrait*. Abrams; 2nd Revised edition.

Löwy, I. (2018). *Tangled Diagnoses: Prenatal testing, women, and risk.* University of Chicago Press.

Sunil Gupta

Pardo, A., editor (2020). *Masculinities: Photography and Film from the 1960s to Now: Liberation through photography.* Barbican Art Gallery. Prestel.

Saguy, A. C. (2020). *The History of 'Coming Out,' from Secret Gay Code to Popular Political Protest. The Conversation.* https://theconversation.com/the-history-of-coming-out-from-secret-gay-code-to-popular-political-protest-129609

Nilupa Yasmin

Greer, B. (2014). *Craftivism.* Arsenal Pulp Press.

Family Albums
Helena Dumas

Boogerd, van den, D., Dumas, M., Bloom, B. & Mariuccia, C. (1999). *Marlene Dumas.* Phaidon Press Ltd.

Dumas, M. (1998). *Sweet Nothings: Notes and texts.* De Balie.

Beyoncé

Adjei, E. et al., directors (2020). *Black is King* [Film]. Walt Disney Pictures.

Hearn, K. (2020). *Portraying Pregnancy: Holbein to social media.* Paul Holberton Publishing.

Knowles-Carter, B. G. (2018). *Beyoncé in Her Own Words: Her life, her body, her heritage. Vogue.*

Oyěwùmí, O. (1997). *The Invention of Women: Making an African sense of Western gender discourses.* University of Minnesota Press.

Valenti, L. (2018). *How Beyoncé is Creating a New Narrative Around Motherhood and the Female Body. Vogue.*

Fukase Sukezo

Fukase, M., (2019). *Family (家族: Kazoku).* Mack Books.

Fukase, M., (1991). *Memories of Father (父の記憶: Chichi no Kioku).* IPC Inter Press Corporation.

Tucker, A. W. (2003). *The History of Japanese Photography.* Museum of Fine Arts, Houston/Yale University Press.

For the Love of the Muse
Ada Katz

Clark, M. (2019). *Style matters: Alex Katz in conversation. TATE Etc.* 25 June 2019. https://www.tate.org.uk/tate-etc/issue-25-summer-2012/style-matters

Tomkins, C. (2018). *Alex Katz's Life in Art*. The *New Yorker*. https://www. newyorker.com/magazine/2018/08/27/alex-katzs-life-in-art

George Dyer
Farson, D. (1994). *The Gilded Gutter Life of Francis Bacon*. Vintage.
Gill, M., director (1966). *Francis Bacon: Fragments of a Portrait* [Film]. BBC.
Maybury, J., director (1998). *Love is the Devil: Study for a portrait of Francis Bacon* [Film]. BBC Films.
Peppiatt, M. (2009). *Francis Bacon: Anatomy of an enigma*. Skyhorse.
Peppiatt, M. (2017). *Francis Bacon in Your Blood*. Bloomsbury Publishing.
Stevens, M., & Swan, A. (2021). *Francis Bacon: Revelations*. HarperCollins Publishers.

Lawrence Alloway
Alloway, L. & Sleigh, S. *Correspondence*. The Getty Research Institute. https:// www.getty.edu/research/special_collections/notable/alloway_sleigh.html
Berger, J. (2008). *Ways of Seeing*. Penguin Modern Classics.
Friedan, B. (2010). *The Feminine Mystique*. Penguin Classics.
Ringgold, F. (2005). *We Flew Over the Bridge: The memoirs of Faith Ringgold*. Duke University Press.
Schlegel, A. I. (2001). *An Unnerving Romanticism: The art of Sylvia Sleigh & Lawrence Alloway*. Philadelphia Art Alliance.

Gala Dalí
Allmer, P. (2009). *Angels of Anarchy: Women artists and surrealism*. Prestel.
Breton, A. (2012). *Manifestoes of Surrealism*. University of Michigan Press.
Chadwick, W. (2017). *The Militant Muse: Love, war and the women of surrealism*. Thames & Hudson.
Mahon, A. (2005). *Surrealism and the Politics of Eros, 1938–1968*. Thames & Hudson.

Performing Muse
Moro
Liao, P. (2018). *Experimental Relationship Vol.1 2007–2017*. Jiazazhi.

Ulay
Abramović, M., & Kaplan, J. (2017). *Walk Through Walls*. Penguin.
Ulay. (2013). *Whispers: Ulay on Ulay*. Valiz.
Ulay. (2017). *Interview Under My Skin*. Louisiana Channel, YouTube. https:// www.youtube.com/watch?v=3e8yXmXXNaU
The Story of Marina Abramović & Ulay. Louisiana Channel, YouTube. https:// vimeo.com/224530065

Marina Abramović e Ulay – MoMA 2010. https://www.youtube.com/watch?v= OS0Tg0IjCp4

Grace Jones
Gruen, J. (1992). *Keith Haring: The Authorized Biography.* Prentice Hall & IBD.

Jones, G. (2015). *I'll Never Write My Memoirs.* Simon & Schuster.

Kershaw, M. (1997). *Postcolonialism and Androgyny: The Performance art of Grace Jones. Art Journal,* 56(4), 19.

Pearlman, A. (2003). *Unpackaging Art of the 1980s.* University of Chicago Press.

Tilda Swinton
Saner, E. (2015). *Tilda Swinton: Collaborative chameleon who doesn't court Hollywood.* The *Guardian.* https://www.theguardian.com/film/2015/jul/24/tilda-swinton-collaborative-chameleon-who-doesnt-court-hollywood

Walker, T. (2012). *Tim Walker: Story Teller.* Thames & Hudson.

Walker, T. (2013). *Stranger than Paradise* [Photo shoot]. *W Magazine.*

Walker, T., director (2014). *The Muse* [Film].

Lila Nunes
Graham, H., Eastham, B. (2011). *Interview with Paula Rego. The White Review.* https://www.thewhitereview.org/feature/interview-with-paula-rego/

McEwen, J. (2008). *Paula Rego, Behind the Scenes.* Phaidon.

Willing, N., director. (2017). *Paula Rego: Secrets and stories* [Film]. BBC.

Muse of a Movement
Elizabeth Siddall
Hawksley, L. (2005). *The Tragedy of a Pre-Raphaelite Supermodel.* Andre Deutsch.

Marsh, J. (1988). *Imagining Elizabeth Siddal. History Workshop Journal,* 25(1), pp. 64–82.

Pollock, G. (2003). *Vision and Difference: Feminism, Femininity and Histories of Art.* Routledge.

Trowbridge, S., editor (2018). *My Lady's Soul: The poems of Elizabeth Eleanor Siddall.* Victorian Secrets.

Witcher, H. B. & Kahrmann Huseby, A., editors (2020). *Defining Pre-Raphaelite Poetics.* Palgrave Macmillan.

Zimmerman, E. (1991). *Art Education for Women in England from 1890–1910 as Reflected in the Victorian Periodical Press and Current Feminist Histories of Art Education. Studies in Art Education,* 32(2), p. 105.

Sunday Reed
Burke, J. (2012). *The Heart Garden.* Random House Australia.

Harding, L., & Morgan, K. (2015). *Modern Love: The lives of John and Sunday Reed*. Melbourne University Publishing.

Hester, J., Burke, J. & Reed, S. (2001). *Dear Sun: The letters of Joy Hester and Sunday Reed*. Random House Australia.

Nolan, S. & Underhill, N. (2008). *Nolan on Nolan*. Viking.

Reed, J., Underhill, N. & Reid, B. (2001). *Letters of John Reed*. Viking.

Nolan, S. (1971). *Paradise Garden: Paintings, Drawings and Poems*. With an Introduction by Robert Melville. R. Alistair McAlpine Publishing Ltd.

Lady Ottoline Morrell

Morell, O. & Hardy, R. (1974). *Ottoline at Garsington: Memoirs of Lady Ottoline Morrell, 1915–1918*. Edited with an introduction by Robert Gathorne-Hardy. Faber.

Spalding, F. (2013). *The Bloomsbury Group*. National Portrait Gallery Companions/National Portrait Gallery.

Marchesa Luisa Casati

Epstein, J. (2014). *Let There be Sculpture*. Hesperides Press.

John, A. (1952). *Chiaroscuro: Fragments of autobiography*. Jonathan Cape.

Mackrell, J. (2018). *The Unfinished Palazzo – Life, Love and Art in Venice: The stories of Luisa Casati, Doris Castlerosse and Peggy Guggenheim*. Thames & Hudson.

Marinetti, F. T. (2006). *Critical Writings*, trans. Doug Thompson. Farrar, Straus and Giroux.

Ray, M. (2012). *Self-Portrait*. Penguin Classics.

Ryersson, S. D. & Yaccarino, M. O. (2004). *Infinite Variety: The life & legend of the Marchesa Casati*. University of Minnesota Press.

Ryersson, S. D., & Yaccarino, M. O. (2009). *The Marchesa Casati*. Abrams.

Muse as Message
Anna Christina Olson

Hadley, B. & McDonald, D. (2018). *The Routledge Handbook of Disability Arts, Culture, and Media*. Routledge.

Pulrang, A. (2019). *How to Avoid 'Inspiration Porn'*. Forbes. https://www.forbes.com/sites/andrewpulrang/2019/11/29/how-to-avoid-inspiration-porn/?sh=383ca09f5b3d

Randall, G. C. (2010). *Andrew Wyeth's Christina's World: Normalizing the abnormal body*. American Art, vol. 24, no. 2, pp. 30–49.

Steinbeck, J. (2014). *Of Mice and Men*. Penguin Modern Classics.

Wyeth, A., Hoving, T., Gilbert, K. & Holt, J. (1976). *Two Worlds of Andrew Wyeth: Kuerners and Olsons*. The Metropolitan Museum of Art Bulletin, 34(2), p. 1.

Doreen Lawrence
Lawrence, D. (2011). *And Still I Rise*. Faber & Faber.
Nesbitt, J. (2010). *Chris Ofili*. Tate Publishing.
Ofili, C. (2005). *Afro Muses 1995–2005*. Studio Museum in Harlem.

Sue Tilley
Feaver, W. (2011). *The Lives of Lucian Freud: FAME 1968–2011*. Bloomsbury.

Ollie Henderson
Wetherall, S. *A powerful moment for the Archibald prize: could a portrait of a black woman win?* The *Guardian*. https://www.theguardian.com/artanddesign/2019/may/02/a-powerful-moment-for-the-archibald-prize-could-a-portrait-of-a-black-woman-win
Pilcher, A. (2017). *A Queer Little History of Art*. Tate Publishing.

Souleo
Wiley, K., Tsai, E. & Choi, C. (2015). *Kehinde Wiley: A new republic*. Prestel.

Epilogue
Murrell, D. (2018). *Posing Modernity: The Black model from Manet and Matisse to today*. Yale University Press.
O' Grady, L. (1994). 'Olympia's Maid: Reclaiming Black Female Subjectivity', in Jones, A. (2003). *The Feminism and Visual Cultural Reader*. Routledge Press.
Pollock, G. (1999). *Differencing the Canon: Feminist Desire and the Writing of Art's Histories*. Routledge.

Acknowledgements

I t's been an absolute joy and honour to work on this book, which has been a collaboration from the very start. To my wonderful editor, Mireille Harper: thank you for believing in *Muse* during those early discussions, and for helping me to refine the book with your wise, informed and excellent suggestions. I am so grateful for your guidance and insights, and for the incisive editing notes and encouragement throughout the writing process. To Maxine Sibihwana: thank you for thoughtful comments, valuable edits, continual support and encouraging emails. Dina Razin: you have breathed life into the muses of this book with your sublime and inspiring illustrations, including the beautiful cover. I have loved working with all three of you.

This book has also been shaped by the immense contributions of those muses and artists who have granted me generous and honest interviews, sharing their experiences of, and offering valuable insights into, their creative partnerships. I am particularly indebted to Kim Leutwyler, Nilupa Yasmin, Oroma Elewa, Peter 'Souleo' Wright, Pixy Liao, Sue Tilley, Sunil Gupta, Takahiro 'Moro' Morooka and Tim Walker.

I am hugely grateful to the artists' estates, archives, art historians, critics and curators who have shared their expertise and kindly provided images for Dina to work from. Special thanks must go to: Australian art expert and book dealer Robert Maconachie, Antony Mottershead and the team at the Sidney Nolan Trust who also granted permission for the inclusion of Sidney Nolan's poetry, Kendrah Morgan at the Heide Museum of Modern Art, Dr Serena Trowbridge, Jennie Anderson at Argentea gallery, Chris Bayley at the Barbican

Centre, Kayleigh Ditchburn and the wider team from the Birmingham Centre for Art Therapies, Jonathan Watkins at Ikon gallery, the Francis Bacon Estate, the Estate of Sylvia Sleigh, the Metropolitan Museum of Art, the Wien Museum, Tate, the National Portrait Gallery, the Getty Research Institute and the Smart Museum of Art at the University of Chicago.

Writing during a pandemic, when libraries were closed, I must thank stealth librarian Tom Hicks, who scoured online archives for relevant articles, and sourced specialist art books, running them from one city to another. Nor could I have written the book without the Birmingham & Midland Institute: Daniel Parsons, thank you for offering me the most beautiful room within which I could write, while you have kept me smiling with your welcome interruptions, Samina Ansari and Taranpreet Panesar. This book would also not have been possible without Latif Qoraishi and his colleagues at the Birmingham and Midland Eye Centre, who have given me the greatest care over the last two years.

I owe a debt of gratitude to those who have championed the arts, taught and mentored me, particularly in the early stages. I wouldn't be working in, or writing about, the arts if it wasn't for Sarah Tennant and the Classics teachers at Repton School: thank you for making the muses sing. Jeremy Bournon: your art department was my happy home for five years. I fondly remember gathering round the mapping chests, as well as our trips to Tate, where I first saw the impactful work of Paula Rego. From school to university, it was in your inspirational lectures, Anthony Parton and Hazel Donkin, that I realised I could, and should, pursue a career in the arts.

To my family, and particularly Christopher and Frankie, Paul and Andy, thank you for keeping me sane throughout the whole process. The unexpected parcels, dinners and video calls lifted my spirits. To my parents, thank you for the sacrifices you made, which meant I received such a great education, including from you. Dad, thanks for your quiet inspiration and kindness, for always listening and for sharing in my excitement for the book, which I look forward to seeing placed within your growing gallery. You were always

the real writer in the family, and first showed me what words can do. I hope I have made you proud.

Most of all, I must thank my family of brilliant friends. Lily, I have loved receiving your handwritten letters and postcards, particularly during the tougher stretches of writing. Julia and Greg, you have been such true friends, always there on the other end of the phone when I needed you. Mike and Sam, I am eternally grateful for the hours you have spent reading, editing and commenting upon the text: I promise to reconsider my use of the comma. Thanks must also go to Anna, Becky, Fiona, Lorna, Chris, Lizzie and the whole Argirou family. Jay, thank you for setting me on the way with the early advice and encouragement, and Joe, the cosmic order actually worked!

Writing *Muse* has taken me on an incredible journey; thank you to everyone who has made it possible and shared in it with me.